DESIGN
THROUGH
DISCOVERY

The Elements and Principles

SECOND EDITION

Design Through Discovery

The Elements and Principles

SECOND EDITION

Marjorie Elliott Bevlin

THOMSON

WADSWORTH

Australia • Canada • Mexico • Singapore • Spain • United Kingdom • United States

Publisher:	Ted Buchholz
Acquisitions Editor:	Barbara J. C. Rosenberg
Developmental Editor:	Terri House
Project Editor:	Margaret Allyson
Art Director:	Burl Sloan
Production Managers:	Monty Shaw, Erin Gregg
Photo Research:	Elsa Peterson

ISBN-13: 978-0-15-500963-9
ISBN-10: 0-15-500963-X

Library of Congress Number: 93-77624

Wadsworth Group/Thomson Learning
10 Davis Drive
Belmont CA 94002-3098
USA

For information about our products, contact us:
Thomson Learning Academic Resource Center
1-800-423-0563
http://www.wadsworth.com

For permission to use material from this text, contact us by
Web: http://www.thomsonrights.com
Fax: 1-800-730-2215
Phone: 1-800-730-2214

To Jenni
who has been with me all the way

Preface

During the early years of *Design through Discovery*, some of the instructors using the book requested a concise version containing only the elements and principles of design, without the subsequent material on the various fields of application. The result was the Brief Edition, which consisted of the first ten chapters of the third regular edition, but which also incorporated condensed text and numerous illustrations from the last chapters of the book. This adaptation was intended to provide a stimulating but easily covered introduction to the field of design and to art courses generally. Four years later, *Design through Discovery: The Elements and Principles* was published; it contained the first ten chapters of the fourth edition exactly as it was originally published. After interviewing teachers who were using either of the two shorter versions, the conclusion was reached that the second version served them well, the exact correspondence with the first part of the full-scale edition making it possible to use the longer book as reference. As a result of these expedients, this second edition of the Brief Edition is now being offered, not in an expanded form as in the case of the original, but as the first ten chapters of the sixth edition of the full-scale *Design through Discovery*. Inasmuch as every revision requires a completely rewritten text, this version of the Brief Edition inevitably becomes a new and contemporary approach to the fundamental issues involved in the art of design.

The Brief Edition consists of three parts. The first two chapters establish the role of design from the beginning of time to the contemporary world. Accepting the fact that the world often seems arbitrary and chaotic, designers seek, through personal associations and imagery, a sphere in which they can induce order, a harmony reached through the sensitive application of the elements and principles of design. As in all editions of *Design through Discovery*, emphasis is placed on the fact that underneath the seeming disorder of the universe the elements and principles of design not only exist but have always operated, even when the results may seem catastrophic. As with previous editions, emphasis is placed on the limitless inspiration nature offers the designer.

An important aspect of Part One is the analysis of the creative process, a discussion of the reasons people create and an exploration of the meaning of aesthetics, both in its traditional association with beauty and in its contemporary interpretation as an expression of all aspects of life, however offensive. The creative

process itself is followed step-by-step, with analysis of each aspect of the problem-solving procedure which forms its framework. Inspiration, imagery, integrity, and originality are all considered in their roles as part of the creative process. And the distinction between art and craft is explored, with acknowledgment of the importance of the time-honored traditions of craftsmanship.

Part Two is devoted entirely to the elements of design, which are presented as ingredients composing any effective design. Each element is shown in a variety of roles, with its variations and possibilities demonstrated, whether it is a distinguishing mark of weaving or of a city skyscraper. Emphasis is placed on the fact that no design utilizes only one element, but is the result of interrelationships and variety.

Part Three discusses the principles of design as the means by which the elements are combined. A principle is not *applied* by the designer but results from the deliberate interplay of elements as the design develops and expands. Here again, the force of interaction is stressed, with any design resulting from the relationships that flow and interweave as the designer makes pertinent choices. Such choices are demonstrated by examples of designs in widely varied fields, ranging from the latest model automobile to a shelter high in the trees of the Philippine jungle.

In addition to a deeper exploration of the fundamentals of design, the present edition represents a specific effort to broaden the examples of design to include a more comprehensive view of past ages, and a representative overview of the designs being created in all parts of the world today. Although art in any field eliminates boundaries that divide people, an awareness of the variety created by differing experiences and individual backgrounds enriches the student's appreciation, not only of the dignity of the individual but of the unifying influence of the creative process.

Each chapter is headed by a list of Keynotes to Discovery, offered as guideposts to emphasize terms, technical and otherwise, that should be retained as part of the vocabulary of the area being studied. Each chapter ends with a summary, again intended as an aid to retaining the crucial points of the preceding discussion. The book ends with a glossary summing up the keynotes and any other pertinent terms, and a bibliography offered as a guide into further adventures in specific areas of design.

Acknowledgments

This version of the Brief Edition is in large part the result of the suggestions of professors who took the time and effort to express opinions according to their own needs and the needs of their students. I extend my sincere thanks to Susan Kimmel of Columbia Basin College, Marilyn Rasmussen of University of Nebraska, and Jerry B. Speight of Murray State University, all instrumental in the updating of this edition. Their valuable comments build upon the expertise of previous reviewers Timothy T. Blade, University of Minnesota, Twin Cities; Mel Casas, San Antonio College, Texas; William Holley, East Carolina University, North Carolina; Jo A.

Lonam, California State University, Sacramento; Lon Nuell, Middle Tennessee State University, Murfreesboro; Harper T. Phillips, Bergen Community College, New Jersey; Carol S. Robertson, Bauder Fashion College, Georgia; Rick Rodrigues, City College of San Francisco; Patricia Terry, The University of Southwestern Louisiana; Mary VanRoekel, North Dakota State University, Fargo; Nicholas H. von Bujdoss, Smith College, Massachusetts; and Lee Wright, The University of Texas, Arlington.

I have been most grateful to Elsa Peterson and her staff as they searched the world for illustrations, often coming up with exciting improvements over my original requests.

It has been a pleasure to work with the team at Harcourt Brace, and my thanks go especially to Barbara Rosenberg, acquisitions editor, and Terri House, developmental editor. I particularly appreciate the warmth and understanding of Margaret Allyson, project editor, who steered the course and bore the brunt of the stress, allowing me to enjoy the privilege of writing.

I am grateful to many friends who contributed in various ways, including Roy Lundgren, Glen Woodward, and Robert Todd, who opened the door to the vast possibilities of human perception. To my family go my eternal thanks for their support and enthusiasm, and special thanks are due Robert Nichols, my husband and collaborator, whose suggestions and meticulous reading of the manuscript made certain that it said what I intended.

M. E. B.

Contents

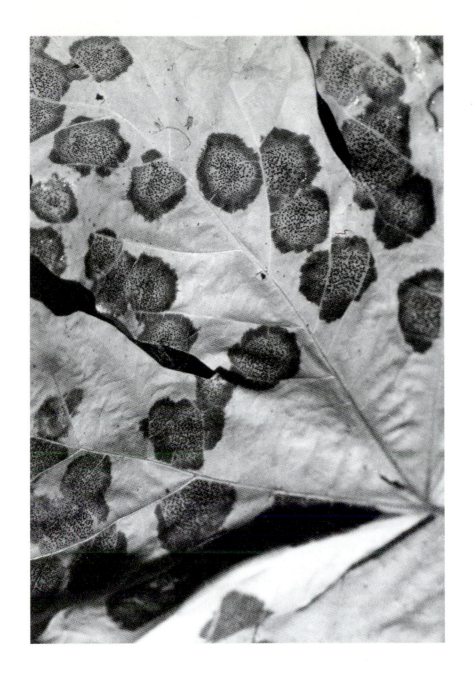

Design As Universal Reality

The Essence of Design | 1

In varying degrees we are all designers by nature. We design our days, our wardrobes, our social activities. We plan where we will go, what we will wear, what we will eat, and with whom we will spend our time. By selecting and planning we bring order to our lives, and in doing so, we engage in the essence of design, for design is, first of all, *a plan for order*.

At any given moment, people in all parts of the world are creating designs. Some are based on traditional skills handed down from generation to generation (Fig. 1-1). Others represent the latest in contemporary materials and concepts (Fig. 1-2). Still others are

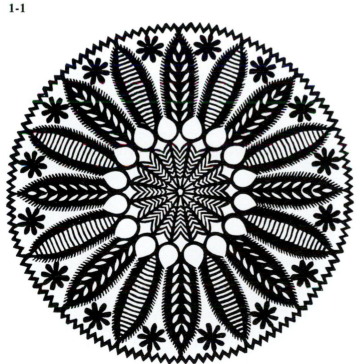

1-1

1-2

1-1 Traditional Polish *wycinaki* (paper cutout).

1-2 Flat display liquid crystal television set.

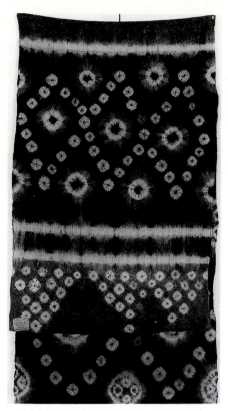

1-3

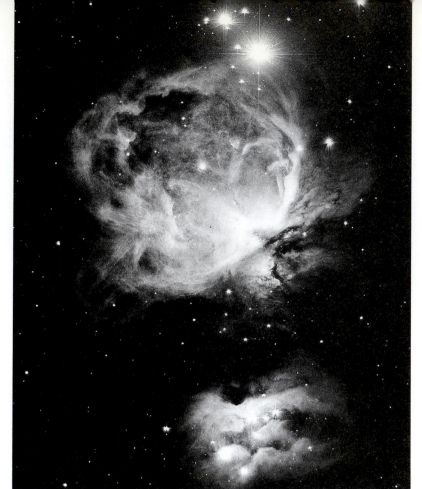

1-4

1-5

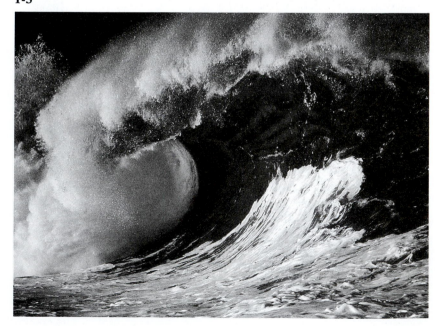

1-3 Poritutu roto (ceremonial textile). Sulawesi, Rongkong region. Planti. Cotton, warp 340 cm, weft 64 cm. Museum voor Volkenkunde, Rotterdam.

1-4 Telescope photograph of two nebulae.

1-5 A wave breaks against the shore.

1-6 Ernst Haas. *Abstract* (rock formation). Photograph.

1-7 Cross-country skiers at Teton Science School, Grand Teton National Park.

1-8 Dehydrated land in the Everglades.

necessary accompaniments to the life of the community (Fig. 1-3). In each instance, the designer is following an urge as old as the universe, for design is fundamental to every process by which the universe is continually being formed (Fig. 1-4).

Wild masses of water are ordered by winds and tides, whose patterns are determined by gravitational pulls among the earth, sun, and moon (Fig. 1-5). Landscapes that seem weird or fantastic can be explained with orderly simplicity by geological theories (Fig. 1-6). Ultimately, universal design defies total comprehension, but we are becoming increasingly aware that human life is only a small part of the total order rather than its reason for being. We climb a mountain, returning to say that we have conquered it, yet one storm can wipe out all trace of our triumph, and the mountain remains impervious to human assault (Fig. 1-7). When we attempt to dominate less forbidding elements of our earth, we may unwittingly cause results disastrous to life of any kind (Fig. 1-8).

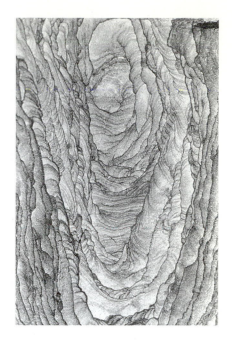

1-6

1-7

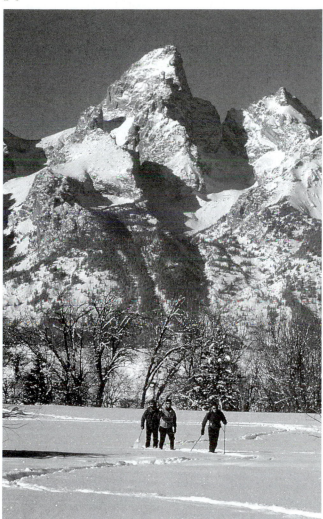

1-8

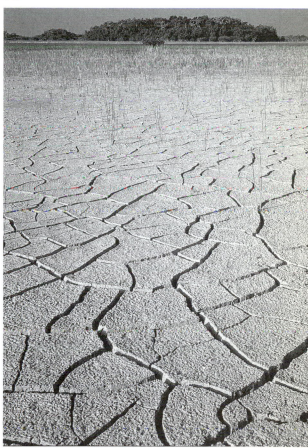

1-9 Queen Anne's lace.

1-10 Orange cup coral.

1-11 Maija Isola. *Medusa.* Screened cotton print designed for Marimekko, Helsinki. Courtesy of Donna Gorman, Inc.

1-12 Roy Lundgren. Sketch directing a dinner guest, with time and telephone number included. Courtesy Roy Lundgren.

1-13 Chermayeff & Geismar Inc., designers. Symbol and logotype for Public Broadcasting System. Courtesy the designers.

The earth surrounds us with designs beyond the capabilities of any human designer, yet offers the potential for limitless inspiration (Fig. 1-9). We will discover that any human design—whether it is wallpaper, a stage set, or a city—is based on the same elements and principles that control the earth and our environment, and that the process of designing, a natural instinct even in sea animals (Fig. 1-10), is also a natural expression of ourselves.

The Nature of Design

A plan for order results from a selective process. From the infinite forms in the natural world, the painter or photographer selects one small specimen on which to focus brush or camera (Plate 1). The textile designer chooses one particular shape or group of shapes and translates it into a length of fabric (Fig. 1-11). It is the same kind of selection we use in directing someone to a specific place. We do not mention every tree or house en route; we select those features that are most pertinent, whether we give the directions by word of mouth or set them down on paper (Fig. 1-12). In making a design we select the important features—lines, shapes, textures—that will guide the viewer to the experience we want to share.

1-9

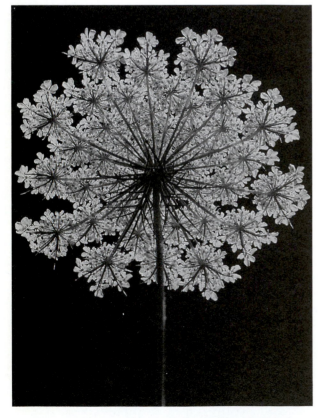

1-10

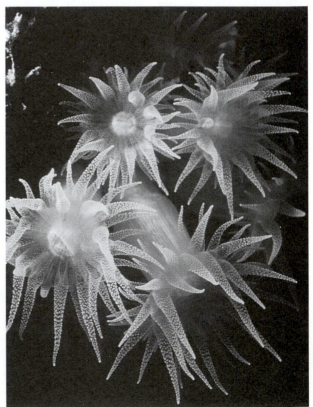

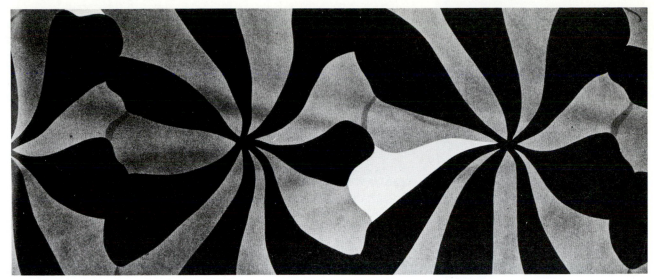

1-11

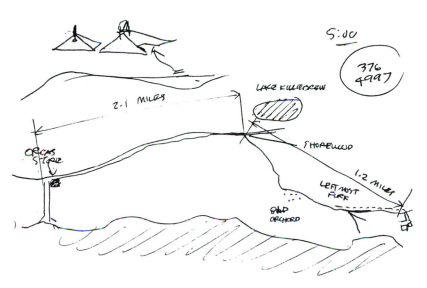

1-12

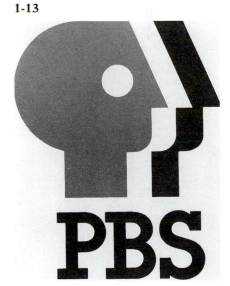

1-13

The distinction between art and design has long been a subject for debate, reflecting prevailing philosophies of different periods as well as the convictions of individual artists. A century ago, Paul Cézanne set new standards of painting through his emphasis on the importance of color in depicting form. He is quoted as saying, "Design and color are not distinct. . . . The more colors harmonize with one another, the more defined is design." Today we are aware that excellent designs exist with no color at all (Fig. 1-13), yet we can agree with Cézanne's ensuing remarks that "the secret of design, of everything marked by pattern, is contrast and relation of tones."[1]

[1]Dewey, John. *Art as Experience*, NY: Capricorn Books, 1958, p. 121.

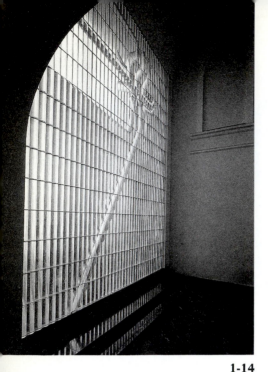

1-14

1-14 Stanislav Libensky and Jaroslava Brychtova. Glass wall. 1981–1983. 8 × 7 m. Municipal Building, Prague.

1-15 Atelier Fontenay-aux-Roses, Sceaux. Stoneware flask.

1-16 Agesander, Athenodorus, and Polydorus of Rhodes. *Laocoön Group*. c. 150 BC Marble, height 8′ (2.44 m). Vatican Museums.

1-15

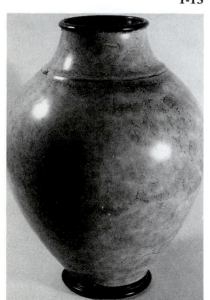

The similarity between art and design is basic. Both are composed of the same elements—*line, space, shape and form, color, texture*—combined by means of the same principles—*unity and variety, balance, emphasis, rhythm, proportion, and scale.* Art incorporates design and many designs can legitimately be considered works of art. In the end, if a distinction can be made, it becomes a matter of the perspective of the artist or designer. A designer works with a specific purpose in mind, a need to be filled, either *useful* (as in cooking equipment or tools) or *aesthetic,* to be appreciated visually, as with a designed floor or wall panel (Fig. 1-14). The artist, on the other hand, is primarily involved in subjective expression of a personal experience, reaction, or mood. Nothing is required of the completed work beyond acceptance by the artist who created it; it does not even have to be viewed by anyone else.

The creation of a design is subject to certain stipulations, even when it appears to be primarily decorative. The vase in Figure 1-15 is attractive with its simple form and textured glaze. As a design, however, it would be expected to fulfill a purpose as a container for flowers. Therefore, if we were to fill it with water and it leaked or if it tipped over when peonies or gladioli were placed in it, we would consider it an unsatisfactory design.

In our exploration of design, it will be almost impossible to make a consistent distinction between design and art. We will discuss painting and sculpture, clearly categorized as works of art, but we will focus on the degree to which successful paintings or sculpture utilize the elements and principles of design. The main concern here is the degree to which the work possesses *design qualities,* those attributes that imbue it with order regardless of its ultimate purpose.

Why Create?

A student creates designs as assignments, and if the procedure goes well, the project becomes totally absorbing. The experimentation, judgments, decisions—the entire process of creation—becomes utterly consuming. Whether one realizes it or not, however, there is also an underlying compulsion, a hope of arriving at a rewarding and satisfactory conclusion. The term usually associated with such successful results is *aesthetic.*

The Aesthetic Sense

The ancient Greeks gave us the word *aesthetikos,* pertaining to sense perception. Although such perception involves all the senses, the word has a long tradition of association with the moral and the beautiful. This association comes into question with some contemporary artists who insist upon a sensual reaction to works involving the tragic or gruesome, offering depictions of the human condition that many find painful or pornographic. Even the Greeks themselves, noted for the ideal beauty of their sculpture, did not always depict beautiful subjects. For more than 2,000 years, the Laocoön

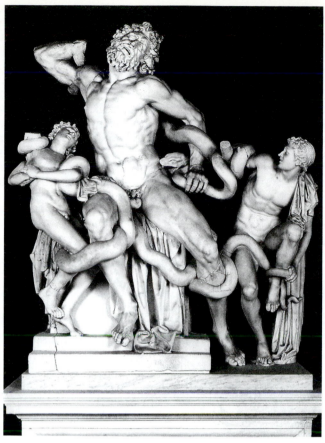

1-16

(Fig. 1-16) has caused viewers to shudder at the son of Priam being strangled, along with one of his sons, by sea serpents. Sensual responses almost invariably involve emotions to some degree and what the eye sees in the Laocoön may result in horror, amazement, or disgust.

Philosopher George Santayana, lecturing a hundred years ago at Harvard, cited three elements of aesthetics:

1. The aesthetic faculty is a matter of pronouncing judgment according to our personal character, perception, enthusiasm, and fineness of emotion.
2. Our judgment of art is a result of anthropological factors associated with the human instinct for artistic activity and its diverse expressions throughout history.
3. Aesthetic judgment is psychological, dealing with the reasons why we think anything is right or beautiful, wrong or ugly, and how we can distinguish transitory preferences and ideals which rest on peculiar conditions from those which spring from elements of mind shared by all humanity and which thus are comparatively permanent and universal.[2]

[2]Santayana, George. *The Sense of Beauty*, NY: Dover Publications, Inc., 1955, p. 5.

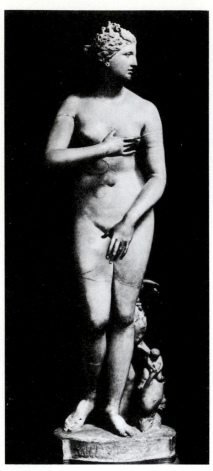

1-17

Speaking today, conductor Riccardo Muti sidesteps the question of rightness or morality as he expresses his approach to music: "We entertain nobody. We make music to make people better. . . . Music expresses feelings, not concepts. It is not moral or immoral. The visions of the great composers are the visions of giants. . . . they give you the certainty of something transcendent within us."[3] Muti does not use the word "aesthetic" but the implication is there. In these two approaches, expressed a hundred years apart, we find a consistent interpretation: The most important factor in the appreciation of the arts is the instinct within us that seeks something of eternal value. When we speak of "aesthetic reactions" to a visual work, then, this connotation is what we have in mind. We have such a reaction because what we see reminds us that eternal values do exist.

Creation as the Search for Beauty

Since beauty and morality were for centuries associated with aesthetics, beauty was considered to be the ultimate good. The contemplation of a work of art, therefore, was expected to reward the viewer with a vision of perfection (Fig. 1-17). This concept placed an impressive responsibility on the artist, particularly when there was disagreement as to what constituted beauty. The artist was viewed as an artisan, yet his or her work was elevated to the realm of mystical inspiration, providing spiritual exaltation, whether in the form of Greek sculpture or medieval glass (Plate 2). On a personal level, the artist strives for beauty to create a haven against a brutal world, a means of feeling in touch with universal harmony. Through beauty one arrives at a measure of freedom—from pain, brutality, and the sufferings of human life.

The Urge to Shock

In direct contrast to the search for beauty is the urge to shock. Picasso's mural entitled *Guernica* was painted for the Pavilion of the Spanish Republic at the Paris International Exposition in 1937 (Fig. 1-18). Motivated by the Spanish Civil War, it symbolizes the bombing of the ancient Basque capital of Guernica, where saturation bombing was used for the first time, later to be widely employed during World War ll. Seeing the act as an evil omen of the horrors that would be perpetrated by modern methods of warfare, Picasso filled the wall with images designed to shock—including the mutilation of women and children and the destruction of the world around them. His work was meant as a prophetic warning to an apathetic world.

Käthe Kollwitz also depicted the horrors of war, with which she was tragically familiar throughout her life in Germany during World War ll. Among her most famous works, however, was a series of etchings entitled *The Weavers*, in which she sought to arouse public awareness of the misery and injustice endured by Silesian weavers during a doomed revolt in 1842 (Fig. 1-19). She succeeded

1-17 Venus de Medici. 3rd century BC? 5′ high. Uffizi, Florence.

1-18 Pablo Picasso. *Guernica*. 1937. Oil on canvas, 11′6″ × 25′8″. Museo del Prado, Madrid.

1-19 Käthe Kollwitz. *The End*. Courtesy Galerie St. Etienne, New York.

[3]Gurewitsch, Matthew. "Model Maestro," *Connoisseur*, January 1991, p. 81.

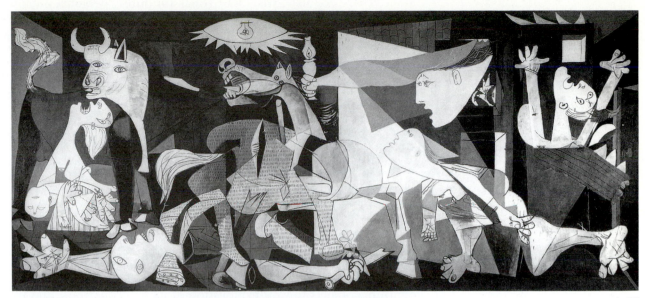

1-18

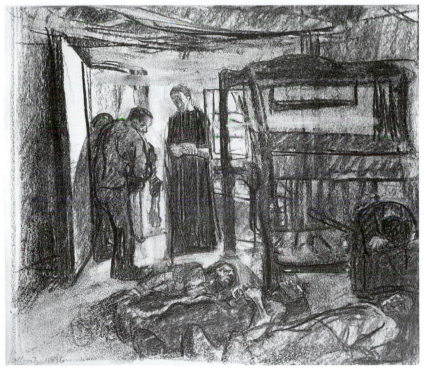

1-19

in evoking a painful response: Kaiser Wilhelm II refused to allow
her to be awarded a gold medal for the series, saying he disliked
Rinnstein Kunst (gutter art).

Kollwitz was concerned with sociological ills, whereas
Picasso's reason for shocking was political. In both cases, the work
is skillfully executed, worthy of admiration for its design qualities

alone. There are also artists who shock for purely personal reasons, as a means of attracting attention. The urge is as old as humanity but seems particularly noticeable in a contemporary world of limitless media coverage and money-minded entrepreneurs who make vast sums of money by bringing shocking art to public awareness. Weird forms, garish colors, and flagrant scenes of violence and degradation can result in widespread controversy, rewarding the artist with coveted notoriety.

The Contemporary View

In a world of violence, extremes of wealth and poverty, and the impersonality of high technology, many artists feel a moral obligation to reveal life as it is with no glossing over for the sake of pleasant viewing. The entire gamut of human activity and emotion becomes subject for art and design. Many skillfully presented films, novels, and television documentaries emphasize the sordid side of life. Drawings and paintings celebrate or memorialize an atrocity. A preoccupation with introspection leads from representation of recognizable objects toward exploration of the subconscious, and psychiatrists and psychologists often ask patients to draw or paint in order to reveal and release inner tensions. Most contemporary artists feel that art must represent the wholeness of life in order to be valid, and that whatever response is evoked, it is ultimately aesthetic in appealing to the senses and involving emotion (Fig. 1-20). The highest form of this kind of art is that in which the artist uses symbols of the sordid or tragic life to reveal strong, admirable individuals who survive. Through contrast, beauty of spirit glows against a dismal background with a sense of hope and human courage.

1-20

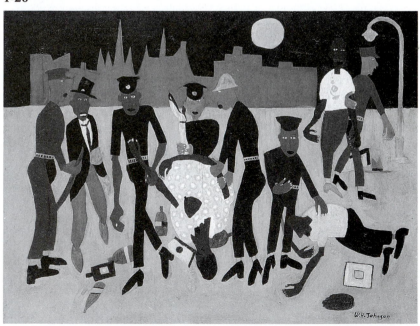

1-20 William H. Johnson. *Moon over Harlem*. 1944. National Museum of American Art, Washington, D.C.

A Fundamental Need

People who have filled a lifetime with designing or pursuing the arts invariably give one predominant reason for doing so: They create because they have to. A verbal explanation of this inner drive is not fully possible; for some artists the need to create is more basic than eating or sleeping. Sometimes the compulsion is expressed as losing oneself, of pulling everything together in inner wholeness; at other times it involves a sense of being at one with the universe. Essentially, the act of creation is a leap toward freedom and fulfillment, breaking the bonds of living within a circumscribed life, entering into a dimension bigger than oneself. Ultimately, there is the hope of creating something that will outlive the creator. More important than any individual interpretation, however, is the fact that at the moment of creation the artist becomes a part of humanity, a voice not only of one place and time but of all the hopes and aspirations of the human spirit throughout history. This is the essence of wholeness, the ultimate reason for creating art.

Visual Design

Visual design is created primarily to be appreciated through the eyes, yet the eye represents only the initial sensory contact. Sensations enter the human eye through the lens, a flattened sphere constructed of numerous transparent fibers, which flattens or becomes more spherical depending upon its distance from the object being viewed. The lens brings *images* of objects to the light-sensitive retina where the images are registered; in fact, the retina of an eye removed from a human being or an animal will frequently show an image of the scene toward which the eye had been turned. Awareness of a design involves far more than such sensory registration. The total experience of seeing has long been analyzed and debated by physicians, psychologists, and, more recently, by computer engineers. This experience is known as *perception*.

The Role of Perception

Familiarity with the computer makes clear the reason for conflicting theories about perception. The computer can be programmed to see, to register images, to create designs in full color. It can be motivated to speak, to answer questions, to make music. However amazing its reaction, though, it is invariably the result of input, of information supplied by its programmer. Human perception can be translated into a similar pattern. We see, we react, and our reaction results from our perception, which is programmed by our genes, our lifetime experiences, our environment, and the culture of which we are a part. Scientific controversy about perception includes, among other things, the degree to which the brain is involved. The structure and function of the brain are still only partially understood. How much of what we see is illusion? For us, perhaps the most important scientific theory is the generally accepted realization that the world is filled with images that we do *not*

see. Our perception is limited to the input provided by our individual experiences and reactions. We recognize an object because of its *identity* and *individuality,* which, because of our own qualifications, have meaning.

The point can be clarified by the drawing in Figure 1-21. Some observers will see a rectangle in the center of the figure; others, focusing their attention above or below the rectangle, will see stripes. The rectangle is not really there; there are no outlines to define it. Such variations in seeing are familiar to psychologists and physicists. What we see is illusion. This happens to our perception continually, and this variable and personal perception is the keynote in appreciating a design. We see what our individual programming allows us to see, and we react accordingly.

Consciousness of the idiosyncrasies of perception affects the designer in various ways. Artists striving for nonobjectivity, in which there are no recognizable forms, find that viewers see images that were never intended, much as we see animal forms in rocks and woolly lambs in clouds. Even in realistic representations, the reaction of the viewer is inevitably subjective. Contemporary painter Julian Schnabel puts it clearly: "All paintings. . . . are metaphoric. . . . It reminds you of something that you might have seen, a key to your imagination. . . . A painting can't help but allude to a world of associations that may be a completely other face than

1-21

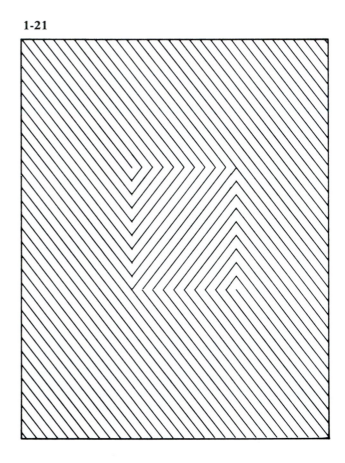

1-21 Ambiguous figure with illusory contours.

that of the image you are looking at."[4] Aspects of this subjective perception have been given specific terms, usually considered components of *gestalt*.

The Gestalt Principle

Gestalt is a German word that defies literal translation but is generally interpreted as relating to the concept of *wholeness*. It became a respected theory in psychological thought from 1912, emphasizing the importance of studying entire patterns of behavior rather than isolated mental phenomena. The idea arose from experiments in perception showing that perception of form does not depend upon seeing individual elements composing the form but tends to grasp the form *in its entirety*. In the field of psychology the theory has been supplanted by more recent developments stressing the function of human consciousness in perception. In the field of design, however, the gestalt principle is still recognized as a valid aspect of the way in which viewers perceive visual images. The pertinent observation is that the whole is not greater than but *different from* the sum of its parts. The classic example is found in music, in which a series of individual notes cannot, of themselves, produce a melody. There has been learned controversy on this point with the consensus that there is something more than just the notes involved—in other words, some unexplained element in the environment or in the viewer's consciousness.[5]

We can make the same point with four lines. When you look at the lines in Figure 1-22, what do you see? Most people will see a square with parts of its sides obscured. Why? A square is a figure with four equal sides. None of these lines is equal to any of the others; they could be four straws floating on the surface of a pond, ready to drift in opposite directions with the first ripple. However, to the mind surrounded from early childhood by building blocks, rectangular doors, books, buildings, pictures, and sheets of paper, the four lines fall into our consciousness as parts of a square.

A similar point can be made with four dots. The dots in Figure 1-23 are unrelated, each a unit in space. Seen in this particular position, however, they suggest to most viewers the corners of a square. Once again, we might ask why. If lines were drawn connecting them in a certain way, a square would indeed result, but lines could be drawn just as readily to produce an X or a Z. In any case, the eye does not see them in their unrelated actuality but insists upon a *wholeness* resulting from a perceptual addition of lines. This perceptual addition is termed *closure*.

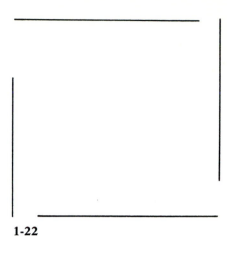

1-22

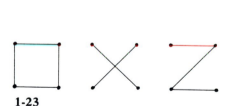

1-23

Closure

Awareness of the phenomenon of closure frees the artist to work with skill and subtlety. Shapes can be indicated and forms suggested in the knowledge that the viewer will complete the image,

[4]Lund, Zoe. "Julian Schnabel's Velvet Touch," *House and Garden,* October 1992, pp. 120-127.
[5]Bolles, Edmund Blair. *A Second Way of Knowing: The Riddle of Human Perception,* NY: Prentice Hall, 1991.

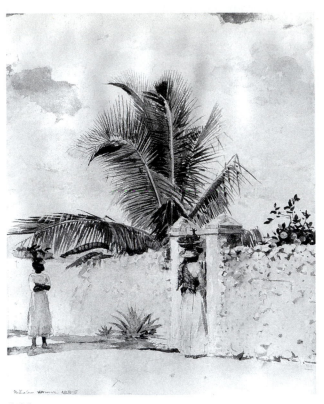

1-24

taking part in the process of creation. The watercolor in Figure 1-24 is a sensitive rendition of a romantic subject. All the shapes and textures are there, with two human figures for emphasis. We feel the *aura* of the garden without factual inventory. The subtle fading away, or *vignetting,* of the inner landscape allows us to pass through the gate in a personal way, with our eye and mind contributing to our response.

Figure-ground

In gestalt perception, the subjects considered were referred to as *figure,* whereas the body of sensations ignored was the *ground.* An obvious example is that of being in a crowded room, in which we recognize one person and carry on a conversation with him or her, meanwhile ignoring the background clamor. The watercolor in Figure 1-25 demonstrates a visual distinction between figure and ground. The artist has created a composition of rocky hills, water, and sky, all similar in tone. The importance of the work lies in the dramatization of one particular rocky outcropping by the use of accenting line, warm color, and detailed treatment of texture. What might be an allover similarity of shape and color becomes a dynamic depiction of geologic interest, a *figure* around which the *ground* provides a complementary setting.

1-24 Winslow Homer.
The Garden Gate, Bahamas.
1885. Watercolor. Worcester
Art Museum.

1-25 Pat Fairhead. *Change Islands, Newfoundland #35.*
Watercolor, 22 × 30″.
Courtesy the artist.

1-26 Jasper Johns.
Cups 4 Picasso. 1972.
Lithograph, 22 × 32″
(56 × 81 cm). Universal
Limit Art Editions.

16 *Design as Universal Reality*

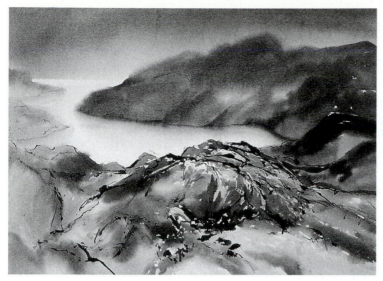

1-25

Perhaps the most intriguing aspect of this technique is figure-ground *ambiguity,* resulting from a figure and a ground that can be seen interchangeably. In Figure 1-26 we can see an urn or, looking at it differently, we see two profiles of Picasso, nose to nose. With prolonged looking, we find that the figures reverse repeatedly. This is classic perceptual trickery, a humorous underlining of our original premise that perception involves considerably more than simply seeing.

1-26

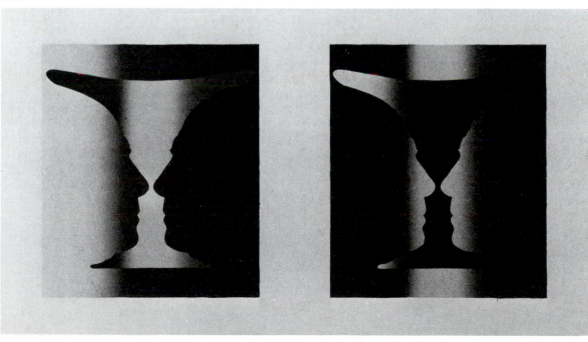

Imagery

Imagery is the raw material of any designer. Composed of an illusive combination of memory, imagination, dreams, and fantasy, it, like perception, is both extremely personal and the product of its time and place. Traditionally, imagery has been characterized as either *perceptual*, referring to things actually encountered by the eye, or *conceptual*, relating to images that exist only in the mind. The two categories are obviously not clear-cut, as no image springs from a vacuum, and visions from the mind frequently have their origins in actual things seen, however they may be distorted. Dream imagery is a good example. It is difficult to describe our dreams because of the illogical way in which familiar images are associated, yet the images do indeed arise from past experience.

Such dual imagery characterizes the fantasies of M. C. Escher, one of which is represented in Figure 1-27. Escher would hardly identify his art as fantasies, for he writes that his works bear witness to his amazement and wonder at the *laws of nature* that operate in the world around us, and he considers himself more closely allied to the mathematician than to his fellow artists. Nevertheless, his works abound in an imagery that is immediately recognizable to anyone familiar with his style. Stairways going nowhere, interlacing rings and gears, and imaginative creatures of earth and sea form only a portion of his rich configurations. It becomes obvious then, that imagery cannot be divided into categories but must be recognized as the result of a lifetime of interweaving *perceptions* and *associations*.

The scope of individual imagery can best be understood by comparing the ways in which two artists depict a similar subject. John Marin, an early twentieth-century watercolorist, was sensitive to atmospheric effect, having done much of his work along the misty seacoast of Maine. When he decided to do an etching of the

1-27 M. C. Escher. *Concave and Convex*. 1955. Lithograph, 10⅞ × 13⅛″ (27.5 × 33.5 cm). © 1955 M. C. Escher Foundation, Baarn, Netherlands. All rights reserved.

1-28 John Marin. *Woolworth Building, New York, No. 3*. 1913. Etching, 12⅞ × 10½″ (33.02 × 26.6 cm). Brooklyn Museum (Dick S. Ramsay Fund).

1-29 Joseph Stella. *The Voice of the City of New York Interpreted 1920–22: The Skyscrapers*. Oil and tempera on canvas, 8′8¾″ × 4′6″. Collection of The Newark Museum (purchase 1937, Felix Fuld Bequest Fund).

1-27

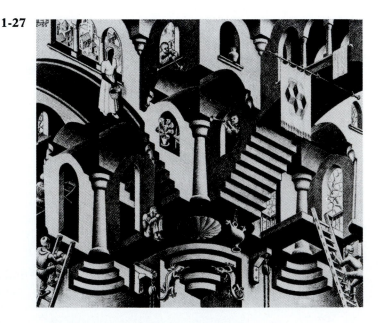

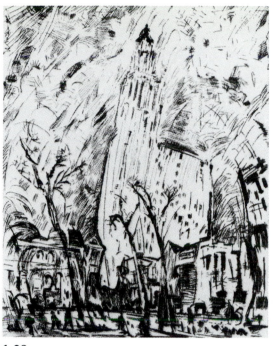

1-28

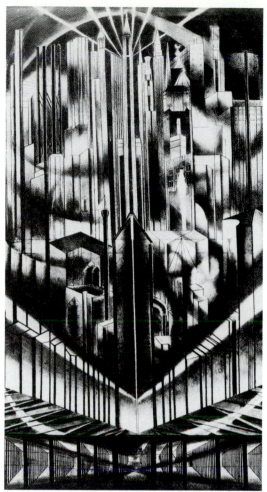

1-29

Woolworth Building in New York, he showed the skyscraper being tossed about in the wind, implying that the structures of human beings are not impervious to the forces of nature (Fig. 1-28). Joseph Stella, on the other hand, surrounded the Woolworth Building with other tall buildings and a bridge, investing the whole scene with geometric precision and lines that are solid and soaring (Fig. 1-29). Stella's spires would never bend in the wind. They are like the spires of a cathedral, perhaps signaling the brash new religion of technology. In treating similar visual elements according to their unique imagery, both artists have achieved *originality*, a keynote in any work of art. We will explore originality in Chapter 2.

Design through Selection

We mentioned earlier the importance of selection and making choices in creating a design. Selection also plays a role in *appreciating design*, for a knowledge of what contributes to a successful

design makes possible discriminating choice of objects, colors, and patterns that constitute our own personal world.

Guides to Selection

We stated at the beginning that a design is first of all a plan for order. This implies an arrangement of *materials* into a *form* that will fulfill a specific *purpose.* In this summation, we find three criteria for judging design:

1. *It should express the material from which it was created.*
2. *It should have an aesthetically pleasing form.*
3. *It should fulfill the purpose for which it was intended.*

Expression of the Material

Some artists plan a design with a specific purpose in mind; others visualize a form interesting in itself. Sometimes a material will seem irresistible—a chunk of stone, a piece of wood, a skein of wool—and the artist will design a work to make the most of its special qualities.

We have just seen the same subject expressed by two different artists; in Figures 1-30 and 1-31 we see how one artist has expressed the human figure in two different materials. Auguste Rodin was clearly responding to the sensuousness of *marble* when he created *The Danaïd,* one of the legendary daughters of an Arabian king. Every bone and muscle is beautifully articulated, and the flesh seems almost as though it would be warm to the touch as the marble luminously conveys the female nude. Twelve years later, Rodin memorialized Honoré de Balzac, the founder of the realistic novel and acknowledged as one of the greatest novelists of all time. The sculptor forged an impression of sheer power, consistent with the

1-30 Auguste Rodin. *The Danaïd*. 1885. Marble, 13¾ × 28½ × 22½" (34.9 × 72.4 × 57.2 cm). Musee Rodin, Paris.

1-31 Auguste Rodin. *Monument to Balzac*. 1897–98. Bronze (cast 1954), 9′3″ × 48¼ × 41″. The Museum of Modern Art, New York (presented in memory of Curt Valentin by his friends).

1-32 John Cederquist. *Marquis de Cide Chair*. 1991–92. Plywood, wood veneers, epoxy resin, analine dye, 32 × 32 × 29″. Private Collection. Courtesy Franklin Parrasch Gallery, New York.

1-30

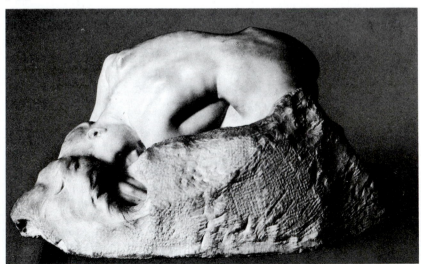

writer's stormy life and revolutionary influences. For this he chose *bronze*, cast from a model first executed in plaster. Working with plaster makes possible modeling with the hands, creating textures and rhythms totally different from the chiseled forms of polished marble. Untrammeled power radiates from Balzac's cloak, culminating in a head whose features are suggested rather than portrayed. The character's essential dynamism is indistinguishable from the bronze itself.

Form

From the standpoint of the designer, form is the combination of size, shape, and mass that composes a work, causing that work to exist in the space around it. The form may spring entirely from the imagination as in the sculpture in Figure 1-32, composed of fanciful forms combined into an imaginative whole. On the other hand, it may result from specific requirements, in which case the form becomes the primary consideration in the fulfillment of the purpose for which the design was intended.

1-32

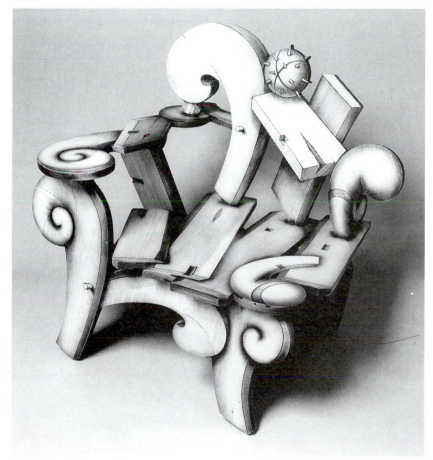

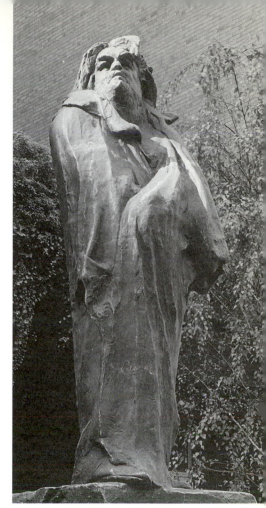

1-31

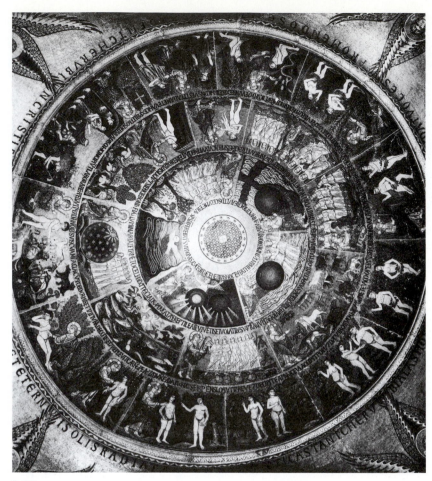

1-33

Fulfillment of Purpose

Creation of the mosaic in Figure 1-33 was governed by four overriding factors. It had to be applied to the interior of a dome, which posed a tremendous challenge. The medium was mosaic, tiny pieces of glass fitted together into a concrete or plaster base. The nearest viewer would be many feet below it looking up, so composition and perspective had to be adjusted accordingly. It also had to be a Christian subject as it would adorn one of the great cathedrals of Christendom. The form was an overwhelming challenge to which the artists and crafts workers rose magnificently, fulfilling a unique purpose with a mastery that has given pleasure to thousands of people for seven centuries.

The Art of Selection

We have now considered certain guides to discernment in selection, not only in works of art but in the myriad products clamoring for purchase in the contemporary world. One of the most

1-33 *The Creation of the World*. 13th Century. Vault Mosaic. St. Mark's Cathedral, Venice.

creative results of studying art or design is the ability to apply this discernment to our personal lives. No longer do we think of the museum as a mere repository for paintings and sculpture; with knowledge of the elements and principles operating through a work we are able to appreciate qualities that were not obvious to us before and to experience a personal adventure in examining works of art. We are not moved by the sensational or pornographic simply because they attract widespread notoriety but are able to view them objectively with a sincere analysis of the artist's motivation, technique, and skill. Similarly, we find it easier to make choices in the artifacts and furnishings with which we intend to live, going beyond the lure of special prices or persuasive salestalk.

The artist has unlimited sources for inspiration, and the consumer has a bewildering assortment of *objects* from which to choose. Through familiarity with different styles of furnishings, architecture, fabrics, and woods, we are able to select those objects with which we will feel most comfortable, those artifacts that express the kind of person we aspire to be. When we choose home furnishings, clothes, or a car, we do not simply make a choice of an individual object. Consciously or not, we are selecting an element of our personal world, a symbol of who we are and how we want to live. When we train ourselves to understand and appreciate the great art of the past and to choose the best from among the contemporary works in museums and galleries, we contribute to the culture of our own era and to the significance of those values that give meaning to human life.

The Element of Time

We create in order to express something within us, and in expressing, we are articulating a fundamental need to share. If an emotion or experience clamors to be transmitted to paper or canvas, clay or textile, it is because, consciously or not, we want to give others the chance to experience something that has enriched or disturbed our own lives. The elements and principles of design facilitate this sharing. Our reaction to music is largely dependent upon the color and texture of the composition, which establish the mood that is elaborated by variety, emphasis, and rhythm. The same can be said of a novel, while a poem or ballad is constructed primarily on rhythm and texture, enhanced by variety and color. The visual arts differ from the other fields of art in one important aspect. A visual work, in most cases, is totally before us in a moment, and our response is instantaneous. Analysis and development of our response depend entirely upon our willingness to spend time.

Those who create in the fields of music, dance, and literature have the advantage of leading us gradually through a succession of notes, movements, and words into the experiences they wish to share with us. We may not care for the opening movement of a symphony or the first stanza of a poem, but may find by the end that we have become not only sympathetic but enthusiastic, as we are guided through variations building to a climax. Our own experience may be touched by just one sound or line and the work suddenly will have meaning. Time provides the catalyst between the artist

and the response. The visual artist seeking our response does not have the help of time unless we allow it. Full appreciation of a design or painting may take repeated exposure, perhaps over a period of years. As in music, extended exposure may lead to a moment of sudden appreciation, the noticing of an image not previously seen, of the harmony of color or the rhythms leading to a spot of emphasis. There is no intermediary influence such as the sound of instruments or the voice of a reader. People create in order to share, and in the visual arts the opportunity for response is in the hands of the viewer.

Summary

Our consciousness of design must include awareness of universal design, to which all human design is related. Any design is *a plan for order.* Art and design are frequently indistinguishable because both are based upon the same elements and principles. Successful design elicits an aesthetic response, involving the senses and emotions, though not always in a pleasant way. People create in search of beauty, as an urge to shock, to relieve inner pressures, or because of a need for a sense of wholeness.

Visual design involves *perception,* three aspects of which are *gestalt, closure,* and *figure-ground distinction.* Imagery is the raw material of any artist or designer; it may be classified as *perceptual* or *conceptual.* We design by making choices, involving the expression of *material,* selection of *form,* and *fulfillment of purpose.* A knowledge of design elements and principles is as essential for the discriminating selection of objects as it is to the creation of specific design.

The Design Process | 2

Designs in nature are formed as the result of instincts and laws governing their creation. A spiderweb, for instance, often materializes within minutes, complete in its intricate geometry and with no tools obvious beyond the moving body of the spider (Fig. 2-1). The human designer transforms nature into new forms and materials according to a personal vision, often with specially designed tools. The personal vision is more closely related to instincts in nature than we usually acknowledge. There are specific steps to creating a design, but the most important aspect lies in the human inner faculties—the powers of imagination, intuition, will, and reason. A vision or plan is frequently in the mind of the designer before the process of creation is begun, and the process takes place as the result of specialized skills. The most fundamental of these skills is *artistic perception*.

Inspiration

Almost everyone can appreciate the beauty of a spiderweb or a tree, but their potential application to human design may not be readily apparent. The inspired designer observes the universe with

2-1(a) Radial orb web of ecribellate spider.

2-1(b) Stabilizing capture thread of argiope spider.

2-1(a)

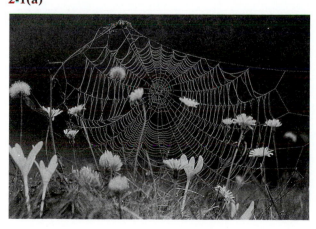

2-1(b)

25

2-2 Anne Goldman. *Wind-Drift*. 1992. Stoneware, porcelain overlay, iron oxide slip, wheel thrown, hand carved. 10 × 16″. Courtesy the artist.

2-3 Helena Hernmarck. *Framed Shadow*. 1985. Linen, wool, cotton—woven. Courtesy Helena Hernmarck Tapestries, Inc.

2-4 Rythesma punctatum on Western Maple leaves.

2-5 Microscope photograph showing cellular structure of black stem wheat rust.

2-6 Jean Dubuffet. *Radieux Meteore*, from *Ferres Radieuses*. 1952. Brush and pen drawing, 19¾ × 25½″ (50 × 65 cm).

sensitivity, absorbing impressions from every experience. These impressions may enter into the subconscious mind like cells that divide and re-combine to form new entities, sometimes germinating for years before they become part of a creative effort. Often, when least expecting it, the designer is made aware of new relationships and, seeing them in unique terms, works to give them a form that will make them apparent to others. This, in essence, is the phenomenon we call *inspiration*.

Such inspiration is often derived from a particular skill or process that the designer finds personally satisfying. The potter will look at leaves or sand being blown by the wind and visualize how the forms and movement might be interpreted in clay (Fig. 2-2). A weaver may be intrigued by the shadow of a window and transform it into a tapestry (Fig 2-3). Many designers find inspiration in travel, others in films of outer space; still others discover unexpected beauty in details by which we are all surrounded but seldom really see (Fig. 2-4). Further treasures can be unearthed in the world of the microscope (Fig. 2-5), revealing patterns and textures that could lead to such drawings as the one in Figure 2-6. Inspiration results from a special kind of perception guided and directed by heredity, past associations, and the various inner qualities of the person who perceives. What we know as *artistic perception* adds the dimension of *creative possibility* to things perceived, making possible a unique solution to any existing aesthetic problem. Pushing our way through the throngs in the TWA terminal at New York's Kennedy

2-3

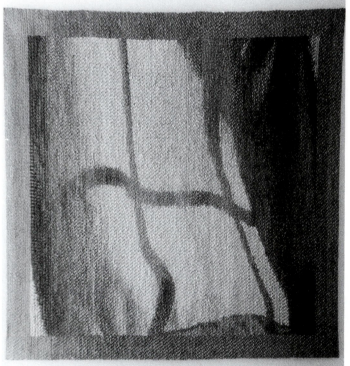

2-2

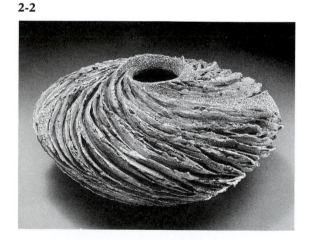

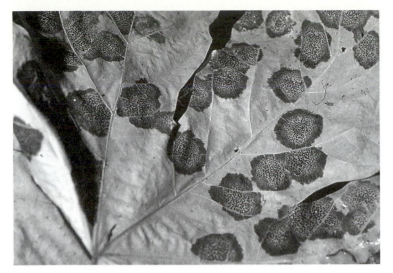

2-4

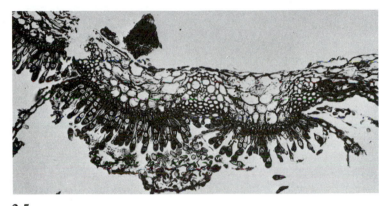

2-5

2-6

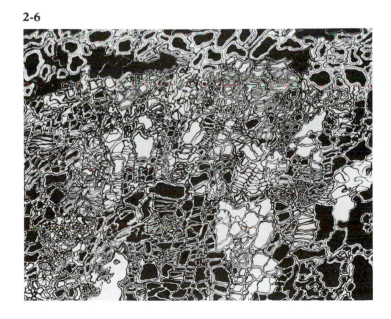

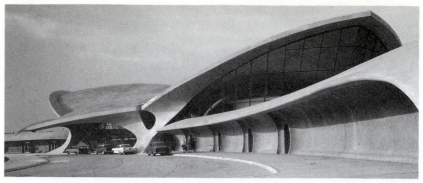

2-7

airport, few of us appreciate the inspiration that motivated Eero Saarinen to design an air terminal with the sweep and drama of huge wings. Saarinen's artistic perception and imagination carried him above the practical considerations of an air terminal to a symbolic structure uniquely expressing the miracle of flight (Fig. 2-7).

Concept

All design begins with concept. It is assumed that the wheel began to take form in the human mind when people noticed that round stones turned underfoot, propelling the body forward. The realization that a heavy load could be moved by rolling it on logs imbued the phenomenon with practical application. The slicing of logs into disks carried the concept into the realm of earth-shaking design. The wheel itself was a design, but it embodied a concept that gave rise to endless refinements, ultimately making possible sophisticated machinery for every conceivable purpose. The clock uses the wheel as gears in a design for recording time (Fig. 2-8); the airplane uses it as components in a machine that enables people to enjoy the convenience and freedom of flight.

Decision Making

From the moment of conception to the display of the end product, the designer is involved in a series of decisions. At each step of creation, decisions must be made: Decisions concerning purpose evolve into decisions about materials, sizes of various parts, textures, colors, shapes. Some decisions automatically eliminate others; if an object is designed in silver, the question of color does not require further consideration. These crucial decisions come under the heading of *problem solving*, which is an accepted approach to all aspects of living, from personal relationships to the management of industry. Problem solving consists of five stages: *definition, creativity, analysis, production,* and *clarification*. In order to understand how the stages work, let us apply them to a hypothetical project, the designing of a teapot.

2-7 Eero Saarinen. TWA Terminal, Kennedy Airport, New York. 1962.

2-8 Astronomical clock, Town Hall, Prague.

28 *Design as Universal Reality*

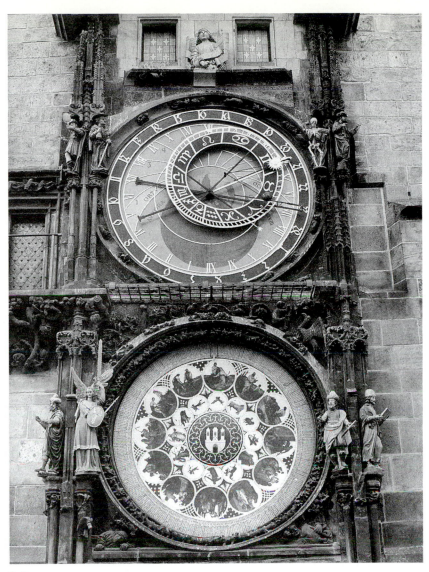

2-8

Problem Solving

Definition

We begin with the concept, which in the case of a teapot is that of a hollow container with a lid and a spout for pouring, perhaps with a strainer for the tea leaves. The definition leads us into specifics, which may be dealt with by making two lists, one headed "Given" and the other labeled "Find." In the case of the teapot, the first item under "Given" would undoubtedly be capacity, determined by the purpose for which the teapot is intended. Is it for the use of one or two people or is it for entertaining at large receptions? The answer to this question could in itself define the problem and provide the items to be listed under "Find." These would include

material, shape, and placement of handle, since a teapot in constant use at a reception must be comfortable to the hands even when filled with very hot tea, and it must be capable of being continually refilled. The definition of the problem can be reassuring, narrowing possibilities into requirements, directing the designer toward logical decisions.

Creativity

This is the stage at which the imagination soars. Problem solvers recommend the practice of "brainstorming," letting the mind flow into all kinds of ideas, regardless of how weird they may seem. No judgment is made at this stage; the purpose is to gather as many ideas as possible. This is the point at which preconceived ideas are discarded and the imagination ranges into new worlds. Drawings and diagrams are helpful, filling pages with shapes and forms, the more outrageous the better. To consider a teapot as a round container with spout and handle is no longer enough.

The teapot in Figure 2-9 is assumed to be the earliest teapot known in New England. It fulfills the definition admirably and it is an expression of its time, decorated in the Queen Anne style, bearing the crest and coat of arms of the family who commissioned it. However, the ingenuity of the designer is unmistakable. It is shaped like a pear with a spout similar to the head and neck of a swan. The spout hugs the pot but the heat-resistant wooden handle curves widely to accommodate comfortably even a large hand.

It is a lively leap from the traditional dignity of New England to the chubby teapot in Figure 2-10. Of brass and gold plate, and also fulfilling the definition, it whimsically exploits the circular form by presenting a rotund body lavishly embellished with circles, even building them into legs and handle.

2-9 Silver teapot by John Coney (1710–1720). Metropolitan Museum of Art, New York (bequest of Alphonso T. Clearwater, 1933).

2-10 Chris Ann Irick. *Pig T'ing*. 1991. Brass, 22k gold plate raised, fabricated, etched. 6 × 6 × 8″. Courtesy the artist.

2-11 Mary Roehm. *Teapot, Reed*.

2-12 Patrick Horsley. *Teapot*. 1992. Stoneware, 15 × 19 × 2½″. Courtesy TWIST Gallery, Portland, OR.

2-9

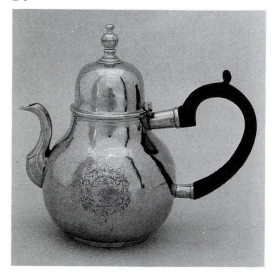

2-10

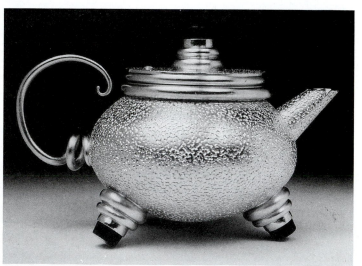

Analysis

After the imagination has soared into fantasy, analysis reins it in, bringing it back into the realm of logic and practicality. Will the favored design really be possible to execute? Can materials and structure be dealt with in a reasonable length of time? If the object is intended for commercial production, this is the point for cost analysis of time and materials and anticipated profit margin. When possible, the designer constructs a model and tests any dubious aspects, using the definition as guidelines. In the case of the teapot, does it pour smoothly? Does it feel balanced in the hand? Should it have legs to protect the table on which it sits? The teapot in Figure 2-10 has legs, but the early American one does not. Checking a porcelain teapot, we find that it does not have legs but its handle goes across the top, another possibility (Fig. 2-11). For that matter, what about spouts? Do they have to be straight or slightly curved (Fig. 2-12)? And what about decoration? The New England teapot is engraved; why not experiment with bright colors on terra cotta (Plate 3)? This is the stage at which any problems are dissected and viewed from new angles, with subsequent adjustments made in the design.

Production

Throughout the production of a work, the designer must remain flexible in order to adapt to unexpected changes in material or in the evolving form. Such changes need not be catastrophic; the truly creative designer may see them as implications of a more interesting result. An unanticipated turn in the grain of wood, clay that is a little too moist, a glaze that fires differently than in the past—any of these can necessitate adjustments to the designer's

2-11

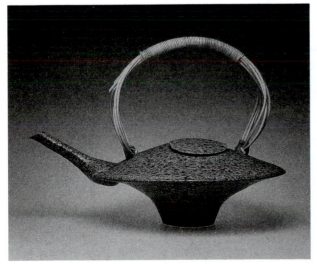

2-12

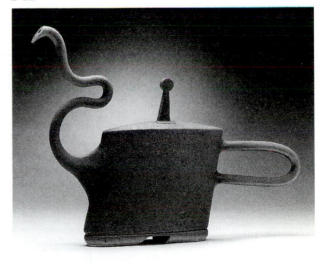

original vision. Imagination fires the original vision but it determines the ultimate character of the design. When the designer remains flexible and uses surprises creatively, an entirely new technique may result.

Clarification

The design process is a continuous unfolding in which each step determines those that follow, each decision leads to others to be made. Regardless of the designer's methods, there comes a moment when the work is complete, and an effort to appraise the results must be made. This moment is known as clarification. Occasionally, the designer is elated with the results. Frequently, particularly if the designer is a perfectionist, the reality will not measure up to the original vision. This is the stage at which real growth takes place within the artist, who becomes critic and objective appraiser of an intensely personal effort. This is not easy, but it is the means to improvement. It is also the mark of the professional designer.

Integrity

The quality that makes a design a unique expression of its time and its creator can be termed *integrity*. Stemming from the Latin *integritas*, the word has as one of its meanings the state or quality of being whole. In design this means a unity of conception and execution that makes a design a complete and original entity.

Integrity of Materials

Before any design can be developed, the designer must know the capabilities of available materials. The architect must be familiar with which materials are strong in compression (when pressed under weight) and which have more strength in tension (when stretched). The designer must be aware of the potential for wear and longevity as well as the mechanics of using materials to their advantage. An innovative painting that begins to crack or flake after a few months on the wall is no better than a building that collapses or a piece of weaving that ravels.

Familiarity with a material can lead to dramatic exploitation of its innate qualities. When steel was introduced as a building material, architects—while welcoming its structural advantages—sheathed it in brick or stone so their works would resemble the traditional works of their predecessors. Concrete had long been used as a structural foundation in which to anchor brick and stone. Today our cityscapes are defined by vast, highly visible expanses of steel and concrete combined with glass and aluminum, exploited to express the contemporary scene of which they are so vital a part (Fig. 2-13).

2-13 Schipporeit-Heinrich, Inc. Lake Point Tower, Chicago. 1968. Reinforced poured concrete and bronzed aluminum with glass. Courtesy the architects.

2-14 Mobile cellular telephone, model no. 3040. Courtesy AT&T Archives.

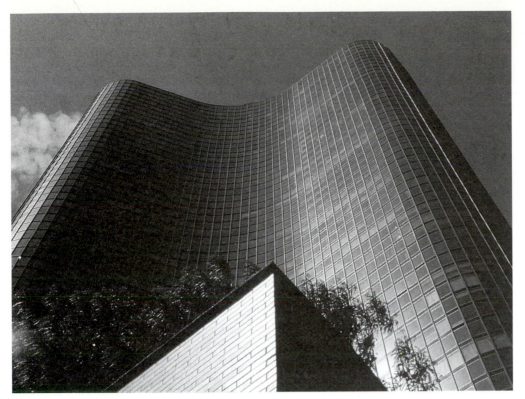

2-13

The advent of plastics after World War ll initiated a prolonged period in which integrity of materials largely disappeared. The relative cheapness of plastic, coupled with its ease of manipulation and apparent durability, spurred manufacturers to put it to every possible use, from furniture to surgical transplants. Tables became plastic, grained to resemble wood, and vinyl floor coverings were designed to look like brick or ceramic tile, all with the flaunted advantages of resisting cigarette burns, scratches, and stains resulting from spills. Traditional glass objects were made of plastic, because it would not break and could be disposed of easily, eliminating the need for washing, as in the case of drinking glasses and containers for food. As different plastics were developed, the picture became increasingly confused. Designers unaware of widely varying characteristics in the field of plastics produced cars with windshields that would not break and toys that shattered at the first dropping, counter tops that were claimed to be impervious to heat and plastic measuring cups that, when filled with hot liquid, melted into a shapeless mass. Today, after several decades of experimentation and refinement, the diversity of plastics has taken workable form, and the role of plastics in contemporary life has been established. The infinite possibilities of plastics are realized daily as designers utilize specific varieties to fill appropriate needs, not primarily as substitutes for traditional substances but as contemporary materials with unique roles of their own (Fig. 2-14).

2-14

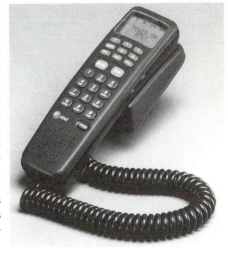

2-15(a) Chippendale make-up table. c. 1780. Courtesy Antique Collectors' Club, London.

2-15(b) Chinoiserie dressing table. c. 1770. Courtesy Antique Collectors' Club, London.

2-16 Gad-dam stilt tree house. Luzon Island, Philippines. Courtesy Department of Library Services, American Museum of Natural History.

Integrity of Form

The two dressing tables in Figure 2-15 make an elegant statement about integrity of form. The one on the left is by eighteenth-century English cabinetmaker Thomas Chippendale, one of the great furniture designers of all time. This piece exhibits his characteristic grace in subtle curves and beautiful wood, finished to utilize its grain and color as vital aspects of the design. The table on the right is an example of *chinoiserie,* a taste for Chinese motifs in art and design that was popular in nineteenth-century England. The table is not a Chinese form; it is simply a table of ungainly proportions that has been encrusted with echoes of Chinese pagodas and painted decorations the designer deemed appropriate. It borders on the whimsical, yet its awkward stance implies that it was meant to be taken seriously. The fundamental difference here is *integrity of form.* The design by Chippendale is a simple dressing table, refined

2-16

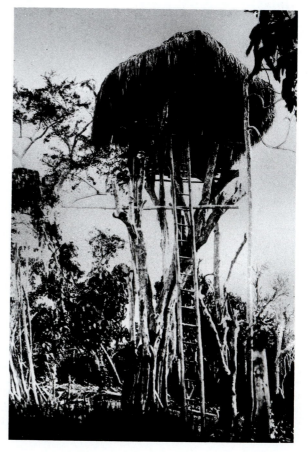

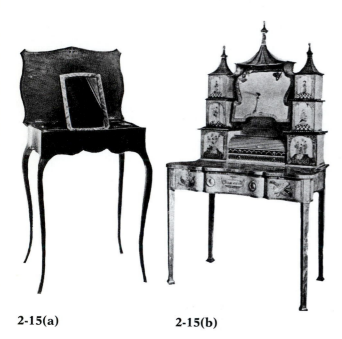

2-15(a) **2-15(b)**

2-17(a) Flatiron. 19th century.

2-17(b) Black & Decker Pro Xpress Iron, model F60.

to be a graceful accent to a lady's room. The other piece is an exercise in extravagant decoration, whose function is not immediately obvious.

The forms in nature are necessarily eloquent statements of integrity. Birds' nests built to disappear amid foliage; beaver lodges that provide disguised areas for swimming under piles of casual twigs and branches; turtles that move through desert or mud, able instantly to withdraw under a bony shield if danger threatens—the list is limitless. People who live close to nature accord as easily to integrity of form. Deep in the Philippine jungle, in an area plagued by high humidity, floods, insects, and dangerous animals, the inhabitants build houses in trees forty feet above the ground (Fig. 2-16). The elevation allows cooling breezes to flow under the dwelling while minimum walls provide maximum ventilation, and a steeply pitched roof sheds torrential rains. Here again, it is form that makes survival possible.

Integrity of Function

Many of the irritations of contemporary life stem from objects that lack integrity of function. Cabinet drawers that do not run smoothly, automobile seats requiring passengers to possess a contortionist's skill, umbrellas that turn inside out with the first gust of wind—these are commonplace nuisances. Such faults in function almost invariably derive from a fault in form, often one inherited from a previous prototype. Irons, vacuum cleaners, and washing machines all evolved gradually from more primitive models of previous years, in which the operator bore down or scrubbed lustily to make the equipment work. The models of today expand function and simplify effort at the same time, providing successful designs for busy and complex lives (Fig. 2-17).

2-17(a)

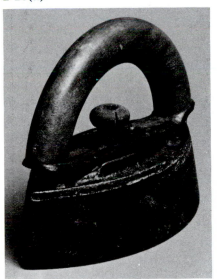

2-17(b)

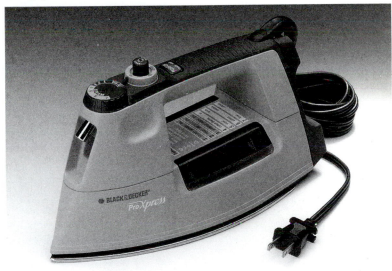

Similar evolution has taken place in the design of motor cars. The first automobile developed from the horse-drawn carriages that had preceded them (Fig. 2-18). They had tiller steering, large, thin wheels (sometimes only three), and generally looked as though they were missing something—the horse—at the front. Later vehicles attempted, through ornament, to establish an image of great luxury, with attachments of chrome and brass (Fig. 2-19). During the later 1920s the "sports car" came into prominence. The car was convertible, had wire wheels and large lights, and offered a combination of advanced design, speed, and style which have guaranteed its continuing popularity. The modern car, low-slung and streamlined, has a minimum of decorative equipment, yet its purposeful body shape gives the impression of unharnessed energy (Fig. 2-20).

2-18

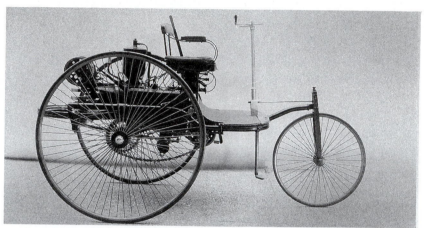

2-19

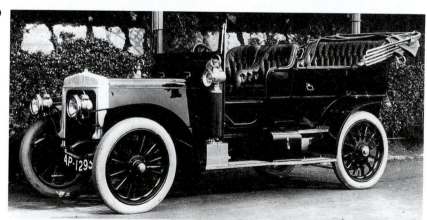

2-20

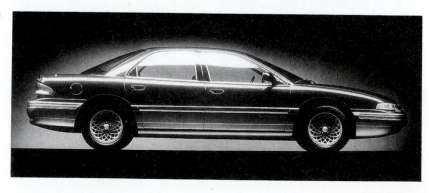

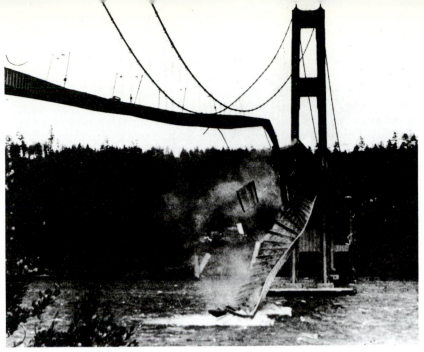

2-21

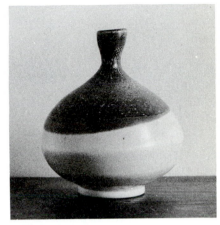

2-22

Any failure in function can usually be traced to a flaw in preliminary decision making. When engineers designed the Tacoma Narrows Bridge in Washington State, their decisions were based on a desire for an aesthetically pleasing span, the third-longest in the country, which, for its length, would be the narrowest suspension bridge ever built. From the standpoint of appearance, the design was a success; the form was widely admired for its delicacy. However, the delicacy had its hazards: The bridge was so flexible that even light winds twisted the roadbed in waves that rolled along its length, leading to its nickname, "Galloping Gertie." The engineers had designed the bridge to withstand winds of up to 120 miles per hour but they had overlooked one factor: When there is vibration, there is also resonance, a phenomenon that increases the force of the vibration in direct ratio to the length of time it persists. On November 7, 1940, a prolonged 42-mile-per-hour wind set the roadway to twisting with increasing violence. After four hours of wrenching, the bridge ripped apart and fell into the waters of Puget Sound 600 feet below (Fig. 2-21). The world of structural design was stunned, and in time a totally different bridge was designed and constructed.

Fortunately, not all unsuccessful designs have such dramatic failures as Gertie, yet faulty designs have one point in common—an erroneous decision either in analysis or in production. The vase in Figure 2-22 was designed as an alternative to the classic narrow bud vase, a container for a single flower but with a solid round form. The clay was well-thrown on the potter's wheel, the glaze unusual, and the form pleasing. However, when the vase is turned to be emptied, the water will not run out. Only by laying it on its side is it possible to empty it and then only by gradual gurgles, drop by drop. The reason? The slight pinching at the base of the neck impedes the flow. One touch by two fingers transformed an attractive piece of pottery into a faulty design.

2-18 Benz, 1886.

2-19 Daimler Touring Car, 1907.

2-20 Chrysler Concorde.

2-21 Tacoma Narrows Bridge, Puget Sound, Washington. Destroyed by violent winds, 1940.

2-22 Pottery bud vase.

Originality

Living today, after centuries of creativity in all possible mediums in every part of the world, we sometimes wonder how we can possibly do anything new or original. Each human emotion and experience has been expressed, every possible work of art created. Yet there are aspects of the world of today that could not have been imagined or expressed in past centuries. There are also contemporary materials that were not available in the past. Some of today's best designs are found in products that are uniquely of our time. The computer is a prime example. The first computers for personal use involved enough equipment to fill a room. Twenty years later, a comprehensive personal computer set-up can be accommodated in less space than that consumed by an office desk, and the computer itself has become compactly portable (Fig. 2-23).

On the other hand, a design that is truly original will retain its unique quality indefinitely. Visitors from all over the world still flock to the chapel of Nôtre Dame du Haut designed by Charles Edouard Jeanneret, known as Le Corbusier. Constructed in 1955 on a hill overlooking the French village of Ronchamp, the building was a replacement for two earlier churches on the same site, a pilgrimage shrine since the early Middle Ages. The first church had been struck by lightning and destroyed in 1913; the second was leveled by artillery in World War II. Early in this chapter, we traced the design process through a hypothetical project of designing a teapot. As a summing-up, it may be helpful to trace in a similar way the actual designing of this unique chapel. In Figure 2-24 we show the

2-23 Compaq *Contura* laptop computer.

2-24 A chart of the design process.

2-25 Sketch for replacement of church destroyed by artillery—one of the plans under consideration until 1950.

2-23

THE DESIGN PROCESS

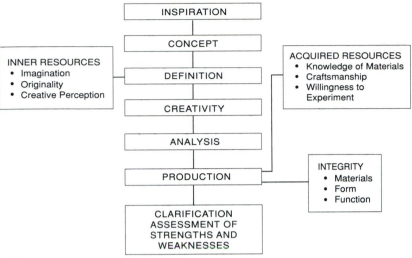

INSPIRATION

CONCEPT

DEFINITION

CREATIVITY

ANALYSIS

PRODUCTION

INNER RESOURCES
• Imagination
• Originality
• Creative Perception

ACQUIRED RESOURCES
• Knowledge of Materials
• Craftsmanship
• Willingness to Experiment

INTEGRITY
• Materials
• Form
• Function

CLARIFICATION
ASSESSMENT OF
STRENGTHS AND
WEAKNESSES

2-24

steps in the design process, a chart that will provide a guide for the accompanying photographs.

The immediate predecessor of the chapel was a church built of stone in the traditional Gothic style with pointed windows and arches. In Figure 2-25 we see the sketch of one of several designs considered as a replacement when the church was demolished by

2-25

2-26(a)

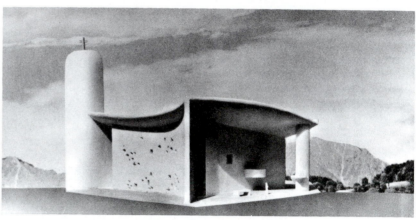

2-26(b)

2-26(a) The architect at his desk.

2-26(b) Le Corbusier's model (plaster) of June 1950, submitted to Ronchamp authorities in October 1950 and accepted after alterations.

2-27 One of several structural models for Nôtre Dame du Haut.

2-28 Chapel in progress.

2-29 Nôtre Dame du Haut after completion.

artillery fire. In 1950, however, Le Corbusier came up with an entirely different *concept,* arising from many inner sources, no doubt, but certainly responding to the woodland setting on a hilltop in a rolling countryside. His plaster model can be seen in Figure 2-26, a highly original shape with sweeping lines and tiny square windows set at random in thick plaster walls. This is his *definition* of what the solution should be. We see the designer at work in the stage of creativity, experimenting, exploring, considering possible treatments for the roof. In the construction model in Figure 2-27 the concept undergoes *analysis,* as critical scrutiny is applied to see exactly what structural procedures will be necessary. *Production* is well under way in Figure 2-28, and in Figure 2-29 we see the completed chapel. Le Corbusier expressed the process of *clarification* in his official comments to the Bishop at the time of the chapel's blessing: "All collaborators have contributed to this difficult achievement with its infinitely demanding thorough details, strong in its means of expression, but extremely sensitive and informed throughout by

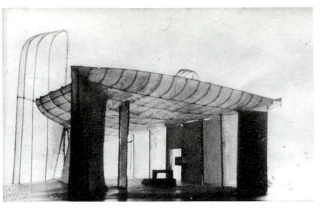

2-27

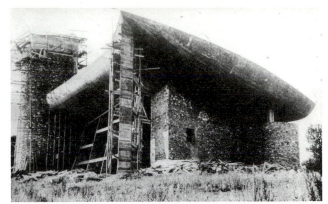

2-28

mathematics, the creator of the ineffable mystery of space."[6]
Further clarification is implicit in the comments of visitors who see
as its inspiration the shape of a Breton nun's hat or the prow of a
ship, endowing aesthetic significance by interpreting its form and
meaning according to their individual perceptions.

When imagery enters in, originality becomes inescapable. Only
when we allow our imaginations to soar and work independently of
others will our designs be likely to have integrity and originality.

[6]Verlag Schnell and Steiner: *Our Lady of the Height Ronchamp*, Munich-Zurich, 1965.

2-29

Craftsmanship

Media and Materials

Every design is executed in a *medium*. For instance, architecture is a medium of design, but the possible materials are extensive and diverse. In a more specific example, oil painting is a medium that stipulates the use of oil paints, but the *materials* extend to a wide variety of brushes, painting knives, thinners, varnishes, and supports such as canvas, wooden panel, or paper.

Much of the success of any creative work results from the "feel" the artist has for the material involved. Some sculptors enjoy the manipulation of clay in their hands, the sensuous forming of a shapeless mass into an object of beauty or interest. Others prefer to chip away with tools at wood or stone, freeing the form within by cutting away the excess. Painters may respond to the adventure of applying thick paint in heavy brush strokes that go in every direction and to the excitement of seeing forms emerge (Plate 4). Others may prefer to lay paint on precisely, keeping the final result firmly in mind (Plate 5).

The designer's affinity for specific tools can be just as compelling an element in the success of the work. A painter has favorite brushes, the carver a knife or chisel that will do exactly what is required. When work does not go well, the designer can often find the answer in a fresh approach to materials.

Art and Craft

The term "artsy-craftsy" has become part of our jargon, usually designating a person who dips into diverse areas of the visual arts for amusement, with no single-minded pursuit of excellence. Although the word "craft" has a centuries-old association with highly respected work performed by skilled hands, in recent years it has been used loosely for those activities that can be pursued as hobbies, with no intense devotion to the result. We are now becoming aware of the importance of *craftsmanship* as a fundamental and extremely important aspect of design. It means total dedication to a medium, exploring its properties, getting the "feel," finding one's own affinity to it and how it can be exploited. It describes the dedication of the musician who practices on an instrument eight hours a day. A potter, writing of his art, has stated that one must practice on the potter's wheel for six hours a day for at least six months before hoping for consistently satisfactory results. The legendary craftworker of past centuries nearly disappeared in the wake of modern industry and consumer demands, but a new generation of craftspeople are aware of the concept of spending a lifetime in dedication and learning and are finding ways to achieve the skill of the true professional (Figure 2-30).

Creating any specific design is largely a matter of problem solving, but behind each individual experience must be the skill to manipulate materials and tools. Only by possessing such skill can the designer concentrate fully on the aesthetic and technical problems of the design itself.

2-30 Photographer-sculptor Stephen Deutch at work.

2-30

In Chapter 3 we will begin our explorations of the elements of design, the tools from which all design, natural or human, is created.

Summary

Designs in nature are formed by natural laws and instincts, whereas human designs are the result of artistic perception resulting in inspiration. All design begins with concept and is the result of decision making. Craftsmanship is an essential skill in creating any design. The design process is a matter of problem solving consisting of five stages: definition, creativity, analysis, production, and clarification. Any successful design will have integrity in material, form, and function. Originality is the result of imagery that makes possible the creation of a unique design.

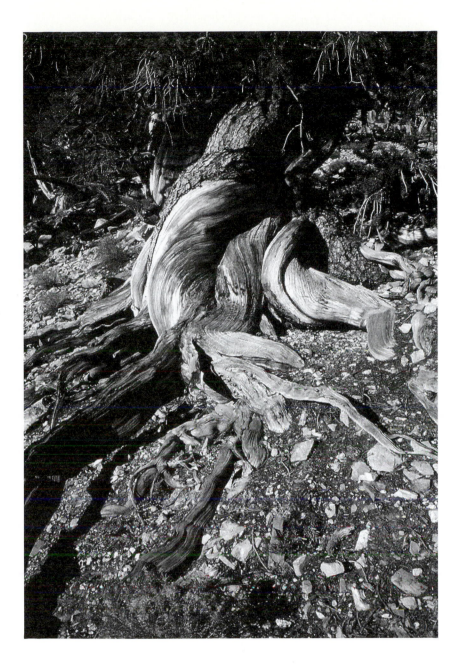

PART TWO

The Elements
of Design

Line | 3

Line is at once the most illusory and the most fundamental of the design elements. In nature, line is entirely a matter of human perception. What we see as lines are actually cylindrical twigs, veins in leaves (Fig. 3-1), cracks in rocks, or the horizon where earth and sky appear to meet but never do. Often what appears as a sharp line is actually the joining of two surfaces (Fig. 3-2). The wealth of linear design in nature extends from familiar

3-1

3-2

3-1 Cacao leaves,
South America.

3-2 Eroded mountains between
Canyonlands and Capitol
Reef national parks, Utah.

47

3-3

3-4

3-3 Burnt trees and their shadows on snow, Yellowstone National Park.

3-4 Charles Sheeler. *Rocks at Steichen's*. 1937. Conte crayon on off-white wove paper, 16 × 13¾″. The Baltimore Museum of Art (gift of Lilian Greif, Nelson and Juanita Greif Gutman Collection, and gift of Dr. Eleanor P. Spencer by exchange).

3-5 Villard de Honnecourt. Schematic plan of the apse and crossing of a church (top) and "a picture of Our Lord as He stumbled" (bottom).

3-6 Li K'An. *Ink Bamboo* (detail). 1308. Yuan Dynasty. Handscroll, ink on paper, 14¾ × 93½″ (37.5 × 237.5 cm). The Nelson-Atkins Museum of Art, Kansas City, MO (purchase Nelson Trust).

sights (Fig. 3-3) to exotic effects carved by centuries of natural processes (Fig. 3-4).

In the hands of the designer, line is a basic tool. When we commit a design to paper we begin by placing a drawing instrument at a *point* on the surface, making our own mark, or point, and then extending the point into a line or lines which give substance to our vision. When our lines are joined, they become *shapes,* delineating *space* (Fig. 3-5). With variations in width, line can of itself become shape (Fig. 3-6). From this fact, we realize one of the fundamental truths about the elements and principles of design: *It is the interaction among the elements and principles of design that creates an aesthetic result.*

3-5

3-6

3-7

3-8

3-7 Archers.
8,000–6,000 BC Del Civil,
Spain.

3-8 Henri Michaux. *Untitled.*
1960. Brush and ink,
29⅜ × 42½".
The Museum of Modern Art,
New York (gift of Michael
Warren and Daniel Cordier).

3-9 Chinese calligraphy.

3-10 Leonardo da Vinci.
Study for *Adoration of the
Magi.* Louvre, Paris.

Line as Expression

Glancing at Figures 3-7 and 3-8, we could easily assume that they are the works of the same artist, a person with a distinctive and individual style. Actually, they were drawn 9,000 years apart, one in charcoal and animal fat on the walls of a gorge, the other in ink on paper. The motivation behind these two works was undoubtedly as different as the time and place of their creation. Mystery will always surround prehistoric wall paintings. Were the archers in Figure 3-7 intended as a talisman, a means of securing success in the hunt? Are they the depiction of a magic ritual performed before the hunters set forth? Or are they simply the work of someone who had the urge to make graphic images and chose a subject close at hand?

Not the least of the mysteries is the fact that charcoal, which smudges readily in the studio, could have survived through nine centuries on stone walls.

The apparent need to make one's mark takes many forms. Children draw lines on the sidewalk and play games around them, and few people can resist picking up a stick and making lines in the wet smooth sand of a beach. Lines scrawled on walls and abutments express rage, frustration, political convictions, religious beliefs, romantic love, or vicious wit, all in a visual interpretation of "shouting it from the rooftops" (Plate 6).

The application of a mark to a blank surface is a commitment, an expression capable of influencing those who view the result, whether it is a pictorial image or the letters of the alphabets of the world, which have developed from linear expressions. Chinese calligraphers engage in a period of meditation before beginning their work (Fig. 3-9). The drawings of the "old masters" were often expressions of the highest order, solving problems of composition and form in a way that laid the groundwork for magnificent paintings (Fig. 3-10).

3-9

3-10

SECTION AT FR. 112½

3-11

The Quality of Line

In architectural and industrial design, line is a matter of *draftsmanship*—clean, precise, and crucial to conveying accurately the information from which buildings or equipment can be constructed. Heavy lines delineate contours, broken lines indicate edges not visible from the view shown, and fine lines broken intermittently designate center lines of shapes or areas. In all cases, crisp even lines are imperative (Fig. 3-11).

In other fields of design, line breaks loose into an eloquent, even emotional means of expression. Thickness, thinness, wavering, direction, repetition, spacing—such variations make possible the conveying of form, the creation of texture and other surface interest, and, with scarcely more than a single skillful stroke, the interpretation of a personality.

The *direction* of line has a certain degree of symbolism. Horizontal lines remind us of calm horizons and therefore connote tranquility, whereas vertical lines seem aspiring—like the lines of skyscrapers or mountains—and diagonal lines can be menacing, reminiscent of streaks of lightning. In Figure 3-12 the artist has used a variety of lines to express the flight of the swallow, capturing the dynamic movement and characterizing the vibrations left in its wake. Vertical, horizontal, and flowing lines of varying widths and values interact to create the sense of speed and motion, their potential for chaos being held in check by the dominant diagonal that slashes from lower left to upper right.

In contrast, the subject in Figure 3-13 is made by human hands, and the sense of movement is a matter of the *quality* of line. Here the title refers to a musical term: In a fugue the theme appears again and again in different forms, sometimes moving from a major to a minor key and back again. Ozenfant has accomplished this

3-11 Naval architecture drafting: Section at FR.112-½.

3-12 Giacomo Balla. *Flight of the Swallow: Dynamic Movement and Sequence*. 1913. National Museum of Modern Art, Milan.

3-13 Amédée Ozenfant. *Fugue*. 1925. Pencil, 18 × 24″ (45.72 × 55.88 cm). The Museum of Modern Art, New York (gift of the artist).

52 *The Elements of Design*

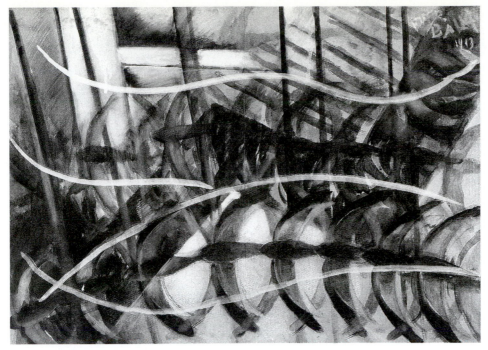

effect by use of line that moves throughout the composition, firm accents flowing intermittently among the finer, more restrained, outlines. Although the group is self-contained, our eyes move continuously through variations and rhythms that are as certain as if they were being translated into sound.

3-13

3-14

3-14 Jean-Auguste Dominique Ingres. *Group Portrait,* 1818(?) Pencil. Louvre, Paris.

3-15 Henri de Toulouse-Lautrec. *Head of Yvette Guilbert.* c. 1894. Graphite on ivory wove paper, 23.2 × 35.7 cm. The Art Institute of Chicago (The Albert H. Wolf Memorial Collection, 1941.132 recto).

3-16 Henri Matisse. *Portrait of Eva Mudocci.* 1915. Pencil, 36½ × 28".

3-17 Honoré Daumier. *Actors in a Scene from a Tragedy.* Pen and wash. Museum Boymans van Beuningen, Rotterdam.

3-18 Ernst Barlach. *Women Mourners.* Chalk. Kunsthalle, Hamburg.

Flight and a group of receptacles offer obvious differences for treatment; let us now consider two ways of adapting line to the human portrait. The family group in Figure 3-14 is by Ingres, whose classic style reflected the ancient Greek ideal of restraint and dignity, here expressed in clean sharp lines. With only a suggestion of shading, he has portrayed a complicated group of people and furniture with warmth and dignity, his lines crisp and narrow on highlights, broad and strong for shadows and accents. A century later, Toulouse-Lautrec, frequenting the artists' quarter in Paris, rapidly moved a pencil across a sheet of paper to capture a familiar personality. The lines are minimal but varied; the *quality* of the line tells us all (Fig. 3-15). Quite a different female portrait has been left us by Matisse. Here again the lines are minimal but they are applied with geometric precision, suggesting the artist's interest in *cubism,* in which objects are reduced to geometric planes. As with Toulouse-Lautrec, the personality is there, this time a cool dignity conveyed by the rigidity of the lines (Fig. 3-16).

3-15

3-16

Thickness of line can tell us a great deal about the subject. In Figure 3-17, Honoré Daumier employs thin lines in a frenetic scribbling to capture the tension implicit in a theatrical tragedy filled with action and drama. When Ernst Barlach chose to interpret two women mourners, however, he chose chalk, with which he bore down in broad somber strokes, imbuing even their clothing with the weight of their emotional burden (Fig. 3-18).

3-18

3-17

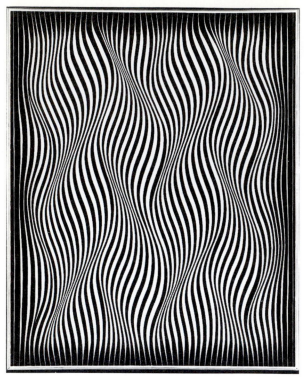

3-19

3-20

3-19 Julian Stanczak.
Provocative Current. 1965.
Acrylic on canvas, 66 × 53″.
Courtesy the artist.

3-20 Peter Paul Rubens.
Falling Figure. Black chalk,
heightened with white. By
courtesy of the Board of Trustees
of the Victoria & Albert Museum.

3-21 George Romney. *Charity*.
Pen in dark brown ink,
7½ × 5½″ (19.1 × 14.0 cm).
Yale Center for British Art,
Yale University Art Gallery
(gift of Mr. and Mrs. J.
Richardson Dilworth, B.A. 1938).

3-22 Kenojuak. *Birds and
Woman Face*. 1963. Stone cut.
Cape Dorset, North West
Territories.

3-23 Feathers of
ring-necked pheasant.

Variation in line was a subject that fascinated a group of artists in the 1960s, loosely termed Op artists because of their experiments in manipulating human perception by means of line and color. The work in Figure 3-19 requires but a glance to convince us of the possibilities. We are surrounded by undulations, almost to the point of motion sickness. It is difficult to believe that this undeniable movement is simply a flat canvas upon which black and white lines in varying widths have been imposed.

Movement can be the result of line in a quite different way, conveying motion that is violent or dramatic. Rubens's falling body in Figure 3-20 involves considerably more than line as far as the drawing is concerned, yet the drama of plunging is the direct result of the way in which the artist used lines. The shading on the figure is secondary; the swirling results from the position in which the figure is outlined and the circular movement of lines articulating the plunge through space. In contrast to the *classicism* of Ingres, Rubens's drawing exemplifies *romanticism*, with vigorous movement, and high emotional impact.

Rubens's drawing is in chalk; George Romney used pen and ink to achieve a different kind of swirling, one that he obviously associated with a more pleasant reaction. His depiction of Charity uses a variety of thickness in its lines, and the movement, while unmistakable, carries no overtone of calamity (Fig. 3-21).

The *repetition and spacing* of line can be an effective device in achieving design quality. We have been focusing our attention on line in expressive drawing, but in Figure 3-22 the drawing comes

56 *The Elements of Design*

3-21

3-22

closer to pure design. The use of small semi-circular lines is, of course, meant to suggest feathers on the birds, yet the artist has used them in differing degrees of density and has artfully balanced them with solid black accents. The texture achieved by the semi-circles is the predominant characteristic. In Figure 3-23 we see texture achieved by groupings of straight lines; here again, the texture is on birds but this is the photograph of an actual bird's wing seen at close range. When a designer uses closely spaced lines in this way

3-23

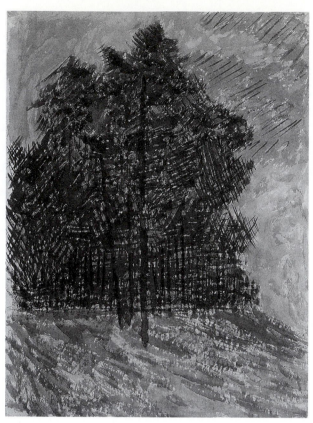

3-24

it is known as *hatching*. The application of a second set of lines at an angle to the first is called *cross-hatching*. We see cross-hatching used to express thick foliage in Figure 3-24.

Symbolic Line

A line becomes a *symbol* when a specific meaning is attached to it. We see readily that all the lines we have considered thus far are symbolic in a sense, conveying emotions of the artist or qualities of the subject, or both. When we consider lines primarily as symbols, it is because two or more people agree about the meaning, making the line a form of communication.

Sometimes the shortest lines have the most comprehensive symbolism. The lines that form letters and numbers can, in combination, represent the total knowledge humanity has ever recorded. Nearly all civilizations have practiced a form of *calligraphy* (from the Greek for "beautiful writing"). It is interesting to compare the evolution of line into such symbols in two different parts of the world. In Figure 3-25 we note that in both Egypt and China the characters are *ideographic*. This means that, instead of simply being assigned to certain sounds as is the case with the Roman alphabet, the characters are actually abstracted images of the objects they represent. With continued usage and the introduction of intangible

3-24 Milton Avery. *Pines*. 1953. Private Collection.

3-25 Egyptian and ancient Chinese characters are ideographic.

3-25

THE EIGHT SYMBOLIC TRIGRAMS

heaven *earth* *water* *fire*

river *mountain* *wind* *thunder*

EGYPTIAN

ANCIENT CHINESE

mountain *eagle* *eye* *garden* *worship*

CORN

TIGER

border *dawn* *to shoot*

woman *agriculture* *west*

to examine *old*

3-26

3-26 Facsimile of autographed manuscript of Ludwig van Beethoven's *Missa Solemnis*, page 25. Musikabteilung, Staatsbibliothek Preussischer Kulturbesitz, Berlin.

3-27 George Sklar. *Raccoon*. 1947. Wash drawing, 10¾ × 9½". Philadelphia Museum of Art (given by Miss Edith B. Thompson).

3-28 Ronald Hayes Pearson. *Sculpture*. 1991. 14k gold and Maine rock, 20" high. Commissioned by Lewis C. Strudwick. Courtesy the artist.

qualities and ideas, the pictorial associations became less obvious, and even the characters shown evolved into more abstract symbols in ensuing centuries.

The fields of science and music have their unique symbolism, intelligible only to those with specialized training, but crucial to communication and performance (Fig. 3-26). Such symbols have made possible the continuity of knowledge and culture throughout the centuries.

Line used as a symbol becomes a powerful tool in the hand of the artist. Perhaps it is never more eloquent than in the works of Islamic designers whose rich tile work plays a vital part in their domes and turreted architecture. Forbidden by their religious commitment to depict the human form, they interweave the shapes

60 *The Elements of Design*

of plants and animals with messages in their calligraphic script to create walls of unique elegance that become in themselves symbolic of their culture (Plate 7).

Line as Form

We mentioned in connection with the portrait in Figure 3-15 how a few lines could capture a human personality. Sometimes a simple line or two can go further and become a recognizable form. This is an art widely practiced as caricature, in which the artist exaggerates a particular physical feature to symbolize a human personality. In Figure 3-27 there is definitely a hint of caricature in the alert expression of eyes and nose, exploring in search of food, yet the mastery of the single line of the body is the predominant characteristic, in which the stroke of a brush lightly dipped in ink has become the actual form of the raccoon.

Line becomes form even more literally in the sculpture in Figure 3-28. The entire work is a symphony of flowing lines interweaving, doubling back then reaching upward much as growing shoots grope upward in search of light. The artist has exhibited a sensitivity to the possibilities of width variation in line, adding immeasurably to the sense of growth and movement.

3-28

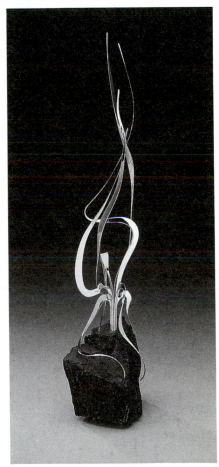

3-27

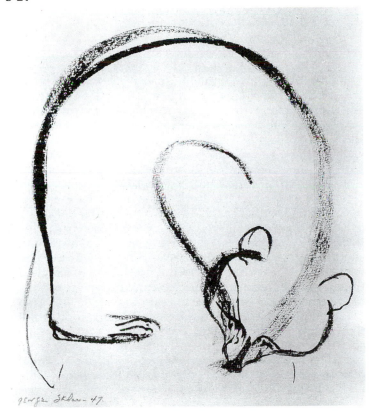

3-29

In the art of weaving, of course, the structure is entirely dependent upon the lines of warp threads strung upon the loom and the weft threads worked across them. In the tapestry in Figure 3-29 the designer has gone beyond these structural essentials in using line as his total design, again with an awareness of the possibilities of thick and thin. Strong contrasts in value combine with direction of line to create an effect that is visually three-dimensional. In Figure 3-30 the lamp itself is not embodied in line, but the base and the light diffuser are held together with bent metal rods that become the most important visual element of the composition. Without the lines separating base and light, the lamp could not function; without the eight lines its effectiveness as a design would be substantially lessened. Here again, the lines become the form.

Contemporary life is a far different world than past periods in which large rooms were filled, even cluttered, with heavy furniture. Many factors contribute to the current taste for simplicity, lightness, and lack of decoration in essential furniture for home or office. Where furniture designers previously carved and turned a wide assortment of scrolls, animal feet, and botanical forms, the designer of today uses steel, chrome, and other materials that insure durability and are quickly manufactured. When wood is used, it is often laminated plywood that can be bent to simple pleasing shapes. The armchair in Figure 3-31 is primarily linear, combining five straight lines and three curves into a simple unity, with the lively pattern of the seat cushion providing dramatic accent. Seen from the side, the chair appears to be composed entirely of lines, a forceful yet highly practical use of the line as total form.

3-29 Stephen Thurston. *Geometric Tapestry I*. Weaving. Courtesy of Joyce Thurston.

3-30 Mitchell Mauk. *Damocle* wall lamp. Plastic material, body diffuser held to base with bent metal rods, 100W halogen lamp. 7 × 13″ h (18 × 33 cm), overhand 8-21″ (20-51 cm). Courtesy Artemide, Inc.

3-31 *Cina* chair by Palazzetti. 55 × 50 × 76 cm high. Courtesy Palazzetti.

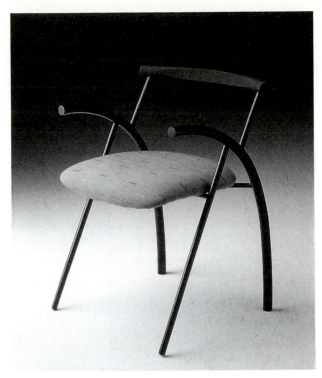

3-30

3-31

Summary

Line is the most illusory and fundamental of the design elements but it does not exist alone, for the minute a line is drawn, *space* is cut into *shape*. Lines can be used for expressing every human emotion, depending upon the *quality* of the lines used. Such quality involves thickness, spacing, direction, repetition, and texture, and makes possible limitless opportunities for expression in design. Line can also be used as form in itself, providing the designer with a direct and creative element adaptable to everything from sculpture to home furnishings.

4 | Space

Unlike line, space is neither applied nor created by the designer. It is there, in infinite abundance, whether a design is created or not. All physical things exist in space. The character of space has engaged thinkers from Euclid to Einstein, and many theories have been advanced as to its reality and extent. For the visual designer, space is not only the vehicle in which shapes and forms exist; it is also a determining element in their aesthetic quality. In many cases, space working in and through a design establishes its essential character.

Visual design is concerned primarily with three types of space: *pictorial, illusionistic,* and *actual.*

Pictorial Space

Pictorial design is design related to a flat surface. Using the lemon as a personal icon, Donald Sultan explored the fundamental aspects of what happens when a flat surface is manipulated into simple shapes. One of his studies (Fig. 4-1) is almost equally divided between areas of black charcoal and white paper. The black shapes are cut off in two places by the borders of the paper, yet the composition seems complete because the space around them, represented by white paper, flows in and out, containing the dominant shapes that overlap slightly in the center of the composition. In Figure 4-2 the black shapes predominate. Here again, they extend beyond the borders of the paper, yet the existence of a small white triangle in upper center gives them coherence and meaning, turning a massive black area into three individual figures. The triangle is *space*, relating to the space flowing around the lemons and the egg, weaving space in and out to create a composition. The triangle is equivalent to the rests and silences in music, which give emphasis to the sounds by providing contrast.

Henri Matisse spent the latter years of his life working with shapes and their interaction in space. Following a long and successful career as a painter, he became too ill to stand at an easel. Refusing to accept defeat, he arranged for an assistant to paint colors of his choice on sheets of paper, then cut them into shapes. Matisse would arrange these at length, experimenting with the spatial relationships until he arrived at a composition he approved, at

4-1 Donald Sultan.
Black Lemons. August 2, 1985.
Charcoal on paper, 50 × 38″.
Courtesy the artist.

4-2 Donald Sultan.
Black Lemons and Black Egg.
August 13, 1985. Charcoal on paper, 50 × 38″. Courtesy the artist.

4-3 Henri Matisse.
The Parakeet and the Mermaid.
1952–53. Paper cutout with gouache, 11½″ × 25′4¼″
(3.37 × 7.73 m). Six parts.
Stedelijk Museum, Amsterdam.

64

4-1

4-2

which time he pasted the shapes onto a background. The result was a series of striking designs, some of which were later interpreted in walls of ceramic tile. For Matisse, however, the importance lay in the experimentation, which he called "sculpting with color," cutting the paper away much as a sculptor chisels away stone, until the shapes and the space flowing through them produced a unified result (Fig. 4-3).

4-3

4-4

Space can be a strikingly graphic element in commercial design, in which it is important to catch the eye and make a memorable impact. The trademark in Figure 4-4 fits this requirement admirably. Its use of black lines and white space dramatizes the central knot with an impact that catches the eye immediately and would make any product bearing it instantly recognizable. It is important to note here that the shapes drawn by the designer are sometimes designated as *positive*, whereas the white paper left around them is *negative*. This design is an eloquent example of the importance of both. A negative shape is not necessarily of secondary importance.

Pictorial space can also be used in an imaginative way to convey to the viewer a *sense* of space. As with the trademark above, Joseph Stella has divided his paper almost equally between light and dark but with an entirely different effect (Fig. 4-5). Where the trademark has sharp lines defined with dark ink, Stella has applied charcoal gently, achieving textural effects by virtue of the paper showing through. The solidity of the bridge is implied effectively, yet the artist's treatment gives it an ephemeral feeling, as if a fog might obliterate the scene at any instant. The space extends far beyond what we see, indicating mystery and changing from moment to moment.

Implied Space

In both Sultan's lemons and Stella's riverside scene, we are aware of more space than is actually on the paper—in the case of the lemons because they extend beyond the borders, and in the

4-4 Robert Miles Runyan Associates. Symbol for The American Protection Industries. By permission of American Protection Industries.

4-5 Joseph Stella. *Bridge*. c. 1908. Charcoal on laid paper, 14⅜ × 23½″ (37 × 59.7 cm). The Carnegie Museum of Art, Pittsburgh (Howard N. Eavenson Memorial Fund, 58.62).

4-6 Milton Glaser. *Quaderno* poster for Olivetti. Courtesy Milton Glaser, Inc.

4-5

landscape because the artist's skill projects us emotionally into vast expanses within the sweep of the storm.

Artists frequently use implied space as a deliberate device for leading the viewer beyond the confines of what can be expressed on a sheet of paper or a stretch of canvas. In the painting in Plate 8 we *see* a closeup of a young girl seated in a theatre filled with people. Renoir has titled the work *La Première Sortie* (The First Evening Out), and he indicates the anticipation of the crowd as it awaits the opening of the performance on the stage. The refusal always to contain the subject matter of a painting within the conventional four borders was one of the innovations of the French Impressionists, whose influence Renoir also shows in his treatment of color to imply diffraction of light. He has drawn our attention to the animated face of the young girl by contrasting it in color and value with the wall beside her and the crowd beyond. We do not see the stage, but her attentive gaze *implies* its presence, and we feel her excitement

Implied space is an effective device for the graphic designer, who frequently makes use of symbolism to achieve a compelling effect. The poster in Figure 4-6 attracts attention not only because of bright color but also because of the black object floating somewhat illogically above the tile-like squares. What is it? We are expected to be intrigued enough to inquire, whereupon we learn that a Quaderno is actually a notebook-sized computer that opens up to be a tape recorder as well. The huge Q sits firmly on the floor of the implied space but the computer floats upward and may at any moment disappear from sight. A flat piece of paper thus becomes a corner with a solid floor and walls extending into seemingly endless space above—space that is implied not only by devices of the artist but by the involvement of the viewer who interprets the *symbolized* space according to personal imagery.

4-6

Illusionistic Space

Both in Stella's river scene and Renoir's *La Première Sortie*, we saw intimations of space going into depth, beyond the flat two-dimensional quality of the paper or canvas on which they were created. Two-dimensional designs work beautifully for allover patterns in wallpaper, fabric, or decorative panels in various media; however, as soon as artists begin to portray *scenes* on a flat surface there arises the question of depicting depth, of establishing one vertical plane behind another. This is accomplished in several ingenious ways.

Overlapping

Artists discovered early that placing one figure in front of another immediately pushed the one behind back into space. There are indications of this discovery as far back as 10,000 BC when Paleolithic cave drawings of running animals placed the legs of one deer or bison over part of the animal behind it. By 2700 BC the

4-7

Egyptians had mastered the technique to the point of using it regularly in their wall paintings and carvings. In Figure 4-7 the overlapping geese seem perfectly natural, even modern, in treatment.

One of the best-known examples of overlapping occurs throughout the Bayeux Tapestry (Fig. 4-8). Actually an embroidered cloth banner, this historic document depicts the Norman invasion of Britain, portraying scenes leading up to the Battle of Hastings and its aftermath, all arranged *sequentially*, so the visitor walking around the gallery where it is mounted on the wall, can "read" the story. Believed to be the work of the ladies of the court of William the Conqueror, it is rich in detail, from the loading of boats on the French side of the English Channel to the flight of the British at the end of the battle. With so much activity, the use of overlapping was the only possible way to include all the essential elements, establishing vertical planes.

4-7 *Geese of Medum*. Egyptian, c. 2700 BC National Museum, Cairo.

4-8 Bayeux Tapestry (detail). c. 1073–88. Wool embroidery on linen; height 20″ (51 cm), overall length 231′ (70.4 m). Musée de l'Évêché, Bayeux.

4-9 Laura Cole, age 7. *House with Rainbow*. Crayon. Collection of the author.

Tiering

Looking closely at the Bayeux Tapestry, we note another interesting characteristic. The main action of the banner takes place in the wide band in the center, but at top and bottom there are narrower bands, both filled with figures. This might be considered purely a decorative device until we notice what the figures are. In the top band are birds and various breeds of cats and dogs. In the bottom band are fallen soldiers and pieces of armor, along with

4-8

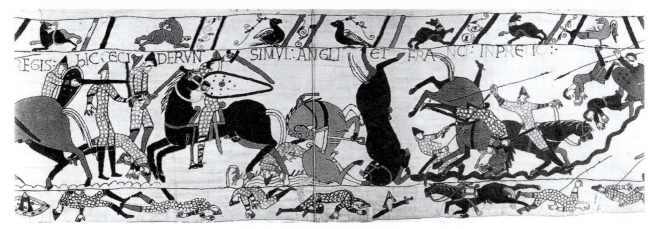

birds and animals. Therefore the top band represents sky and distance whereas the bottom band shows fallen victims in the foreground. Degrees of distance are indicated by *tiers*, or layers, in which the foreground action is at the bottom and the distance recedes upward.

Tiering or layering is not merely a primitive method for denoting distance. It follows the natural sequence by which we focus our eyes on the ground where we are standing and raise them gradually to take in our immediate surroundings, or *foreground*, then the *middle distance*, and finally the far horizon. Children find this a logical way to draw a scene, placing all objects along the bottom of the paper and letting the more distant ones rise to the top (Fig. 4-9).

Adults in many parts of the world use similar devices. The Persian miniature in Plate 9 is a sophisticated design in which the figures are beautifully executed, and the many areas of ornamentation are rich in pattern. The Islamic artist made no effort to show the paving stones in the path as though they were receding nor to flatten the rug upon which the upper figures are sitting. Still, we have no doubt that the lower figures are moving about in the part of the garden nearest to us while the higher ones sit in a recess farther back. The use of tiers tells us exactly what the artist wants us to know.

Size

Probably the most obvious and natural way to depict distance is by varying the sizes of objects. We see a small figure in the distance and wait as it approaches, growing larger and more recognizable as it comes closer to us. Any artist conveying a landscape relies upon contrasts in size: Nearby trees will be larger than distant mountains even though the mountains are actually thousands of

4-9

4-10

feet higher. The drawing in Figure 4-10 is particularly eloquent in its contrast, with the haystack rising to the top of the paper while the distant church steeple is almost infinitesimal. The more contrast there is in size, the greater the distance appears to be.

Perspective

Diminution in size to indicate distance is a proven essential in perspective, the classic system by which artists of the Western world have depicted distance for five centuries. Attributed to Renaissance architect Filippo Brunelleschi, perspective is a mathematical system for creating three-dimensional space on a two-dimensional surface, a feat hailed as nearly miraculous during the Renaissance and accepted as imperative in artistic training ever since.

Linear perspective. For anyone designing a three-dimensional object, linear perspective can be the means of making preliminary sketches of working drawings. There are three types of linear perspective: *one-point, two-point,* and *perspective with multiple vanishing points.*

One-point perspective. The cubes in Figure 4-11 give us the key to drawing in perspective. When we position ourselves so that our eyes are looking directly at the center of one side of the cube, we see only a square. When we stand looking down upon it, or it sits above us on a glass shelf, we see a set of parallel lines outlining the top or bottom. These lines seem to become closer together as they recede from our viewpoint. If extended, as in our diagram, they would meet at a point known as the *vanishing point*, which is located on

4-10 Andre Jacquemin.
The Harvest in Cheyrac,
Haute-Loire. 1954.
Pencil on paper, 11 × 14⅞″.
Private Collection.

4-11 Diagram of
one-point perspective.

4-12 Diagram of
two-point perspective.

70 *The Elements of Design*

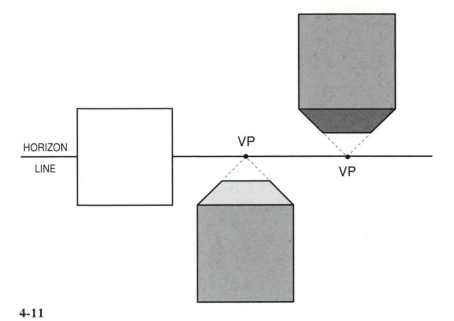

4-11

the *horizon line*, the line representing the farthest distance that we can see. The cube in this instance is reminiscent of the classic example of perspective, the railroad tracks that seem to meet in the distance.

Two-point perspective. The minute we move to one side, so that we see parts of two sides of the cube, we see two sets of parallel lines (Fig. 4-12). These begin at the edge of the cube nearest to us and converge at vanishing points that are located on each side of the cube. In all these examples, it is important to note that *all vertical lines remain vertical; only horizontal parallel lines appear to converge.*

Perspective with multiple vanishing points. In designing tools, houses, or other objects, we are not always dealing with simple cubes. In the house in Figure 4-13 the slanting edges of the roof are parallel but not to the ground. Lines extended from them would

4-12

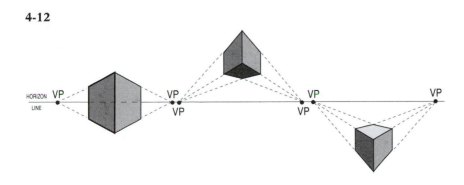

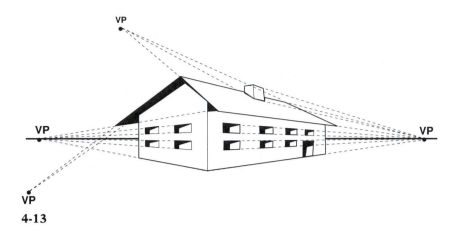

4-13

meet at a point in the sky. Similarly, the underside of the roof is parallel to the edge of the house wall joining it; lines extended from these two parallel lines would meet in the foreground rather than on the horizon line as is shown in the vanishing point at far left. The possibilities become complex but are actually summed up in a simple statement: *In a perspective drawing, all parallel lines appear to meet at a vanishing point, with the exception of lines that are vertical, which remain an equal distance apart.*

As practiced in the Renaissance, linear perspective became an extremely involved mathematical science. We can see its evolution by studying two Renaissance paintings. Giotto, considered by many to be the first great painter of the Renaissance, was seeking a way to depict depth in his work (Fig. 4-14). He had mastered the idea of

4-14

4-13 Perspective with multiple vanishing points.

4-14 Giotto. *Annunciation to Anna*. c. 1305–10. Fresco. Capella Scrovegni, Padua.

4-15 Piero della Francesco and Luciano Laurana. *View of an Ideal City* (detail). c. 1460. Tempera on panel, 1′11⅜″ × 6′6¾″ (0.58 × 2 m). Galleria Nazionale delle Marche, Palazzo Ducale, Urbino.

4-16 Perspective drawing based on *View of an Ideal City*.

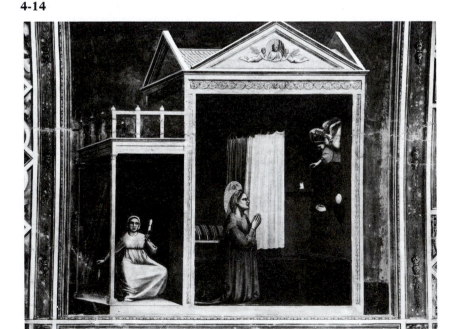

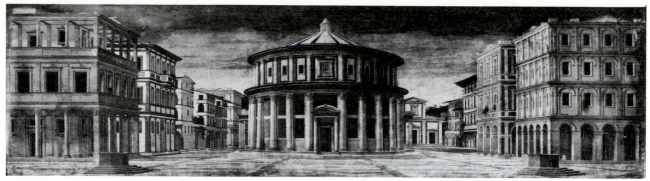

4-15

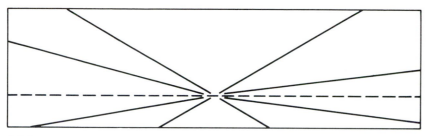

4-16

parallel lines slanting into the distance and had managed to place his figures in space with walls behind them. However, the space ends there, and the effect is one of figures in a box on a stage set. A hundred and fifty years later, Italian painters were producing elaborate studies like the one in Figure 4-15, in which they constructed buildings of all shapes with arches, towers, cupolas, colonnades, and paving blocks, deliberately combined to demonstrate the master's virtuosity in perspective. The diagram in Figure 4-16, though reducing the framework to one-point perspective, gives us an indication of the basic framework underlying even such elaboration.

Atmospheric perspective. The relationships inherent between space and light are sometimes placed under the heading of *atmospheric* or *aerial* perspective. This term refers to a fundamental aspect of the correlation between space and light—the manner in which human perception sees objects in the distance in less detail and in more muted colors than objects that are close. This effect is caused by two factors: the softening quality of the body of air intervening between object and viewer, and the inability of the human eye clearly to distinguish forms and colors at a distance. Artists attempt to duplicate this reality by a progressive graying and blurring as a composition recedes into the distance. The quality of lightness or darkness, brightness or grayness, is known as *tonality,* and it is a particularly effective tool for the landscape painter (Fig. 4-17).

Space can be depicted in the opposite way as well, however, by highlighting a center of interest and implying receding distance by surrounding areas of darkness. Rembrandt was a master of this device, dramatizing his many religious subjects particularly by

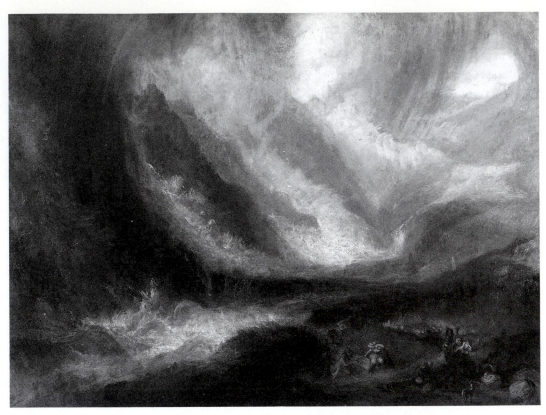

4-17

4-17 Joseph Mallord William Turner. *Valley of Aosta—Snowstorm, Avalanche, and Thunderstorm*. 1836–37. Oil on canvas, 92.2 × 123 cm. The Art Institute of Chicago (Frederick T. Haskell Collection, 1947.513).

4-18 Pieter de Hooch. *Interior with Card Players*. 1938. Oil, 30 × 20½". The Royal Collection.

4-19 Hans van de Bovenkamp. *Mariner's Gateway*. 1986. White epoxy paint on Cor-ten steel. Height, width, and depth 30' (9.15 m). Haverstraw Marina, New York, Circle No. 11. Courtesy the artist.

bathing the central figures in mystical glow while the less important characters blend into a background rich in deep color (Plate 10). Here great *physical* space is not necessary, but the dramatic lighting establishes a sense of *symbolic* space, not only behind the figures but also above them, where angelic forms appear to be descending from infinite space beyond.

A group of Rembrandt's contemporaries used the reverse means of relating space and light. Known as *genre* painters because of their specializing in everyday scenes within Dutch homes, these artists flooded the entire room with sunlight, even conveying the feeling of sunshine pouring in through doors and windows (Fig. 4-18). The people who became the focal point, rather than being highlighted, were rendered partially sunlit and partially in shadow, providing dark accents to contrast with the pervading sense of air and light.

Actual Space

Pictorial space implies space that is the product of the skill of the artist, in relating shape and space with an aesthetic or pictorial result. *Illusionistic* space tells us clearly that the artist has provided the sense of space and motion through various devices, some subtle and some highly scientific, but creating perceptual illusions none-

74 *The Elements of Design*

4-18

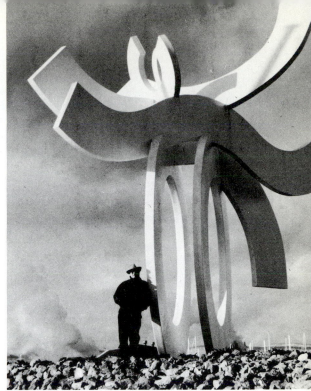

4-19

theless. *Actual* space is concerned with three-dimensional works, in which space is a real and tangible part of the design. This is the case with pottery, in which the inner space is often the main reason for its being; or it may concern sculpture, in which positive and negative space interact to create the form of the work. It may also allude to architecture, in which existing space is enclosed in such a way that it serves the needs of the people who live and work within it.

Space is a dominant element in the sculpture in Figure 4-19. From the open circles the observer's eye follows the wing-like forms, soaring up and dipping down, seeming to react to the space around them, even though they are actually rigid. The standing figure emphasizes scale and proximity; this is not a work to be viewed from a distance but walked around and *felt*, providing the full impact of the flow of space within and around it.

Space, Time, and Motion

If all things exist in space, we must expect some movement within it. We experience this in parks and plazas, where spaces are designed specifically for human enjoyment, with ponds and flower

beds, paths and sweeping lawns. These spaces require time for appreciation; they are planned for the pleasant expenditure of time. It also takes time to walk through a building. Visitors to the great European cathedrals find themselves returning again and again in order to experience the full impact of the impressive spaces with their woodcarving, stone sculpture, stained glass, and other treasures.

Impressive in a different way is the public space provided in a major opera house. Such a building is designed to heighten anticipation by surrounding the visitor with glamor and an aura of elegance from the moment of entering (Fig. 4-20). Especially at night, with crystal chandeliers sparkling and lighted fountains shimmering, one lingers, climbing the richly carpeted staircase slowly, absorbing the eloquent stage setting in which the viewer, as a member of the audience, is about to become a living part of the performance.

Smaller-scale architecture may also stimulate anticipation. The house in Figure 4-21 seems to have been sculpted rather than built, and it gives the viewer a feeling of curiosity as to what the interior spaces will reveal. The house was designed for a woman who collects seashells as a hobby, and its swooping curves and intriguing arcs seem to echo the configurations of a shell (Fig. 4-22). The

4-20 Staircase and foyer
of Metropolitan Opera House,
Lincoln Center,
New York City.

4-21 Augustin Hernandez.
Hernandez House, Mexico City.

4-22 Trumpet shell from
the Philippines. Courtesy
Department of Library
Services, American Museum
of Natural History.

4-20

4-21

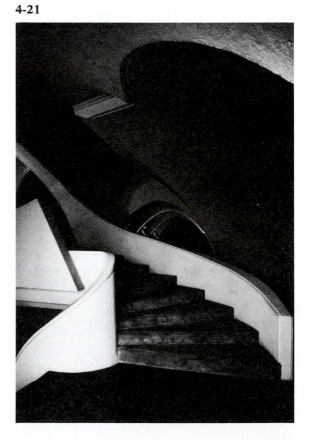

element of time is important in appreciating such a house, and certainly movement is a vital part of the experience. The viewer must linger and *experience* the spaces, feeling their flow and rhythm rather than merely viewing them.

Contemporary Concepts of Space

We have explored devices for conveying space and distance that have been used over thousands of years in all parts of the world. If we were to make a survey of the past century we would find just as many concepts, ideas, and experiments developed by artists seeking new ways of expressing age-old realities. For centuries the linear perspective of the Renaissance was considered the ultimate solution to conveying three dimensions on a two-dimensional surface, but in the twentieth century artists began to question whether this was even ethical, much less the ultimate goal of the artist. If one is going to work on a two-dimensional surface, is it not a violation of the integrity of the surface to create illusions? Such reasoning has led to fresh conceptions of what design should and should not be.

Advanced technology also has led to many innovative approaches to design, not the least of which is an expanded vision of the possibilities of controlled light in designing space and color (Plate 11). "Installations" of a transient nature have opened an entirely new area, in which a design is not on view permanently but is experienced briefly and then remembered, like so many lifetime experiences, replete with the associations of the viewer's personal perception. Design thus becomes a part of human living, continually vacillating, weaving itself into the vital and ever-changing tapestry that is each individual's total experience.

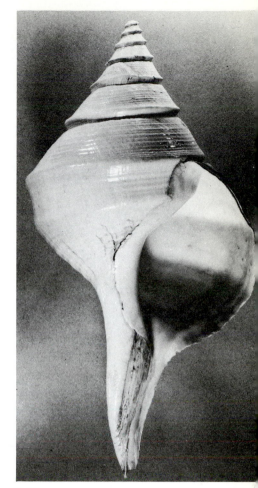

4-22

Summary

Visual design is concerned with three types of space: pictorial, illusionistic, and actual. *Pictorial* space is the product of the skill of the artist and is achieved by the flow of space among shapes and forms in a work. It includes the use of implied space, which carries the eye of the viewer beyond the margins of the paper or canvas. *Illusionistic* space can be achieved by overlapping, tiering, adjustment of size, and perspective, either linear or atmospheric. *Actual* space is concerned with three-dimensional works, in which space is a real and tangible part of the design. Time, space, and motion become interwoven in the appreciation of actual space. Contemporary artists continually experiment with concepts of space, often combining original experimentation with traditional methods.

5 | Shape and Form

As elements of design, shape and form are inseparable, since they are frequently human perceptions of the same object, seen from a different viewpoint. We usually think of form as the three-dimensional extension of shape, with qualities that are also described as *mass* or *volume*. Any form seen as a silhouette becomes a shape, as in the case of a tree viewed against a moonlit sky. Seen in daylight, the tree has *volume* in its cylindrical trunk and *mass* in the foliage that now goes beyond mere shape to a sphere or cone of leaves or needles. In its totality, the tree is seen truly as a *form*, an element in the landscape.

5-1

5-1 A shape often becomes a mass through a change in viewpoint or in lighting.

5-2 Giorgio de Chirico. *Le Pere*. 1918. Pencil on paper, 19 × 17 cm. Fondazione Giorgio e Isa de Chirico, Rome; VAGA, New York.

5-3 Martha Alf. *Two Pears*. 1986. Derwent colored pencil on bond paper, 14 × 17″. Courtesy the artist and Newspace Gallery, Los Angeles.

5-4 Tide pools, Año Nuevo State Reserve, California.

78

5-2

5-3

In Figure 5-1 we see three shapes that most of us perceive in
one form or other nearly every day. In the right-hand column of the
drawing, the shapes have become forms simply by our moving our
viewpoint to where we perceive them in a different light or from a
slightly altered position. In Figures 5-2 and 5-3 we see how two
artists have made a similar transition from shape to form without
changing either light or position. The two pears in Figure 5-2 are
the result of simple contour lines, delineating shapes. Half a century
later, another artist saw pears as metaphors for human relation-
ships and psychic states (Fig. 5-3). Using strong lighting and a spe-
cial pencil, she modelled them into solid rounded forms sitting
heavily on a table.

Shape

Contour lines are not the only means of delineating shapes. In
nature a patch of growth provides a shape, as does sunlight striking
a facet of a cliff, or the sweep of a receding tide (Fig. 5-4). Each of

5-4

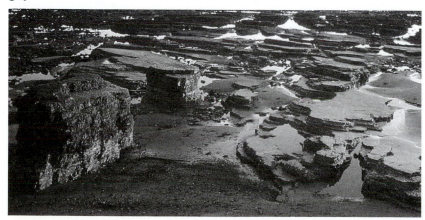

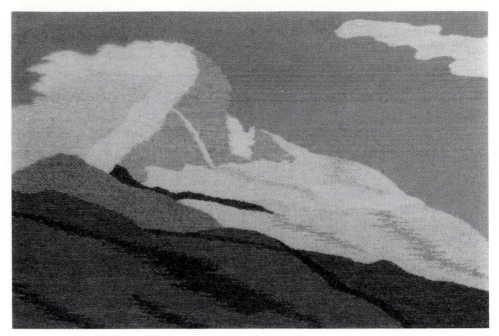

5-5

these shapes implies a form: A patch of moss has thickness, a cliff
has imposing form, and it is a mass of water that through the cen-
turies has carved hollows in the forms of coral. The designer sees an
interesting form and visualizes it as an element in a two-dimen-
sional design. Thus the Matterhorn becomes a textile (Fig. 5-5).

Shapes are categorized in one of four ways: *natural, geometric,
abstract,* and *nonobjective.*

5-6

Natural Shapes

Natural shapes are those deriving from anything in the natural environment, including the human figure. The Japanese silk design in Figure 5-6 could have been inspired by either flowers or snowflakes or both; its charm lies in the originality that brings both shapes together in a new and decorative design. Placement is crucial here, for the overlapping implies movement, adding a rhythmic quality to the decorative shapes.

The shapes of animals have been interpreted by artists for more than fifteen thousand years—as paintings on cave walls and skins, often with a touch of humor. Contemporary artist Tak Kwong Chan, with a few masterful strokes, creates horses that are full of action

5-7

5-5 Janet Daniel. *Plumed Alp*. 1991. Wool on cotton/linen, Moorman technique, supplementary warp and weft, 2½ × 3½′. Courtesy the artist.

5-6 Japanese stencil used to decorate silk. c. 1680-1750, Tokugawa period. Slater Memorial Museum, Norwich Free Academy, Norwich, CT (Vanderpool Collection).

5-7 Tak Kwong Chan. *The Horse—Away He Goes*. 1980. Brush and ink, 24 × 40″ (.61 × 1.02 m). Collection of the artist.

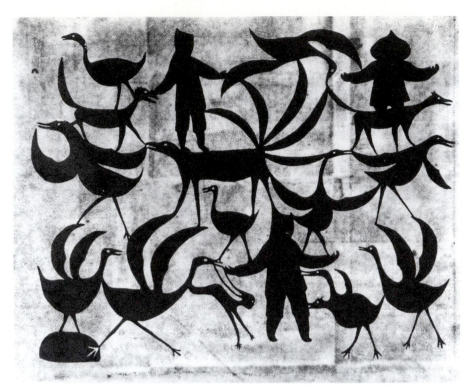

5-8

5-9

and beauty, yet are striking designs as well (Fig. 5-7). In direct contrast to Tak's horse racing off into space are the animals in the designs of Canadian Eskimos. Living close to nature, these artists shape it in its purest manifestation, without implication of depth or form, weaving birds, animals, and people into decorative compositions expressive of the interaction in their daily lives (Fig. 5-8).

Geometric Shapes

We tend to think of geometric shapes as having been invented by human beings, but of course many geometric shapes exist in nature. We can find the square in mineral crystals, the triangle in trees and certain leaf shapes, the circle developed to a spiral in shell formations (see Figure 4-22). The hexagon is a fundamental natural shape, far more prevalent than we realize when viewing the world with the naked eye. Characteristic of its unexpected functions is its structural role in an insect's eye as seen under a microscope (Fig. 5-9).

Designs from early periods of civilization or from outlying areas of the world frequently have predominantly geometric themes. Native American designs on rugs, pottery, and baskets are almost always geometric shapes symbolizing natural forces (Fig. 5-10). The quilt in Figure 5-11, composed entirely of squares and variations on the triangle, is from the dowry of a woman in Kutch, a region on the west coast of India.

5-11

5-10

5-8 Keojuak Ashevak. *Complex of Birds*. 1960. Stone cut. West Baffin Eskimo Co-operative, Cape Dorset, North West Territories.

5-9 Microscopic view of the cornea of an insect's eye.

5-10 Left to right: Red Mesa black-on-white bowl (AD 875–1125), Cebolleta black-on-white canteen (AD 950–1100), Kiatuthlanna black-on-white bowl (AD 825–910). Museum of Indian Arts and Culture/Laboratory of Anthropology, Santa Fe.

5-11 Harijan patchwork quilt from Kutch district of India. n.d. Embroidered and pieced cotton, 6′9¼″ (2.06 m). Fowler Museum of Cultural History, UCLA (gift of Mr. and Mrs. Richard B. Rogers).

5-12

Human construction is dominated by geometric shapes. The skyscrapers of the cities of the world are the outgrowth of basic post-and-lintel construction, in which a horizontal beam is placed across two separated uprights, creating a square or rectangular space between them. Although the rectangular shapes are modified by the rugged stones buffeted by the storms of centuries, the post-and-lintel construction at Stonehenge (Fig. 5-12) provides eloquent testimony to the strength of the system, having stood for 3,500 years after being erected by primitive means with no mortar to sustain them.

The symbolic significance of the circle pre-dates even Stonehenge. Having neither beginning nor end, it has enjoyed universal importance in denoting wholeness, eternity, and perfection, timelessness enclosing space and spacelessness as having no above or below. Roy Vickers, working on the west coast of British Columbia, has used it in a particularly personal yet universal interpretation in

5-13

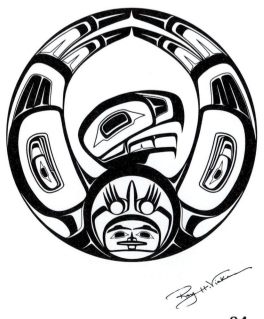

5-14

his work entitled *Eagle Full Circle* (Fig. 5-13). Combining his tribal totem of the eagle with other symbols to signify a totality of life and nature, he expresses, among other things, his personal fulfillment as a native Northwest artist whose work has found enthusiastic approval in a contemporary technological world.

The painting by Victor Vasarely in Figure 5-14 is composed entirely of circles used in such a way that their overlapping creates new shapes yet does not destroy the original circles. The variations in color spark the interplay of shapes to result in a lively composition filled with movement.

Abstract Shapes

When a natural shape has been altered to emphasize its essential qualities without reference to realistic depiction, we say that it has been *abstracted*. Another term for this is *stylization*. Some of the most beautiful abstract designs are those created by native North American potters, in which religious symbols and earth forms become totally interrelated. The pottery in Figure 5-10 is stylized to the point of classic dignity, yet every element has symbolic meaning, dominated by the eagle feathers that cover jar and bowl. Even the animals are embellished with geometric symbols. Although the casual observer cannot fully appreciate the symbolism, the pottery is highly significant simply as design.

Although Matisse worked with shape for its own sake, many of his compositions inevitably became abstractions. His title for Figure 5-15 tells us of his intent in this case, and we suspect that he enjoyed playing with the different shapes and combining them in a whimsical way to become a human figure.

5-15

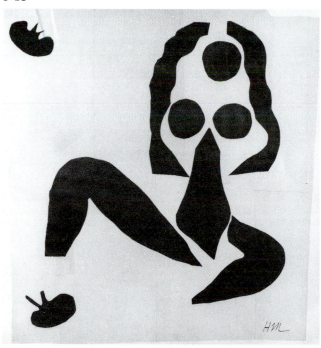

5-12 Stonehenge. 1800–1400 BC Height of stones above ground 13′6″ (4.1 m). Salisbury Plain, Wiltshire, England.

5-13 Roy Vickers. *Eagle Full Circle.* Courtesy the artist.

5-14 Victor Vasarely. *Design Based on Circles.* 31.1″ (84 cm). square. By permission of Michele Vasarely.

5-15 Henri Matisse. *Blue Nude —the Frog.* 1952. Gouache, decoupee, 141 × 134 cm. Courtesy Galerie Beyeler, Basel.

Nonrepresentational Shapes

In contrast to abstract shapes nonrepresentational, or nonobjective, shapes do not originate in any recognizable shape or object. Since human perception tends to see familiar shapes even when the artist did not intend them, the labelling of a work as nonobjective becomes more a matter of the artist's intent than of the work itself. Wassily Kandinsky became an unconditional advocate of the nonobjective in his paintings, stating that as his career progressed he found the presence of objects detrimental to his work (Fig. 5-16).

We have mentioned earlier the fact that people tend to see familiar shapes in works that artists consider nonobjective. When such shapes seem organic, as though they might be part of some living thing, they are termed *biomorphic*. The tapestry in Figure 5-17 falls into this category. Its nonobjective patterns could easily have resulted from the designer's experimentation with his medium, enjoying the novel effects that evolved as he interwove various wefts among his warp fibers, yet as we view it there is a sense of moving

5-17

5-16

forms, perhaps floating in water as in a tidepool. Another viewer might see rock formations, or the shapes one sees when looking up into a tree. Here again we find the viewer taking part in the aesthetic experience by creating purely personal interpretations, perhaps one of the most important aspects of nonobjective designs.

Form

Since shape and form are inseparable, the categories applying to shape apply as well to form. It is important to realize that although we think of form as *structural*, it can also be fluid and changing. An ocean wave, for instance, roars and crashes, seeming more like a *mass* of water than a structural form, yet for every moment of its existence it has form, even though the form is different during each of those moments (Fig. 5-18). The rising wave, tornadoes, thunderclouds, and waterfalls all become dramatic natural forms, full of sound and movement and structural as well.

5-18

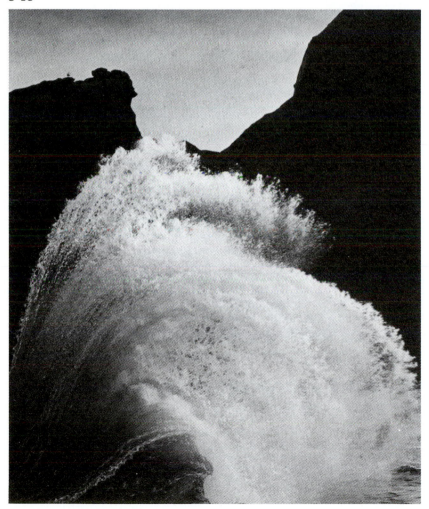

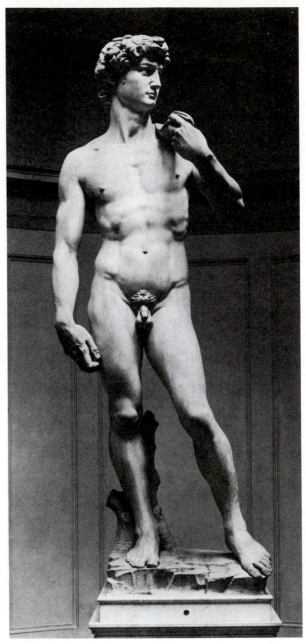

5-19

5-19 Michelangelo. *David*.
1501–1504. Marble, height 18′
(5.48 m). Accadèmia, Florence.

5-20 Centennial Square.
Victoria, British Columbia.

Natural Forms

Probably the most widely used natural form in the world of art has been the human figure. The artist began with the subject most conveniently at hand, creating sticklike figures more than 4,000 years ago and reaching a pinnacle at the time of early Greece, when human beings became models for the gods, thus inspiring sculpture

that was as near to perfection as human hands could create. We saw an example of such sculpture in Figure 1-17; in Figure 5-19 we see the Renaissance interpretation of the godlike beauty of the human form. Inspired by the examples of ancient Greece, Michelangelo depicted the biblical character of David to personify the indomitable spirit of his beloved Florence at a time when its security was threatened by invasion. Sculptures of birds and animals have also played a significant part in human expression, particularly in the days of ancient Egypt, when many of the gods were represented in the forms of cats, falcons, serpents, wolves, and other animals.

Natural forms are the inevitable medium of the gardener and the environmentalist and have grown increasingly important as we become aware of the necessity for modifying our cityscapes with plantings and parks, areas of beauty and relaxation to counteract the severity of steel and concrete, pollution and noise. The shapes and scents of nature enhance the forms that become havens in the midst of a busy city (Fig. 5-20).

5-20

5-21 Isamu Noguchi. *Cube.* 1969. Steel and Aluminum, painted and welded, height 28′ (8.53 m). Located in front of 140 Broadway, New York.

5-22 Pavel Hlava (in cooperation with the workshop of Miroslav Lenc). *Satellite.* 1972. Blown crystal hemispheres joined by welding, diameter 13¼″ (34.93 cm). Courtesy the artist.

5-23 Magician's Pyramid, Uxmal, Mexico.

5-24 Lino Sabattini. Silverplated flower vases designed for Argenteria Sabattini. 1974. Heights 14″ and 10½″ (35.56 and 26.67 cm). Courtesy Argenteria Sabattini, Como, Italy.

Geometric Forms

The busy city is dominated by geometric forms, giving the impression of stability through square and rectangular masses that rise to heights thought impossible a century ago. Sculptor Isamu Noguchi, creating a symbol of the contemporary world, placed a cube in a plaza surrounded by such buildings. A simple cube in such a setting would have attracted little interest, seeming but a fragment of the towering world around it. However, Noguchi rose to the challenge with a concept that irresistibly draws attention. He tipped the cube on one corner (Fig. 5-21) so it not only becomes a startling contrast to its background but appears to challenge gravity as well.

The symbolism of the circle translates readily into the glass sculpture in Figure 5-22, which shimmers with light, echoing the form of the earth in its role as satellite. Even though it rests on a pedestal, we can imagine this airy form beginning to lift upward and hover in the air, gently spinning as it goes. The sphere in any form seems mobile, always turning, never static. There are no sharp edges to bring motion to a halt, as there are in a cube. A sphere nearly always implies movement and time.

With the pyramidal form we return solidly to earth. The pharaohs of Egypt were well advised when they built their burial pyramids to last for eternity, for they have withstood more than 4,000 years of climate, wars, pillage, and geological upheaval. Only

5-21

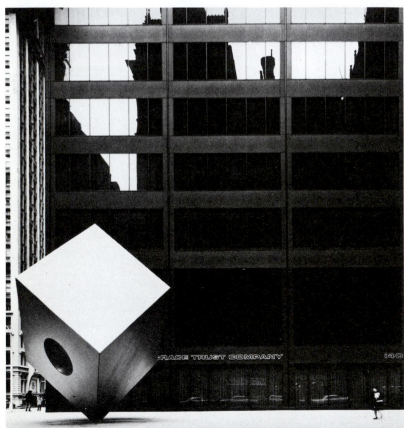

5-22

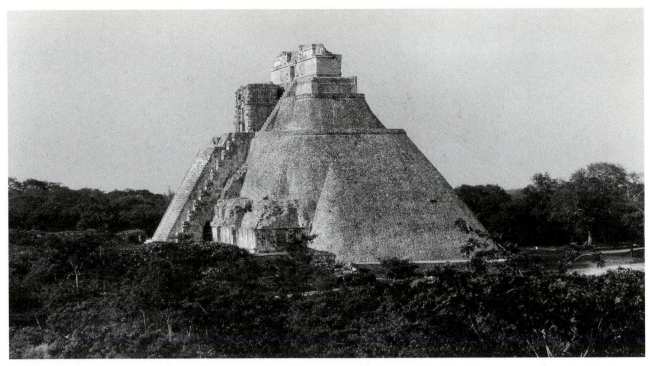

5-23

5-24

now, in the twentieth century, are these stone memorials being eroded seriously by pollution, the nemesis of the modern age. Pyramids are not exclusively Egyptian, of course; early civilizations from the Middle East and Southeast Asia to the cultures of pre-Columbian America built pyramids in an effort to reach the gods, using them for rituals of many kinds (Fig. 5-23). Although the cube is the most visually solid form, the pyramid is immensely stable from an engineering point of view. Stresses beginning at the top spread out in all directions to the broad base. It is no accident that these structures have outlasted all the other wonders of the ancient world.

We began our consideration of shape with three geometric shapes that expand under varying conditions of perception: the square expanding to the cube, the triangle to the pyramid, and the circle to the sphere. We now translate angles into curves and discover two more basic forms: the *cylinder,* deriving from the square or rectangle, and the *cone,* the curvilinear counterpart of the triangle.

The uses of the cylinder are limitless, partly because the shape makes every scrap of space useful, with no corners or crevices in which contents can lodge. Cans, drinking vessels, cooking pots, hoses, tubes, grain elevators—all attest to the practicality of this simple shape. As a form in itself, the cylinder can be classically elegant (Fig. 5-24).

The cone, in contrast, appears to be a *thrusting* form, as in the nose cone of a spaceship or the cone of a volcano. We find that wherever architecture uses the cylindrical form it is usually topped with a cone-shaped roof, whose circular base fits neatly onto the top

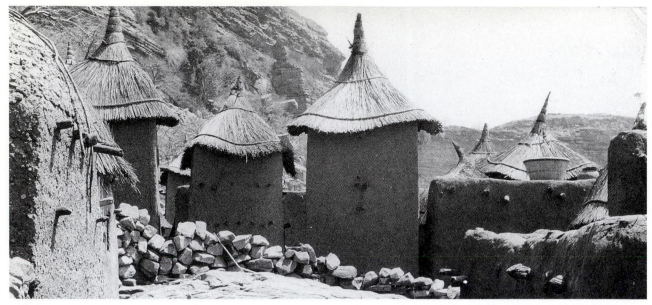

5-25

5-25 Village of the Dogon tribe, cliffs of Bandiagara, Mali, West Africa.

5-26 Walls of the old city and the chateau of Carcassone, France.

5-27(a) Henri Matisse. *The Back, I*. Issy-les-Molineaux, autumn 1909. Bronze, 6′2⅜″ × 44½″ × 6½″ (188.9 × 113 × 16.5 cm). The Museum of Modern Art, New York (Mrs. Simon Guggenheim Fund).
5-27(b) Henri Matisse. *The Back, II*. 1913. Bronze, 6′2¼″ × 47⅝″ × 6″ (188.5 × 121 × 15.2 cm). The Museum of Modern Art, New York (Mrs. Simon Guggenheim Fund).
5-27(c) Henri Matisse. *The Back, III*. 1916. Bronze, 6′2½″ × 44″ × 6″ (189.2 × 111.8 × 15.2 cm). The Museum of Modern Art, New York (Mrs. Simon Guggenheim Fund).
5-27(d) Henri Matisse. *The Back, IV*. 1931. Bronze, 6′2″ × 44½″ × 6″ (188 × 112.4 × 15.2 cm). The Museum of Modern Art, New York (Mrs. Simon Guggenheim Fund).

of the cylinder. We find such combinations in Africa, where traditional thatched roofs have wide overhangs to direct torrents of rain beyond the mud walls (Fig. 5-25) as well as in the architecture of medieval Europe where the roofs are of slate or tile to withstand both rain and snow (Fig. 5-26). The conical-topped tower was a standard feature of medieval castles, which often had several, all allowing for a 360-degree view of the surrounding countryside which was in constant need of surveillance against approaching enemies.

5-26

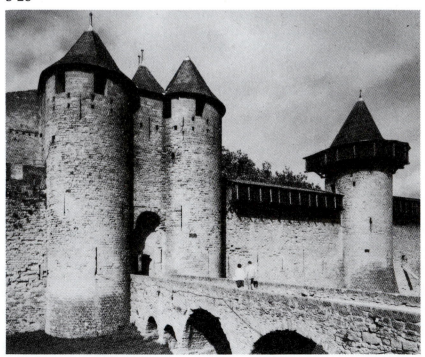

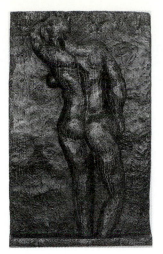

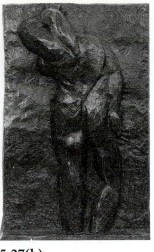

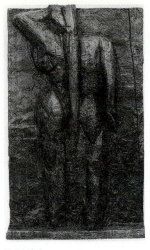

5-27(a) **5-27(b)** **5-27(c)** **5-27(d)**

Abstract Forms

If we smiled at Matisse's *Blue Nude* in Figure 5-15, we can look with serious interest at his three-dimensional abstraction of the human body in Figure 5-27, for here he shows us exactly how an abstract form evolves. Evolving at intervals, the four versions express the artist's increasing concept of human form as structural design. Two years before he began the first version of *The Back*, he was telling his students to express masses in relation to one another, not as parts building up a body but as legs working up into a torso which clasps down over them. He also mentioned that there must be a spinal column, which opinion we see firmly expressed in the last two versions. Once again we see evidence of his interest in cubism, abstracting the human body into geometric masses that ultimately become cylindrically architectural.

Nonobjective Forms

Like nonobjective shapes, nonobjective forms do not refer to anything recognizable. The sculpture in Figure 5-28 fits into this category, with its combination of assorted materials constructed into forms that do not seem seriously reminiscent of any recognizable object. We can, of course, conjure up similarities to standing legs and hunched shoulders suggestive of some exotic bird or animal, but for all aesthetic purposes it is an original and unique work arising solely from the perceptions and imagery of the artist.

Perhaps more than any other medium, glass lends itself to the nonobjective form. The fluidity of molten glass leads the artist into adventures not to be experienced elsewhere, as the fire reaches intense heat and the glass melts and runs, blending and responding to the actions of the glassblower. The cooled results are often surprising and exciting, with a sense of movement and light that makes them unique in every sense (Plate 12).

5-28

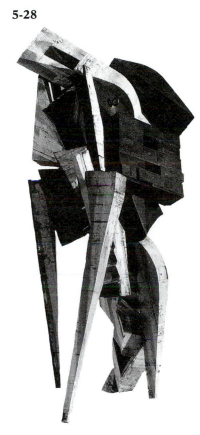

5-28 Mel Kendrick. *Sculpture No. 2*. 1991. Wood, lampblack, linseed oil, and pipe, 113 × 48 × 55″. Courtesy John Weber Gallery, New York.

Summary

As elements of design, shape and form are inseparable. Form has volume and mass in addition to shape. Both shape and form can be classified in four ways: *natural, geometric, abstract,* and *nonobjective.* Abstract shapes and forms are those in which the essence of an object has been extracted and expressed. Nonobjective shapes and masses do not originate in any recognizable object but are purely the imaginative work of the artist.

Texture | 6

Keynotes to Discovery:

tactile
haut relief
batik
collage
motif
impasto

As we explore the element of texture, the sensory connotation of the word "aesthetic" acquires a new importance. We appreciated line and color by *seeing;* we *experienced* space, particularly in three-dimensional works through and around which we could move; and we *sensed* form as having mass and volume, even when we were not in a position to see them in their entirety. We now discover a new dimension in our aesthetic explorations, for our consciousness of texture relies not only on our sight but also on the tactile sense, our sense of *touch*.

As infants we touch before we see, and throughout our lives the role of texture remains a vital one. The lives of thousands of people have been enriched by the invention early in the nineteenth century of the Braille system of printing books by embossing type in paper points or dots that make it possible for people without sight to read by touching them.

Even with vision, much of our response to our environment occurs by touching. If we were to run our fingers over the weathered root in Figure 6-1, we would feel roughness in the bark and in the crevices, yet the smooth lower surfaces would tell us much of the vicissitudes of harsh winters and mountain storms. Similarly, looking at the design in Figure 6-2 we are aware of texture in its small circles, occasional open spaces, and meandering lines that

6-1 Bristlecone pine roots, White Mountains.

6-2 Jack Lenor Larson. *Water Lilies* (batik). 50″ wide (127 cm).

6-1

6-2

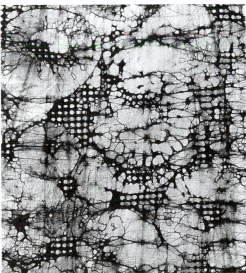

could indicate cracks or crevices. This surface, too, is rich in texture; however, if we were to run our fingers over the design we would feel only the softness of the cloth. This is *visual* texture whereas the texture of the stump is *tactile*. Generally speaking, *tactile textures are intrinsic in the material of the object, representing the physical surface and the structure underlying it.* Visual textures are just as real; we simply experience them in a different way, often with emotional overtones echoing past experiences with textures we have actually felt.

Tactile Textures

An awareness of the textures in nature offers a treasure of possibilities for the designer. Each variety of seashell has its distinctive shape, but it also has individual texture resulting from its chemical composition and its buffeting by the sea (Fig. 6-3). Many trees are readily recognizable by the texture of their bark, which represents the outer layer of years, sometimes centuries, of growth. Some varieties peel annually, substituting their familiar roughness for a bright smooth surface that eventually becomes new bark (Fig. 6-4). Others offer a storehouse where birds can peck out bugs and drill holes for safeguarding the winter's supply of acorns (Fig. 6-5). The roughness of a mountain wall with its hand- and foot-holds for the mountaineer is a direct expression of geologic upheaval; and even

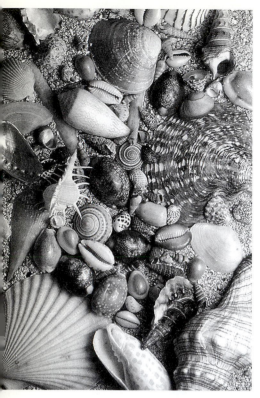

6-3

6-4

6-5

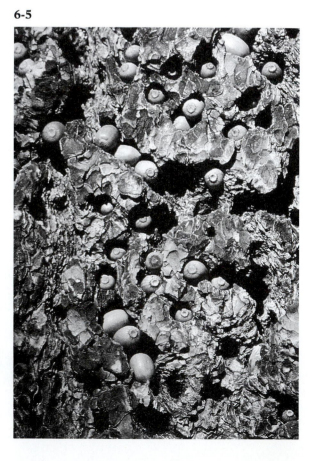

the forest trail carpeted with seasons of trampled leaves and ribbed with tree roots, is a textural manifestation of the earth from which it has been cleared. Texture in nature can be a matter of protection, not only for those who invade it but for its native inhabitants. Scales on fish, reptiles, and many varieties of animals provide protection without impeding movement, much as chain mail fortified medieval warriors.

Texture and Structure

The original definition for the word "texture" related to textiles and the surface interest resulting from weaving in various fibers. We can see five superb examples of this interpretation in Plate 13. It is easy to sense the variations in their surfaces, some in a regular pattern, others in nonobjective shapes that add interest visually while offering surprises to the touch. The choice of fibers and the highly personal ways of using them have made each piece a truly original design. Richly imaginative textiles of an entirely different sort were created by the Incas in pre-Columbian Peru. The tunic in Figure 6-6 is an example of a technique in which feathers were knotted on cords which were then stitched on a plain-weave cotton ground, resulting in a soft, lush texture.

In Plate 14 we see an excellent example of the fact that the artist does not *apply* tactile texture but *produces* it. The visual texture of beautiful grain existed in the wood; it is what the designer did with it that is important. First, he shaped the bowl to take full advantage of the striations, curving the form to emphasize its roundness, then he produced grooves cutting across the grain in the opposite direction, creating a visual counterpoint to the underlying material. The resulting texture could be considered both visual and

6-6

6-3 A random assortment of seashells.

6-4 Bark of a madrone tree.

6-5 Oak tree with nuts stored in the bark.

6-6 Inca feather tunic from Peru. 1100–1400. Feathers knotted on cords stitched to plain weave cotton ground, 5'11" × 2'9" (1.81 × .84 m). Los Angeles County Museum of Art (gift of Mr. and Mrs. William T. Sesnon, Jr., 1974).

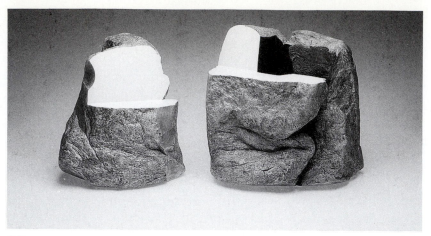

6-7

tactile, but the predominance of the grooving makes us aware primarily of the tactile quality.

In Figure 6-7 the texture is an even more obvious production of the artist. Beginning with a glob of clay, he has constructed two forms, texturing them roughly in a manner that recalls the natural state of clay in river bank or hillside. To emphasize the texture, he has provided sharp contrast by slicing out a section of each form to reveal surfaces totally smooth. The contrast is heightened by the use of color—blue and magenta on the rough surfaces, brilliant yellow on the smooth. Seeing the forms in black and white, we become even more aware of the importance of shadows in dramatizing texture. Depending upon the source of light, any protrusions will become more pronounced by virtue of the shadows engendered by the difference in plane. *Light is an important factor in any use of tactile texture.*

Shadows play an even more explicit role in the design in Figure 6-8, again cast from metal. A typical example of Renaissance humanism in depicting the beauties of the earth, the panel of fruit, flowers, and ribbons was cast in bronze to enhance the door jamb of a church in Florence. Its explicit subject matter and the scale of its protrusions make it seem more than texture, which we usually associate with an overall surface quality. This degree of variation in plane has a special name: *haut relief,* a sculptural term denoting carving that stands relatively high above its background. The door panels, then, can be considered sculpture in one sense, but viewed from a distance, as part of the design of the church, they become a textural element.

A contemporary version of this concept is seen in Figure 6-9. Although twentieth-century cities seldom provide such decorative effects for their busy thoroughfares, texture and pattern are becoming recognized increasingly for their ability to relieve the stark impersonality of glass and concrete walls. Here, panels of relief sculpture have been cast in concrete by using molds of wet sand, and then applied to the concrete wall of the building. The play of light over the textural surface, casting a lively pattern of sun and

6-8

6-9

shadow, offers a quality related to the natural environment, a welcome relief from the hard surfaces that compose the typical city.

For centuries the people of Africa have been aware of the decorative contributions of texture. The ceremonial mask in Figure 6-10 displays four different textural designs applied with an instinctive sense of contrast and unity. The area of the hair with its central

6-10

Texture **99**

axis impressively balances the forceful nose and cheekbones, and the eyes, with their own unique pattern, serve effectively as the focal points of the facial configuration. For a native of the Cameroon Highlands, this wooden mask no doubt carries deep-seated tribal significance, but even for the uninitiated it holds the fascination of a highly decorative work of sculpture in which tactile textures play a major role.

From the examples shown, we find that tactile texture arouses not only sensory interest but emotional response in the viewer and that it is generally related to the material and structure of which it is a part. There are possible exceptions, of course. Unlike science, art does not provide rules and formulas, only distinctions, and they remain flexible and subject to individual interpretation. We could, for instance, drive nails partway into a plank at close intervals, leaving a texture of nailheads that would be tactile yet not be a part of the plank from which they emerge. We could suspend pieces of broken phonograph records on monofilament as was done in Figure 6-11, creating a texture that can be felt but has no relationship to the material on which the pieces rest. It is important as well to realize that tactile texture does not have to be three-dimensional. We have only to think of the many varieties of woven fabric used commercially and the ways in which we finger them when we consider putting them to use. There is the ribbed texture of corduroy or piqué, the pebbled surface of seersucker, the thick softness of velvet or plush. There is the art of quilting (Fig. 6-12) which fulfills the criteria of tactile texture by producing texture from existing material and being readily responsive to our fingertips, yet which we would generally consider to be two-dimensional in its finished form. The distinguishing feature of tactile texture, then, is simply that it not only *looks* textural but *feels* textural when we explore it with our sense of touch. We will now consider the other category of texture: those textures that are applied by various means to existing surfaces without making any structural change in the surface.

6-11

6-11 Mattie Berhang. *Costello Ferry* (detail). 1985. Broken record pieces suspended on monofilament, 5′9″ × 9′3″ × 1′2″ (1.76 × 2.83 × 0.36 m). Courtesy the artist.

6-12 A quilted linen coverlet from the first half of the 18th century. Victoria & Albert Museum, London. The interwoven circular and radiating forms produce a rich textural surface.

6-13 Square facing the Opera House, Manaus, Brazil.

6-12

Visual Textures

The paving design in Figure 6-13 serves as an appropriate transition between tactile and visual textures. Composed of small pieces of tile laid in concrete, the *texture* is the product of the dark lines between the pieces which give each piece individuality and the total surface a visual sparkle. The dark areas, while less obviously

6-13

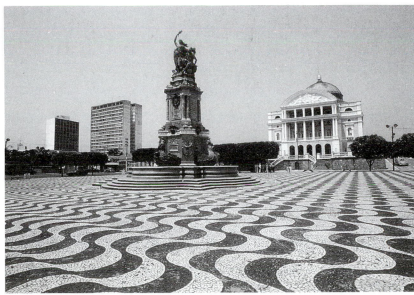

textured, provide the balance and the accent that gives the total surface meaning . Because this is paving on a city square (in Brazil), we think of it as smooth and therefore as *visual* texture, yet if we were to bend down and run our fingers over it, we would undoubtedly sense considerable subtle variation. To carry the assumption further, the same tiles could be laid in a panel of concrete to be used on the wall of a building, and some of the tiles deliberately allowed to protrude further than others to produce shadows that would accentuate the design. The distinction between tactile and visual texture thus becomes a variable, and often personal, interpretation.

And what are we to think of the design in Figure 6-14? This is not inlaid; these casual footprints were made with paint to form an expanse not too different at first glance from the pavement in Brazil. The concept, however, is entirely different. The footprints are not designed as an area for extended use; probably they are

6-14

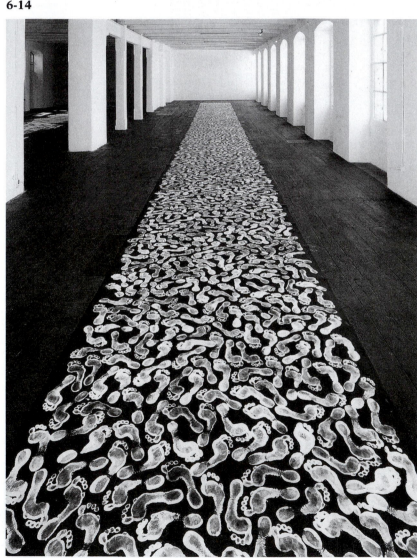

6-14 Richard Long. *Footprint Line*. 1989. Mixed media. Installation view at Galleria Tucci Russo, Turin.

6-15 Kain panjang: batik. Central Java, Jogjakarta. Cotton. Warp 276 cm, weft 105 cm. Los Angeles County Museum of Art (gift of Sylvia, Nanies, and Gordon Bishop).

102 *The Elements of Design*

meant as a whimsical expression of human passage, not as it actually would be if the day-to-day traffic were recorded in this manner, but as a symbolic fantasy we can each interpret in our own way. Meanwhile, they transform the center panel of a wide hallway into a lively pattern. And here we confront yet another of the controversies that flourish in the field of art: What is the difference between visual design and pattern?

Texture and Pattern

The batik in Figure 6-2 has a strong visual texture composed of varied elements: rhythmic lines, open spaces, and areas of *pattern*. These areas are composed of small circles repeated over a large enough space to provide an overall effect of similar shapes. Batik is an ancient technique in which portions of cloth are covered with wax and the cloth then dipped in dye. The dye creeps into cracks in the wax and works in the spaces between the patches of wax in fascinating and unpredictable ways that could not be achieved in any other medium. The small circles in the waterlily batik were produced by deliberate painting of the wax, yet they, too, have an unpredictable quality, revealing at close inspection that few are totally similar in shape. If we think of them as pattern, it is because they are similar enough in size and shape to give the effect of repetition, of orderly distribution.

Let us now consider a batik from Java (Fig. 6-15). This displays a much less arbitrary effect than the waterlily design, for the ovals and symbolic birds are carefully executed. A more determining factor is the careful arrangement of the various *motifs,* or decorative units, which are repeated throughout the length of the fabric. *When the motifs are repeated at regular intervals to create an orderly overall design, the design becomes pattern.* Pattern is not opposed to visual texture; a design may very easily be both. Polka dots of some sizes might readily be considered texture; they certainly are pattern,

6-15

6-16

as are stripes, tartans and plaids, herringbone weave, and floral designs with small enough motifs to be obviously repetitive. The Chinese glass *design* in Figure 6-16 is composed of six motifs. Each motif fills an allotted space *with an orderly repetition* of motifs in such a way that they create diagonal bands. Lively contrast between light and dark backgrounds transforms the bands into stripes which compose an all-over *pattern*. It is important to understand that without the stripes, the individual motifs, placed at regular intervals, would still create a pattern.

Constructed Textures

In drawing, painting, or printmaking, the structure of the *ground* is important because it influences the work upon it. The color and texture of drawing paper shows through the pencil, chalk, charcoal, or ink simply because the medium isn't capable of covering all the declivities between the tiny bumps (Fig. 6-17). Watercolor paper varies from smooth to extremely rough. Many artists prefer a rough surface on which they leave areas of untouched paper for highlights, achieving luminosity by virtue of the paper sparkling through the paint. Oil painters frequently engage in painting *impasto*, laying the paint on so thickly that the canvas is not obvious and the finished surface becomes authentically tactile. All of these textures can be considered as constructed, either by the manufacturers of the *ground* or by the artist who works upon it with purposeful strokes or application.

6-16 Detail of Chinese design on glass. 18th century. Musées Royaux d'Art et d'Histoire, Brussels.

6-17 Carl G. Nelson. *Angel*. 1962. Ink on paper, 39 × 33″ (99.1 × 84.2 cm). Worcester Art Museum.

6-18 Kurt Schwitters. *Merz 199* (detail). 1921. Papers, fabrics, and paint on newspaper, 7¹⁄₁₆ × 5¹¹⁄₁₆″ (18 × 14.5 cm). Solomon R. Guggenheim Foundation, New York (gift, Katherine S. Dreier Estate, 1953).

Early in the century Georges Braque and Pablo Picasso conceived the idea of combining painting and sculpture, thus triumphing over the restrictions of the flat plane. Braque purchased a roll of oak-grained wallpaper and cut out pieces that he then attached to his charcoal drawings. Picasso began his own experiments, and between them they invented a new art form, known as *collage*, which included not only cutout paper but all manner of everyday materials—newspapers, burlap, theater tickets—whatever struck their fancy or had meaning in their lives. These bits and pieces were stuck in oil paint or pasted to drawings, resulting in a surface that had characteristics of both painting and sculpture. Contemporary artists find collage a rewarding approach to individual expression, using colored tissue, broken glass, shells, sand and gravel, twigs, photographic prints, and a multitude of plastic-based materials to create works generally classed as "mixed media." The mixture of elements is assumed to evoke associations, integrating past experiences into the conscious image (Fig. 6-18).

6-17

6-18

Symbolic Textures

An area of texture carries emotional impact just as surely as a spot of color does. To most of us, smooth textures seem cold and remote, something associated with hospitals and sterility, perhaps even ominous. Rough textures, on the other hand, denote warmth as in a stone fireplace in a ski lodge or gentle beauty as in a garden wall, places where we enjoy laying a hand, feeling the variations in surface. Textural qualities attract or repel within a wide range—slimy or prickly, soft or curly. Native Americans in the tribes of Northern California associate the textures of baskets with the spiritual significance of human life. As they state their philosophy, "Baskets stay with you from the dawn of light until the last light touches you. Immediately after you are born, you are placed in a basket. At death a basket is put on your grave and a stake is driven into it in order to release the spirit."[7]

[7]Pam Mendelsohn. "Northwest California Basketry", *Southwest Art*, June 1983, pp. 57-63.

6-19

6-19 United Gulf Bank, Manama. Bahrain. Architect: Skidmore, Owings & Merrill, Chicago.

6-20 Hillary Heminway, designer. Heminway residence, Montana.

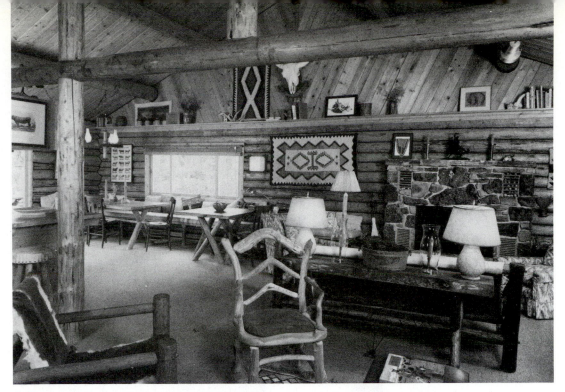

6-20

What we have learned thus far about tactile response can be summed up in the comparison of two examples of texture as an expressive medium. A bank in Bahrain, an island five miles off the east coast of Saudi Arabia, and a cattle ranch in Montana might easily represent the ultimate contrast, geographically, climatically, philosophically, and in practical use. The bank stands in Manama, the capital city of Bahrain and the Arab world's banking center, surrounded by hot dusty desert and light green sea, a place where a zoning ordinance requires every building to have a public arcade to protect people from the sun. We see in Figure 6-19 the ground-floor arcade in which the smaller openings are angled or flared to modulate the daylight. The interior has fabric-covered ceilings, fluorescent lighting, and a pool in the lobby with a tile design reminiscent of patterns in Bahraini weavings. Aside from these textures, the main impression is one of uncluttered dignity, the principal materials being pre-cast concrete, glass, and marble base and pillars at the entrance. The texture is subtle and visual, relying upon the grain of the marble to provide accent to the expanses of concrete. The impression here is of wealth, security, and power. These qualities are primarily an achievement of the architecture, of course, but our present interest can only admire the restraint with which the texture supplements and supports them.

Meanwhile, a family who had traveled widely in the Middle East and Africa built a haven in a wild uncluttered part of Montana. The objective here was a life in the out-of-doors, well-earned respite from the trials of the world, and a working life in a setting filled with both seclusion and beauty. The furniture made from tree limbs reflects the countryside, photographs and artifacts concerning cattle underline the owners' interests, and the relaxed comfort speaks of homecoming after a life of travel or a day in the saddle (Fig. 6-20).

Texture **107**

The textures are rough and warm—Navajo rugs, natural peeled logs, local stone. In both these cases, texture includes not only the quality of individual surfaces but the total effect of each interior.

Before we move on to the *principles* of design it is interesting to analyze how many of the *elements* are involved in creating the distinctive characters of these two buildings. The *lines* are as different as the textures—long, vertical, and virtually unbroken in the bank, short and diverse in the ranchhouse, much like the staccato quality in music. The spaces are equally opposite in character, as are the shapes and forms. Most revealing of all, perhaps, is the contrast in color. The bank, protecting its clients from the sun, presents the coolness of stone and concrete; the ranchhouse, which is surrounded by snowdrifts in winter, radiates warmth from within. Thus we see the way in which the elements of design work together, some more predominant than others according to the design in question, yet all interacting to create a unified harmonious whole.

Summary

As an element of design, texture is unique in its reliance upon the tactile sense. There are two categories of texture. *Tactile* textures are not applied by the artist but *produced* from the structural material on which the texture becomes the surface quality. *Visual* textures are *applied* to an already existing surface, which often plays an important role in the quality of the texture. Texture carries an emotional quality as well as a sensory one and affects us in many ways, many of them symbolic.

Color | 7

Keynotes to Discovery:

additive
subtractive
refraction
diffraction
primary
secondary
tertiary
achromatic
gray scale
hue
value
tint
shade
chroma
intensity
saturation
complements
split complements
analogous
monochromatic
neutral
simultaneous contrast
afterimage

Of all the design elements, color is perhaps the most appealing. It has been called the music of the visual arts, and whenever it is used it undoubtedly has the power to elicit an emotional response not otherwise possible. Although it is not necessary for the creation of a great work of art, color suggests a mood and depth of experience beyond those possible with the other design elements. We speak of the color wheel in the visual arts in much the same way that we speak of the tonal scale in music. Like the basic notes of the musical scale that can be expanded into symphonies, colors can be combined in an unlimited number of ways and have great capacity to manipulate our emotions. Undoubtedly, color is one of the most powerful tools of the designer.

Color is both art and science. Physicists explain the abstract theories of color and its relationship to light, as well as the optical principles involved in color sensation. Chemists formulate rules for mixing and applying colors. Psychologists study emotional responses to specific colors. The artist can work successfully simply by experimenting with color, seeing what happens when certain colors are placed next to each other, when colors are mixed or softened, or allowed to flow into one another (Plate 15). Such explorations can lead to exhilarating discoveries, not only about the use of color but about one's own reactions. There comes a time, however, when one wonders why colors respond to each other in a certain way, why gray or brown results from mixing clear bright colors, why a red seems brighter when placed next to green. For these reasons, anyone intending to work in the field of design will profit by some basic knowledge of color theory.

Color and Light

Without light there can be no color. Things we identify as being red, green, or orange are not innately those colors. Rather, we *perceive* them as being red, green, or orange because of the way our brains interpret the message transmitted by our eyes.

Although the perception of color has psychological overtones, it is fundamentally a neurophysiological process, which means that it makes use of both the nervous system and the physiological apparatus for seeing. The dynamics of color are not yet fully understood,

109

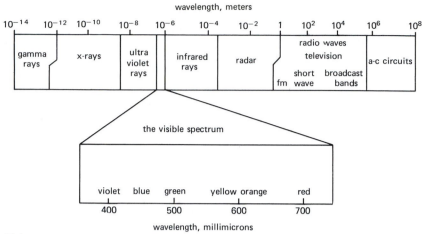

7-1

but we do know that color is actually produced by light as it is broken down into electromagnetic vibrations. What we call light represents only a small portion of the electromagnetic field—the part that is visible (Fig. 7-1). Within that portion, variations of the wavelengths of the vibrations cause the viewer to see different colors. The longest wavelength is perceived as red, the shortest as violet.

Although ancient Greek philosophers asserted that color is not a physical property but a matter of perception, it was not until 1666 that Isaac Newton produced scientific evidence of the fact. As an experiment, Newton directed a beam of sunlight into a glass prism. Since glass is denser than air, the light was refracted, or bent, as it passed through the prism. Newton expected this but he did not expect the light to be dispersed into colors as it left the prism. The short waves in the light were refracted more and the long waves less, and as they emerged from the prism they arranged themselves systematically into the colors of the rainbow: indigo, blue, green, yellow, orange, and red (Fig. 7-2). There is no purple in the natural spectrum of color, but where the first and last colors, indigo and red, combine or overlap, the result is purple or violet. Realizing this, Newton joined the colors into a circle so the flow from tone to tone would be continuous, thus creating the first color wheel. After separating sunlight into its color components with the first prism, he

7-1 Diagram of electromagnetic field.

7-2 Diagram of a prism.

7-2

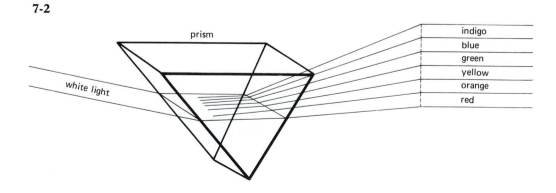

used a second prism to reverse the action of the first. The colors fused again into sunlight. This established that color is, basically, sunlight, and further that *in light* all colors mixed together result in white.

The Impressionist painters of the late nineteenth century sought to divorce art from intellectual interpretations, to paint what we actually see rather than what we think we see. If we know a house to be red, we might logically paint it exactly the same red all over, when in fact the light striking it would produce many different reds and perhaps other colors as well. The Impressionists, then, tried to see forms in terms of shimmering light and color, breaking up visual images into tiny dabs of colored paint (Plate 16). They abandoned hard lines and edges, believing that these do not really exist in nature but are supplied by our reasoning process. The aim was to bypass the brain, to translate visual impression directly into sensory experience.

The sparkle of Impressionistic painting is the result of painting primarily in sunlight. We must realize that diminishing daylight has a marked effect on our perception of color. A closet filled with bright-colored clothes becomes totally dark if we enter the closet and shut the door. However, the darkness is not black. Generally speaking, darkness, indoors or out, is not black but more akin to deep gray space. The effects of evening light, cloudy days, fog, storms—all of the variations in climate and light—have a significant effect on our perception of color. This effect is one of the fundamental challenges to the realistic painter and an element that requires consideration in any design involving color. Will the work be viewed indoors or out, in natural or artificial light, during the day or primarily throughout the evening?

Additive and Subtractive Color

Although the mechanism by which surfaces produce color is not thoroughly understood, it can be assumed that it has to do with the molecular structure of the surface, since inorganic compounds are generally colorless in solution, and the hue of organic compounds can be changed by altering them chemically. Most colors seen in everyday life are caused by the partial absorption of white light. A surface we call red will absorb all the rays *except* those from the wavelength that produces red, so we perceive red. When light is totally absorbed by a surface, we see black.

Refraction and Diffraction

Many factors influence the way in which light is absorbed or reflected, including the texture of a surface and the direction of a light source. Light waves passing through the prism are *re*fracted, or bent, from their original course. Colors in a soap bubble or raindrop result from *di*ffraction, in which a wave of light, after passing the edge of an opaque or solid object, breaks or spreads out instead of continuing in a straight line. The blue of the sky is the result of

the scattering of short-wavelength blue components of sunlight by tiny particles suspended in the atmosphere. A tree in the sunlight seems a different color on its shaded side, and its leaves display a tremendous variation in color, depending upon the way in which the light strikes them.

Light and Pigment

Additive color is color in direct light. This is a scientific theory and becomes highly complex, particularly when pursued with computerization, in which one color can be given thousands of variations and color relationships are altered and intensified.

Subtractive color is color in relation to pigment, or to any surface that absorbs wavelengths of color; in other words, to *reflected* light. This is the area that concerns the artist. It may be helpful to note a few distinctions between the two.

Plate 17 demonstrates the additive principle. In light, three colors are considered to be *primary* in that all other colors are derived from them. The three primaries in light are *red, blue,* and *green.* When these colors are combined or overlapped, they form *secondary* colors: magenta from red and blue, cyan (a turquoise blue) from blue and green, and yellow from red and green. When all six of these colors are combined, as in the center of the rectangle, they add up to white light.

We see at once the difference between this approach and the experiences we have had with color in school projects. For one thing, red and green would never form yellow in paint or crayon. For another, no amount of paint mixed together, whatever its colors, is going to produce white paint. The most likely result would be a muddy gray or brown.

Plate 18 demonstrates the subtractive principle whereby the process is reversed, and thus comes closer to the reactions with which we are familiar. In this case yellow, cyan, and magenta are considered primary colors. When they are overlapped, they do not add color but those wavelengths that we do not see. The result is that the overlapping colors look like the primary colors with which we began in Plate 17. The process of subtraction is completed when all six of the colors are combined in the central rectangle. Here we have not white but black, which is actually the *absence* of all color.

The field of color experimentation is still very much alive, with possibilities enormously expanded by the computer. People who work professionally with color have strong personal feelings on the subject, and many have developed individual theories and formulas to serve their needs. The history of painting is enlivened by groups of painters with innovative color theories or with distinctive ways of seeing and using color.

Color Theory

For many years, students learned color theory on the basis of studies begun in the eighteenth century and culminating in the work of American physicist Herbert E. Ives in the late nineteenth

7-3 The gray scale.

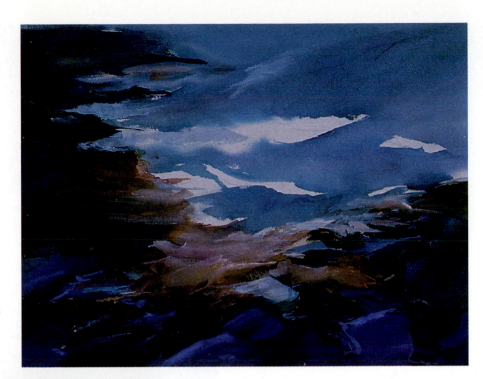

Plate 1 Lila Lewis Irving. *Deep Cove, Grand Manan Island, New Brunswick.* Gouache, 22 x 30″. Courtesy the artist.

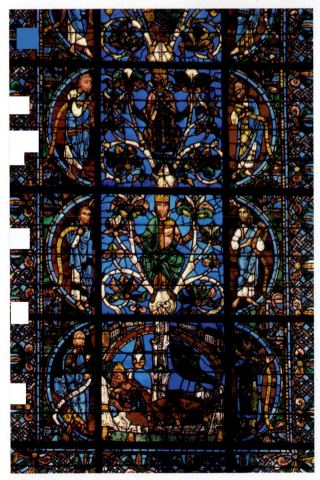

Plate 2 *Tree of Jesse* window (detail), Chartres Cathedral.

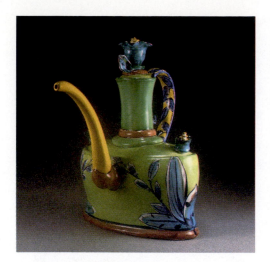

Plate 3 Linda Arbuckle.
Teapot. 1992. Majolica on
terra-cotta, thrown and
altered, 13 x 12 x 9½."
Courtesy the artist.

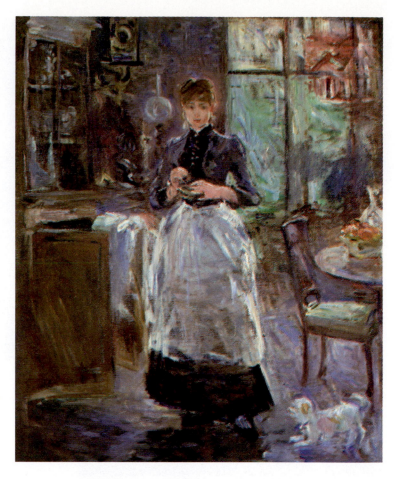

Plate 4 Berthe Morisot.
In the Dining Room. 1886.
Oil on canvas, 24⅛ x 19¾"
(.613 x .500 m). National
Gallery of Art,
Washington, DC (Chester
Dale Collection).

Plate 5 Dennis Albetski.
Red Covering. Watercolor,
28½ x 38¼." Courtesy
the artist.

Plate 6 Graffiti gloats over the demise of Checkpoint Charlie, Berlin Wall, 1990.

Plate 7 Islamic script is featured as a tile decoration in the entrance to a mausoleum in the Shahi-Zinda Complex, Samarkand.

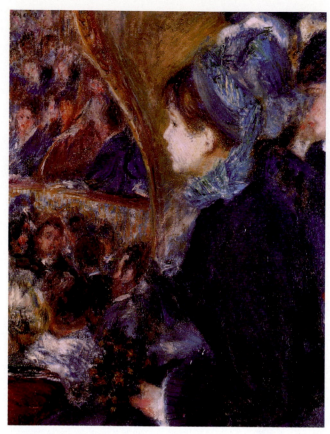

Plate 8 Pierre Auguste Renoir.
*La Première Sortie (The
First Outing).* 1875-76. Oil
on canvas, 25½ x 19¾″
(65 x 60 cm).

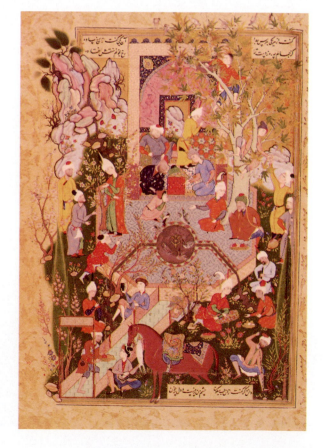

Plate 9 Haft Awrang of Jami.
A Father's Discourse on Love.
16th century. Manuscript
illumination. Freer Gallery
of Art.

Plate 10 Rembrandt Harmenesz
van Rijn. *Deposition from
the Cross.* Hermitage Museum,
St. Petersburg.

Plate 11 James Turrell. *Daygo.*
1990. Light into space,
dimensions variable.
Courtesy Barbara Gladstone
Gallery, New York.

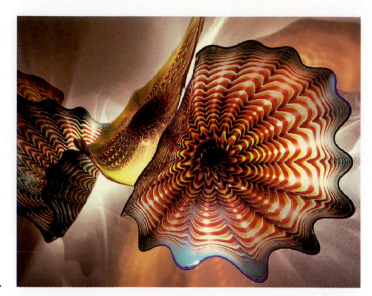

Plate 12 Dale Chihuly. *Persian* series wall installation. 1991. Glass.

Plate 13 American Handweavers Competition 1992. Clockwise, bottom to top. 1st prize, warp: worsted wool, wefts: hand-dyed rayon boucle yarns and cotton yarn, woven on jacquard loom from early 1900s, by Tracy Leigh Hazzard, Pittsford, NY. 2nd prize, cotton and rayon, woven on 16-harness Compu-Dobby, by Paige T. Berrien, Atlantic Highlands, NJ. 3rd prize, warp: worsted wool, wefts: silk and cotton, 4½″ repeat, 96 ends per inch, woven on jacquard loom from early 1900s, by Owen Sea Luckey, Branford, CT. 4th prize, wool and rayon, woven on AVL Compu-Dobby, by Elizabeth C. Tapper, Toledo, OH. 5th prize, 100% mercerized cotton, woven on AVL 16-harness Compu-Dobby, by Lisa A. Olson, New York, NY.

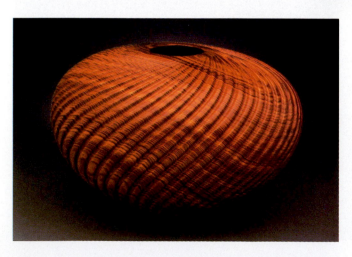

Plate 14 William Hunter. *Dalbergia Rhythms/Cocobolo.* Wood, 8 x 12.″ Courtesy Banaker Gallery, San Francisco.

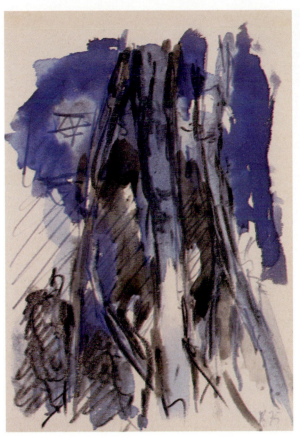

Plate 15 Georg Baselitz.
Sachsische Motive. 1975.
One from a series of 54
watercolors, each 9 x 6¼″
(23 x 16 cm). Courtesy
Michael Werner Gallery,
New York and Cologne.

Plate 16 Claude Monet. *Woman
with a Parasol – Madame Monet
and Her Son.* Oil on canvas.
National Gallery of Art,
Washington, DC (Collection
of Mr. and Mrs. Paul Mellon).

Plate 17 Additive principle of color combining (light).

Plate 18 Subtractive principle of color combining.

Plate 19 Traditional color wheel by Herbert Ives.

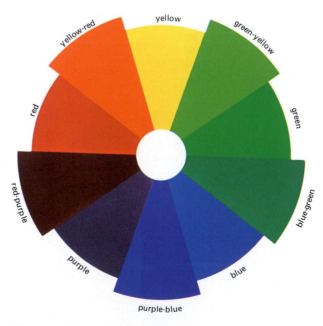

Plate 20 Munsell Color Wheel.

Plate 21 Munsell Color Tree.

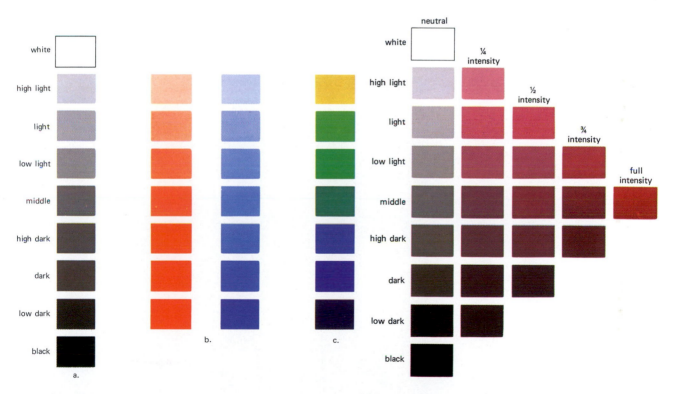

Plate 22 Value scale for hues in the color wheel.

Plate 23 Intensity or chroma scale.

Plate 24 Home designed by Betsy McCue Train.

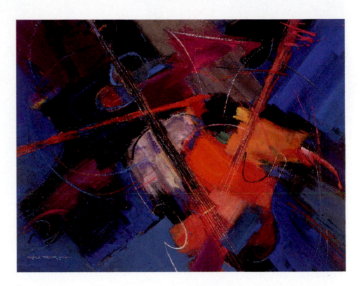

Plate 25 Maxwell Desser. *Music Series: Seriatim #54.* Watercolor – acrylic, 29½ x 39½." Courtesy the artist, AWS, VP, ANA.

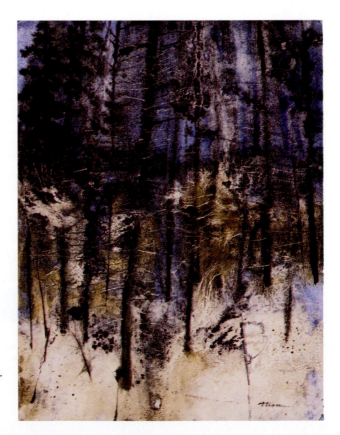

Plate 26 William Thon. *Winter Twilight (#972)* Watercolor, 27 x 20½." Courtesy Midtown Payson Galleries.

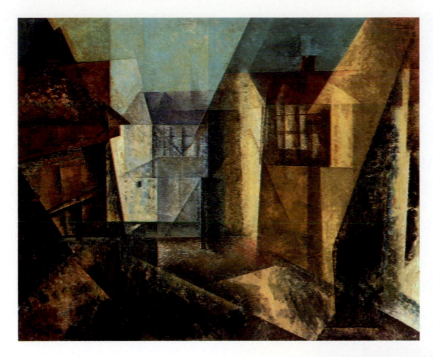

Plate 27 Lionel Feininger.
Village Street. 1927-29.
Oil on canvas, 80.6 x 101 cm.
The Art Institute of Chicago
(gift of Mr. and Mrs. Sigmund
Kunstadter, 1955.27).

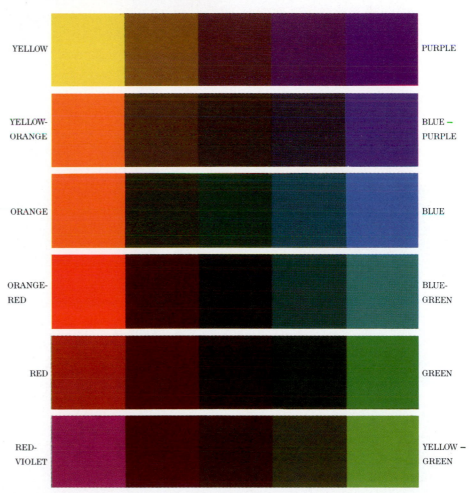

YELLOW	PURPLE
YELLOW-ORANGE	BLUE-PURPLE
ORANGE	BLUE
ORANGE-RED	BLUE-GREEN
RED	GREEN
RED-VIOLET	YELLOW-GREEN

Plate 28 Complementary
color pairs and the
chromatic grays that
result from their mixture.

Plate 29 Experiment in *afterimage.*

Plate 30 Experiment in *reversed afterimage.*

Plate 31 Josef Albers. Plate IV-1 from *Interaction of Color,* revised edition (1975) by Josef Albers. By permission of the Josef Albers Foundation.

Plate 32 Elmer Schooley. *Goodbye Gallinas.* 1978. Oil on canvas, 70 x 80". Collection of Teddy Schooley, Taos, New Mexico. Courtesy Munson Gallery, Santa Fe.

Plate 33 Leroy Setzoil. *First Grid Relief Carving.* 1962. Teak, 27 x 30." Collection of Françoise Campbell. Courtesy of the collector and artist.

Plate 34 Susan Iverson. *Ancient Burial VI – Night Secrets.* 1990. Hand-dyed wool, linen warp. 6' x 7'6." Courtesy Peden Gallery II, Raleigh, NC.

Plate 35 Kazimir Malevich. *Morning in the Village after Snowstorm.* 1912. Oil on canvas, 31¾ x 31⅞" (80.8 x 80.7 cm). Solomon R. Guggenheim Museum, New York.

Plate 36 Ian McKeever. *By Signal Rock.* 1984. Oil and photograph on canvas, 220 x 230 cm. Courtesy the artist.

Plate 38 A porpita jellyfish, free-floating off the Great Barrier Reef, Australia.

Plate 37 Blacked out by the earthquake, stunned San Francisco is lit only by an inferno fed by broken gas lines in the Marina district, October 1989.

Plate 39 John Alexander.
Spring Frenzy [formerly
"Wet Road to Respectability"].
1990. Oil on canvas, 76 x 96."
Private Collection. Courtesy
Marlborough Gallery, New York.

Plate 40 Tony DeLap.
Zanadu. 1991. Acrylic
paint on canvas, wood,
69¹/₂ x 78 x 10³/₄."
Courtesy Modernism,
San Fransisco.

Plate 41 Syrian. Ceramic
tile panel, decorated with
parallel undulating vines
and blossoms. Composite body,
underglaze painted. 33 x 22″
(83.8 x 55.9 cm). Metropolitan
Museum of Art, New York
(Rogers Fund, 1922).

Plate 42 Natalia Goncharova.
Cats (rayist percep.[tion]
in rose, black and yellow).
1913. Oil on canvas, 33¼ x 33″.
Solomon R. Guggenheim
Museum, New York.

Plate 43 Frank Stella.
Empress of India. 1965.
Metallic powder in polymer
emulsion on shaped canvas,
6′5″ x 18′8″ (195.6 x 569 cm).
The Museum of Modern Art,
New York (gift of
S. I. Newhouse, Jr.).

Plate 44 Guest room with
fireplace from Kips Bay
Show House. Designed by
Noel Jeffrey.

century. Ives constructed a color wheel based on red, yellow, and blue as the *primary* colors (Plate 19), from which all other colors were derived. In mixing the primaries on Ives's wheel, one arrived at the *secondary* colors of green from yellow and blue, orange from yellow and red, violet from red and blue. Going a step further, one could mix a primary and a secondary color to produce a third group, known as *tertiary* colors: yellow-orange, orange-red, red-violet, violet-blue, blue-green, and green-yellow. When all of these colors are placed in such a way that they modulate into one another, the basic color wheel results.

Any color wheel is to some extent arbitrary. Ives designed another wheel for use in mixing dyes and pigments, and there are wheels that concern themselves with human vision and the sequence in which we see colors. There are wheels that use eight colors and others that use more than a hundred. There are also variations in the names given the same color. Orange on one wheel becomes yellow-red on another, or violet may become purple. Some theorists discard the idea that color exists in the prism at all, claiming that different colors result from the different frequency of vibrations excited by light in the retina of the human eye.

In 1912 Albert Munsell devised a color theory that has been generally accepted as the most scientific of the systems in use. It has become a standard method of designating color for government agencies such as the National Bureau of Standards, as well as a basis for standards in Great Britain, Japan, and Germany. In this method, color is described in terms of three attributes: *hue, value,* and *chroma* (or intensity). There are five key hues: *red, yellow, green, blue,* and *purple* (Plate 20). Secondary hues thus become yellow-red, green-yellow, blue-green, purple-blue, and red-purple. Munsell's unique contribution lay in using a numerical scale to designate variations in value or lightness and chroma or brightness, so any given color can be defined with precision. Because of the scientific accuracy of this system, we will focus our attention on the Munsell theory.

Color Properties

The color tree in Plate 21 demonstrates visually the properties of color—hue, value, and chroma—as Munsell understood them and their relationships.

Hue is the name by which we identify a color. It refers to the pure state of the color, unmixed and unmodified as it is found in the spectrum. The hue "red" means pure red with no white, black, or other colors added. Hue is the basis for all other color properties.

Value refers to the relative lightness or darkness of a color. It can best be understood by a study of the *gray scale* (Fig. 7-3). We show nine blocks, each containing a center circle of the same value but with the rest of each block portraying a degree of gray so that the total scale ranges gradually from white to black. The differences in the center circles are illusory, the result of the changes in background. Since none of the areas has any hue, they are termed *achromatic.* The average person can determine perhaps 30 or 40 gradations between white and black, although a person with high acuity (visual sharpness) might be able to see as many as 150 gradations.

7-3

white

high light

light

low light

middle

high dark

dark

low dark

black

Every color has what is termed a *normal* value. This is the value of the hue when it is seen at its highest intensity. For instance, yellow is always very light when it is most intense, and purple is always quite dark when it is most intense. Therefore, the normal value of yellow is lighter than the normal value of purple. Normal values of red, green, and blue are closest to the middle value scale. The hues are represented in their normal values on the color wheel; however, hues at their normal value can themselves be arranged in gradations of value corresponding to the gray scale (Plate 22).

The reverse process, the conversion of colors into values of gray, occurs in black-and-white photographs (Figure 7-4). In general, values are less noticeable in color photographs and color reproductions of a work, since intensity and hue are more diverting to the human eye.

Color values that are lighter than normal value are called *tints*. Those darker than normal value are *shades*. Thus, pink is a tint of red, and maroon is a shade of red. In mixing paints, the addition of white will lighten value and black will darken it; however, since neither black nor white is actually a color, the addition of either to a color will lessen the chromatic value of that color.

Chroma, also known as intensity, indicates the brightness or dullness of a color. Colors that are not grayed, that are at their ultimate degree of vividness, are said to exhibit *full intensity*, as shown in Plate 23. Chroma is often the most difficult of the color properties for the student to understand. One way of visualizing chroma is to imagine a jar of powdered pigment in any hue and a saucer of oil

7-4 Jeremy Brett as Sherlock Holmes confronts his arch-enemy, Professor Moriarty, played by Eric Porter. Courtesy Photofest.

7-5 Color mixing bowl and pestle.

7-4

into which the pigment will be ground. The oil is poured into a *mortar,* the classic container in which chemists have traditionally mixed their potions, and the pigment is added to it and ground thoroughly by use of a *pestle,* a small club-like implement, until it becomes a thin paste (Fig. 7-5). When the first portion of color is added, the chroma is weak and dilute, but as the amount of pigment is increased, the hue becomes more intense. Ultimately the oil is *saturated* with pigment and therefore with color. In this sense, *intensity, chroma,* and *saturation* may be considered to be synonymous. If, however, the pure pigment is altered when being added to the oil, the intensity is affected. The term *low intensity* means that the pigment has been grayed by the addition of another color or of black or white, and therefore its character has been altered from the original pure hue. Low-intensity colors are often referred to as *tones,* and they include some of the most subtle and useful ranges of color.

Many dark colors are not only low in value but low in intensity. Maroon, in addition to being a *shade* of red, is also a low-intensity version of it. Browns are generally low-intensity, low-value yellow-red. Tan is a low-intensity, high-value yellow-red.

Color theory is the beginning of understanding color. With the properties of color clearly in mind, we may now consider how these properties can be put to use through the relationships of colors to each other.

7-5

Color Relationships

The modulated flow of color around the color wheel has a far greater impact than the aesthetic one in which the wheel resembles a circular rainbow. In actual fact, the position of each color on the wheel has an inherent influence on its role and possibilities.

We naturally assume that any two colors next to each other on the wheel have traits in common; their names establish that fact, such as blue and blue-purple, or green and green-yellow. Adjacent colors are close relatives and can be expected to blend and harmonize with one another. The term for such colors is *analogous. Any two colors adjacent to one another on the color wheel are analogous colors.*

Experiments with all the basic color wheels have shown another interesting fact: Colors diametrically opposite one another on the wheel are as different from one another as is possible—for example, yellow and purple-blue, or red and blue-green. This fact has far-reaching implications for working with color harmonies, and we will explore them shortly. For the moment, however, it is enough to know that such colors are known as *complementary. Any two colors opposite each other on the color wheel are known as complementary colors.*

For purposes of creating color harmonies, another distinction is frequently made. A color on the color wheel has not only its direct complement as a possible partner in creating harmonies, but it has *split complements, the two colors on either side of its complement on the color wheel.* The split-complements of purple-blue, therefore, will be yellow-red and green-yellow, and split complements of red

will be green and blue. These relationships are of fundamental use in formulating and analyzing color harmonies.

Color Harmonies

A color harmony results from combining colors into an aesthetically pleasing composition. This may refer to a great painting, a piece of folk art, the decoration of a bathroom, the choice of clothing, or the arrangement of food upon a plate.

Monochromatic

A monochromatic color harmony is based on a single hue, and it can be one of the most ingenious, varied, and pleasing of color harmonies. The idea of selecting one hue and developing all its possible values, with tints and shades and tones, its full range of intensity, and its possibilities for modulation through slight additions of its analogous neighbors, can be one of the most challenging of design projects.

Neutrals

Technically, a neutral is defined as a color that has no color quality but that simply reflects light. The scientific explanation is that such colors reflect *all* the color waves in light, leaving none for the human eye to see. Under this definition, white, of course, is the ultimate neutral. However, black reflects *none* of the color waves in light, so it, too, has no color quality. With black and white both classified as neutrals, it follows that any mixture of the two would produce modified neutrals—in other words, an entire range of grays or achromatic neutrals. However, from the artist's standpoint, a more satisfactory range of neutrals is formed by mixing complements which, when combined in equal parts, also produce gray. The mixture of any two complements results in a spectrum of *chromatic neutrals,* bordering on gray or on beige, depending upon the hues and on the proportion of each that is added. With so much theory to comprehend, perhaps an example will be helpful.

The home in Plate 24 was designed for an American industrialist with a special affinity to Pompeii who wanted his winter home in Florida to reflect the spirit of the ancient site. The house is based on variations of beige, its open spaces and uncluttered walls evoking an almost monastic serenity. The lively play of light and shade is reminiscent of southern Italy, and the neutral setting provides a complementary background for the discriminating display of artifacts expressing the ambience of ancient Rome. Variations in materials on floors and walls inevitably provide subtle gradations in tone, and the broad stripes on the stone chaise defining the hallway increase the contrast that reaches a climax in the bright cushions. Such accents are a classic device in using neutrals. In this case the earthy red becomes a harmonious supplement to the rosy cast of

the variations of neutral beige. This is monochromatic color harmony at its most effective, carrying neutrality to an extreme but with an underlying tinge of warmth highlighted by single exciting strokes of color.

Analogous

Analogous colors, being next to each other on the color wheel, are obviously the most closely related of all hues, each having something of its neighbor in its composition. Simply reading the color names of any two analogous hues leaves no doubt of their compatibility. In designing a fabric or a room, one can be certain of a harmonious result when using analogous colors; however, there is also the possibility of monotony. Analogous colors, on the whole, will both be in the same range of warmth or coolness, and a room that is all cool—or all warm—can be less than comfortable to live in. The most effective analogous color harmonies often have an accent of a *complementary* color for balance, most generally a small area that acts as a stimulant in an otherwise bland composition. The painting in Plate 25 could never be described as "bland" with its diagonal structure, yet if it were entirely a matter of blues and purples, much of the impact would be lost. It is the bright splash of orange and yellow-orange on the right that makes the composition vibrate, and the linear extensions to the left and upward provide not only balance but a dynamic contrast.

Complementary

William Thon's painting in Plate 26 is a convincing example of the compatibility of complementary colors. At the ultimate distance from each other on the color wheel, purple-blue and yellow provide stimulating contrast, but in Thon's hands they achieve a subtle harmony through muted interwoven tones. Each color has its predominant area but they flow into one another as accent and balance, with the unifying white echoing the blue in the predominantly yellow area and taking on a gold tinge where the forest becomes deep purple-blue. The artist's skill in highlighting and deepening both colors emphasizes the best characteristics of any complementary color harmony—contrast and unity.

Split Complementary

When complements are split, the possibilities for contrast are expanded while the inherent compatibility is retained. Instead of contrasting two colors opposite one another on the color wheel, the artist chooses one color and harmonizes it with the two colors on either side of its complement. For example, if green is used, its split complements will be red and purple rather than the red-purple complement directly opposite on the wheel. In Plate 27 Lionel Feininger uses the same yellow as William Thon, but by splitting its

complement, he uses variations of blue for the light areas and purple for the darks. Here again, the use of a variety of tones and values provides interest, and the blending of the complements throughout the canvas achieves harmony and balance. Warm bright variations of yellow predominate in the foreground buildings, their golden planes reflecting sunlight, while lighter, softer variations of the purple-blue denote buildings in the distance yet achieve balance with a similar area on the pavement in the foreground. In his handling of both colors, Feininger has made generous use of flecks of the contrasting colors to give textural interest to walls and pavements: Flecks of blue-green liven areas of yellow while orange and yellow texture the planes of blue-green. The fundamental harmony can be named (split complementary) but it is the artist's virtuosity that gives the painting character. Here, perhaps, we have the most important fact about color harmonies. The terminology is merely a means of identifying and categorizing what the artist knows instinctively.

Color Interaction

Color harmonies provide a framework for the use of color, but the interactions between colors present an extensive field for exploration, leading to confidence in mixing, combining, and creating with color. For the designer, perhaps the most important area of color interaction is found in the effects that complementary colors have upon each other. We have just seen that they have an affiliation that makes their use together harmonious, but there are other aspects to their relationship that are vital to anyone working with color in any form.

Interaction of Complements

As we mentioned earlier, when two colors directly opposite each other on the color wheel are mixed in equal parts, the result is a neutral, usually a variation of gray. We stress this phenomenon because it is fundamental to the art of mixing color. Grays resulting from the mixing of complements retain the color quality of both complements and can be modified infinitely by the variations of proportion in the mixture. Red and blue-green mixed equally produce gray, but if a fraction more of red is added, the gray becomes warm, even rosy. If the green predominates, the result will be a cool gray. We saw warm beiges in the house in Plate 21 that would have been mixed in this way with slightly more orange added to the gray mixture. An entire range of grays would be different from one another if mixed from different pairs of complements (Plate 28). If lighter values are desired, yellow may be used; if greater depth is required, purple can be the answer. It is, of course, possible to lighten or darken with white or black, but one must remember that there will be a certain amount of chroma or color intensity lost with the use of either white or black. This is not necessarily undesirable. Mixing color is a matter of experimentation, and results vary with

the chemical composition of the paint, with the light where the final result is displayed, and with the individual peculiarities of the human eye.

Simultaneous Contrast

The graying effect of mixing complements becomes even more tantalizing with the discovery that placing complements next to each other has exactly the opposite effect. *Complementary colors mixed together produce gray, but complementary colors placed next to each other become not grayer, but more intense.* Josef Albers, one of many specialists who have made careers of studying color, has left us a series of experiments that make this phenomenon clear.

If you look at Plate 29 you will see two circles, one red and one white, each with a small black dot in the center. Fix your eyes on the dot in the center of the red circle and stare at it for half a minute. When your eyes have become thoroughly used to the red circle, quickly switch them to the white one, focusing once more on the little black dot. If you have the usual reaction, you will see a circle that is not white but blue-green, the complement of red.

Albers reasoned that this reaction is due to the fact that the human eye is tuned to receive any one of the three primary colors of red, yellow, and blue (as perceived in light rather than on the color wheel). Staring at red fatigues the nerve ends in the retina so that a sudden switch to white (which consists of red, yellow, and blue) will register only a mixture of yellow and blue, which in this case appears as blue-green, the complement of red. The complement thus seen is called the *afterimage.*

This theory of the tiring nerve ends in the retina would explain the increased intensity of adjacent complements. If circles of red and blue-green are placed side by side and the eye concentrates on the red until the nerve ends tire, the eye, when moved to the blue-green, will perceive only the blue and yellow mixed together. The blue-green will therefore be of maximum intensity.

Albers stated unequivocally that color is the most relative medium in the field of art. Not only does human perception of color differ widely, the scientific aspects are still very much in question. However, theories such as simultaneous contrast give us clues as to how colors will react when used in design.

Many interior design problems have arisen from the purchase of a single object that looks wonderful in the shop but changes entirely when set in the room for which it was intended. Any combination of colors, from everyday clothing to a stage set for an opera, should be considered in its totality and, if possible, under varying conditions of light, before final decisions are made.

The illusory quality of color is demonstrated by another experiment that Josef Albers termed *reversed afterimage.* Look at the yellow circles in Plate 30. Once again, fix your eyes upon the circles, staring fixedly for half a minute or so.

Now shift focus suddenly to the white square below the circles. One might logically expect to see purple or blue circles (the complement), but this is not the case. One does not even see circles, but the curved diamond shapes resulting from the difference between the

circles and the squares. These are not in the complement but are yellow. Albers characterized this as a double illusion and gave it the name *reversed afterimage* or *contrast reversal.*

Interaction of Analogous Colors

Since complementary colors produce a neutral when mixed in equal parts, we can conclude that colors farthest from each other on the color wheel lose the most reflective light when mixed. Conversely, colors adjacent to each other (analogous colors) will retain the highest degree of reflective light, or intensity, when combined. This is an important aspect of mixing color. For instance, an equal mixture of yellow and blue makes green. A mixture of yellow-green and blue-green also makes green. If the intensity of all original hues is equal, then the green made from yellow and blue will be duller than the green made from yellow-green and blue-green, which are closer to each other on the color wheel. The greater the distance between two colors on the color wheel, the more the intensity of their mixture will be lowered. On the other hand, the closer colors are placed to one another, the more their differences increase. This applies not only to hue but to value and intensity as well.

Color Interaction and Tonality

Tonality is defined as the relationships of color within a composition or design, and it obviously is closely akin to the interrelationships we have been considering. The limitless possibilities can be demonstrated by one more of Josef Albers's experiments, as shown in Plate 31. In this instance, Albers has placed two squares of neutral gold in two positions, one surrounded by two cool blues of different value, the other—a square of identical size and color—surrounded by two warm colors, a yellow and an orange. The effects of the adjacent colors are dramatic: Surrounded by blue, the square becomes lighter and more gold, whereas when flanked by yellow and yellow-orange, it becomes dark enough to be considered light brown. In Albers's own words, "Color deceives continually."

The Psychology of Color

Psychologists have long known that certain colors have the power to evoke specific emotional responses in the viewer, partially because of symbolic associations with warm and cool and all the reactions this psychological temperature involves. Color stylists make careers of designing color harmonies for subways, factories, hospitals, airports, and other public buildings, and their services depend upon a thorough knowledge of the relationships of color to human reaction.

In general, warm colors stimulate and cool colors relax. Doctors' offices are usually painted in light blue or green, and restaurants and bars are more apt to be decorated in warm colors to

stimulate appetite and thirst. Employers have discovered that workers suffer from chills when working in blue surroundings and that they produce at higher levels when stimulated by bright colors. Although cats and dogs are color-blind, insects react emphatically to color. Mosquitoes avoid orange but approach red, black, and blue. Beekeepers wear white to avoid being stung, for they have found that if they wear dark colors, they are besieged. The knowledge that flies dislike blue has helped the meat-packing industry.

Color theory provides infinite material for design, making possible combinations previously considered incompatible simply by varying the values or chroma of individual hues. The interior designer can learn much from the master painters who for centuries have been creating atmospheric effects, distance, time of day, or geographical flavor by skillful use of hue and tonality.

Beyond general shared responses to color, each individual may react in a personal way to particular hues. Each of us brings to the perception of visual stimuli a collection of experiences, associations, and memories that may be triggered by a given color. This could be the color of one's room as a child, or the color of the sky on a special fondly remembered day. Color can evoke strong responses, pleasant or unpleasant, and even the viewer does not always understand the reason for the response.

Color and Space

The *local color* of an object is the color of its actual surface, as opposed to the color that it appears to be when placed in colored surroundings. We are all aware of the manner in which shiny surfaces reflect the colors within visual range of the viewer, and dull surfaces may also have a reflective quality that is less obvious but nonetheless modifies the "feeling" of a room. Objects with warm local color appear to be closer to the viewer than cool objects do, and they may seem to be larger as well. An overlarge chair or sofa seems less overwhelming if upholstered in a dark cool color; a chair too small for the room gains importance from a bright warm tone. Small rooms seem larger if their walls are light in tone—whether warm or cool—and rooms that feel too spacious take on a degree of intimacy with judicious use of darker hues. Large country homes in Europe, whose spacious rooms and high ceilings seem out of touch with contemporary life, are frequently given walls of deep red to pull the furnishings into a livable unit. A single wall of dark green or blue is a useful device in any room that seems unduly large.

Balance of Color

Any hue can be made to harmonize with any other hue or group of hues, simply by the use of the proper value or gradation. Two hues that are said to "clash" with one another at normal value can be blended into subtle harmony by graying one, or both, into pleasing tones, or by making one very dark and the other bright and light. We have seen how shapes interweave with space, and spaces with each other, in order to create pattern. In the same way, colors

must interweave and balance, in warmth and coolness, in subtlety and intensity, in lightness and darkness. A single stroke of contrast may be the difference between a mediocre design and a masterpiece, and a light graying of tone may transform a crude work into a distinguished one.

Physicists can analyze color composition, and psychologists can tell us something about how the human mind perceives it. Color stylists manipulate color's physical and emotional effects. It is the designer who synthesizes all these reactions and reveals perhaps the most important of the many aspects of color, its effect upon the human spirit.

Summary

Color has three properties: *hue, value,* and *chroma.* Hue is the color as it appears on the color wheel, value is the comparative lightness or darkness of a color, and chroma (or intensity) is the brilliance or purity of the color. The Munsell color theory is based on a color wheel with five key hues: *red, yellow, green, blue,* and *purple,* all at their normal or middle value. A *tint* is lighter than the normal value and a *shade* is darker than the normal value. Any two colors next to each other on the color wheel are *analogous.* Colors opposite each other on the color wheel are *complementary.* A *monochromatic* color harmony is based on one color. Neutrals are grayed colors or tones. *Achromatic neutrals* have no color properties, being mixed from black and white. Neutrals mixed from complementary colors are known as *chromatic neutrals.* A color harmony is a combining of colors into an aesthetically pleasing composition. *Tonality* is defined as the relationships between colors within a composition or design.

The Principles
of Design

Unity and Variety | 8

Keynotes for Discovery:

chiaroscuro

In exploring the *elements* of design, we have been aware of ways in which the artist uses each element to achieve a desired effect. Starting with a blank sheet of paper, the designer *places* a line, a shape, color, and other elements to create a design. The designer does not, however, *place* principles. The principles evolve as the design develops, and the designer *achieves* them by the choices made in the process. The designer achieves *balance* by attention to placement of elements and establishes *rhythm* by use of line, color, and shape. Similar considerations determine the development of the other principles. Another way of expressing it is that the elements are the ingredients of a design and the principles represent the recipe by which the ingredients are combined.

The Partnership of Unity and Variety

We begin our consideration of the principles of design with unity because it is the most fundamental of the principles. Like integrity, unity denotes wholeness. Whatever other principles may direct a work, if the final result does not hold together as a convincing sum of all its parts, it cannot be considered a successful design.

We balance our analysis of unity with a survey of the many kinds of variety, for unity and variety are particularly interdependent. Perhaps the ultimate in unity can be attributed to the work of painters who flood a canvas in a single color or its variations, forgoing variety of any kind (Fig. 8-1). In its true sense, however, unity is not the *absence* of elements but the synthesizing of elements into a harmonious whole. The extreme opposite of Figure 8-1 can be seen in Figure 8-2, the work of Jean Dubuffet who, working at the turn of the twentieth century, initiated a style known as *"l'art brut"* (art in the raw). The objective of such art was a kind of defiant spontaneity which Dubuffet considered superior to the refinement of the professional artist. Here again, the work is not an authentic example of variety because its deliberately chaotic quality goes beyond the usual meaning of the term. An effective design falls somewhere between these two examples, achieving harmony through a balance of unity and variety.

125

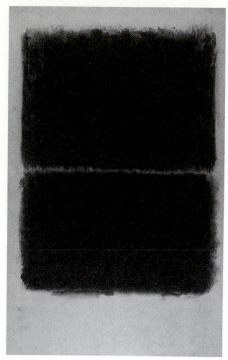

8-1

8-2

8-1 Mark Rothko. *Light Red over Black*. 1957. Oil on Canvas. Tate Gallery, London.

8-2 Jean Dubuffet. *Mire G66 (Kowloon)*. 1983. Acrylic on canvas-backed paper, 26¼ × 39¼″. Courtesy The Pace Gallery.

8-3 Minor White. *Capitol Reef, Utah*. 1962. Photograph (gelatin-silver print), 12⅛ × 9¼″ (30.73 × 23.5 cm). Courtesy Minor White Archive, Princeton University.

8-4 Black mussels exposed at low tide.

The Meaning of Unity

The term "unity" has extensive associations; an exploration of its philosophical implications will be helpful in understanding its role in design. Two people who agree on something are said to be in unity. "Community" from the Latin *communitas* denotes a group with a common organization or interest, in other words, unity in a fundamental aspect of their lives. A metaphysical use of the word "unity" implies the sense of feeling a part of all creation, of being at one with the universe.

The Role of Variety

In respect to the partnership of variety with unity we have only to consider the human race—people of many colors, sizes, and shapes, widely varied in geographical background and cultural viewpoint, yet all with the same biological functions: the heartbeat, breathing, the need for food and rest. These same people also possess a broad philosophical unity in the need for religion, ranging from devotion to tribal gods through major worldwide belief systems—yet all unified by the fundamental assumption of a governing power for the universe and the necessity for a code of morality. If we accept the concept of unity and realize that differences provide variety rather than grounds for dissension, we begin to grasp the relationship between life itself and its expression through human design.

Variety in nature seems obvious as we glance at trees and fields, forests and rivers. Actually, these manifestations are only superficial indications of the variety that rewards investigation. A river hosts an aquatic world ranging from the algae that covers its surface to the muskrats that burrow along its edges; a field, surveyed at close range, reveals a world busily humming with the projects of insects, animals, and plant forms. When we walk through a forest, the variety is infinite; to the eye of the artist, even a wooded hillside becomes a rich tapestry of color and texture (Plate 32). A mountain may seem the ultimate in unified form, yet when we approach it we find unimaginable variety, as in Minor White's photograph of the cliffs of Utah in Figure 8-3. When we see a rock at the seashore we may look closely and find it covered with an elaborate texture of edible mussels, filled with variety of color and sheen from the effects of light and moisture (Fig. 8-4). After exploring nature, the task of the designer becomes not so much one of stimulating unity with variety as of unifying the variety that provides inspiration all around us.

Contrast

The essence of variety is contrast: rough against smooth, light against dark, large against small. In Figure 8-3 the photographer used dramatic lighting to emphasize all of these. The result is a fascinating interplay of shapes and textures whose relationships seem to shift as we watch. Lights and darks flow dramatically throughout, unifying the rugged surface into a harmonious composition.

8-3

8-4

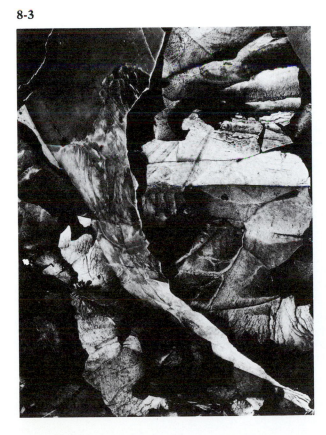

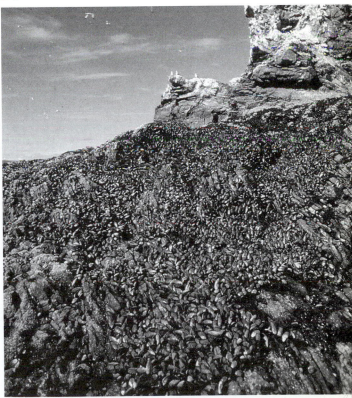

The shapes and textures of stone seem to have been translated into clay in the vase in Figure 8-5. Outlines are as rugged as though they were formed by erosion, and deep cracks seem more typical of geology than of human hands. The overall effect is organic, a segment of the earth interpreted by a potter sensitive to the essence of the material. Not only does the work have both variety and unity, but we see universal unity implicit in the fact that the vase, originating with a designer in Hungary, catches the same qualities as the cliffs dramatized by a photographer in Utah.

Variety through Structure

We have seen variety through shape and texture, but sometimes variety is a result of fundamental structure. The panel in Figure 8-6 is composed entirely of small sections of brass upon a rectangular sheet mounted, in turn, on wood. Although the designer has embellished the brass with both surface treatment and paint, variety predominates in the structure into which the sections have been composed. All square, they vary in size as well as height. Small squares cluster, divided by a linear flow of background space. Variety is emphasized by light paint that edges the squares and extends to border and background areas. By thus articulating the *variety,* the artist has accomplished, as well, a fundamental *unity.*

Philosophically, the unity apparent in the woodcarving in Plate 33 goes far deeper than the work itself. Trained in both theology and philosophy, the artist spent many years seeking his true calling, ultimately discovering it in an obsession with the character of wood. The work shown was the turning point; while attempting to clear away the top layer of wood in order to begin relief carving, he realized that the saw lines and chipped areas had a beauty that

8-5

8-5 Karoly Szekeres. *Vase I.* 1991. Porcelain, 23 × 13 × 4″. Courtesy Clay Studio, Philadelphia.

8-6 Zoltan Kemeny. *Banlieue des Anges (Suburb of Angels).* 1957. Patinated and painted brass relief of square tubular sections on a rectangular sheet, the whole mounted on wood, 26½ × 37¾ × 3″ (67.5 × 96 × 8 cm). Tate Gallery, London.

8-7 Smolensky Cathedral, Novodevichy Monastery, Moscow.

8-6

could be developed into symbols for life and growth independent of human domination. His vertical divisions anchor the teak into a unified composition to which the vocabulary of natural forms such as knotholes, buds, and other irregularities of growth contribute a rich variety of texture and personal meaning.

Variations on a Theme

One of the most certain ways to combine unity and variety is by the exploitation of a single motif, developing it in a variety of ways. Just as many great symphonies begin with a simple melodic theme and progress through harmonizing variations using different instruments, so many visual designers find fascination in exploring all possible variations on a simple shape. Built in the heart of old Russia, the church in Figure 8-7 reveals its genealogy immediately by its use of the onion dome. Variations on this form are found throughout the architecture of Czarist Russia, and the Smolensky Cathedral combines several. Beginning with the decorative rooflines, the motif becomes a narrow dome encrusted with diamond-patterned gold leaf, bulges into dark bulbous forms, and reaches a climax in a combination of the two topped with a large golden ball. White walls contrast with the black and gold, which is elaborated into intricate edging underlining each dome and becoming an allover wall pattern beneath the diamond tower. The series of crosses provides both symbolic and visual unity.

8-7

8-8

8-8 Maria Plachky.
Modulation Centrale.
Tapestry, 10′2″ × 10′2″
(3.09 × 3.09 m).
Courtesy the artist.

8-9 Gourd-shaped water bottle.
Before 1930. Possibly
Abarambo peoples, Zaire.
Fired clay, incised and
impressed decoration, natural
pigment. 11½ × 8½″
(29.2 × 21.6 cm). National
Museum of African Art
(Ex-collection Count Maurice
Lippens, purchased with funds
from the Smithsonian
Collections Acquisition
Program).

8-10 Robert Sperry. *Plate #989*.
1991. Stoneware, white slip
over black glaze, 27½″ diameter.
Courtesy the artist.

The diamond-shaped pattern on the roof of the Smolensky Cathedral is echoed in the striking tapestry created in Vienna (Fig. 8-8), which becomes a masterpiece of elaboration on the theme of the triangle. Using a shape older than the pyramids, Maria Plachky creates a contemporary expression that is fresh and vibrant. Just as the triangular shape thrusts to a sharp tip, the composition radiates outward in an orderly progression from the square area in the center, the triangles varying in size and proportion to imbue the entire surface with movement.

The Achievement of Unity

Having explored a few of the ways of achieving variety, we will now reinforce the concept of unity. It should be obvious that variety can be attained through contrasts in all of the elements we have studied: contrasting colors, shapes, lines, spaces, forms—all provide variety to the degree that the contrast is pursued. Variations on a theme are actually a matter of contrasting a single shape, color, or other element by altering it into interesting variations.

Achieving unity follows much the same pattern in using the elements of design as tools for making a work harmonious. There are other means as well, and we will touch on them as preparation for creating unified designs.

Unity through Line

The African water bottle in Figure 8-9 is an excellent example of variety in shape and would be interesting without any textural treatment whatever. The potter, however, has given it the refinement of both texture and unity by the use of a linear surface design. Most noteworthy is the fact that the lines do not simply follow the form of the vessel as a means of making it more tactile. Instead, the lines on the curving body repeat the shapes of the handles, and the areas above the handles echo the same patterns in alternating areas that provide additional interest. In her sensitivity to the shape itself, the potter has provided total unity by her handling of the linear texture.

The linear element is even more obvious in the plate in Figure 8-10 where the surface design echoes and amplifies the fundamental circle of the plate itself. The designer has exercised considerable ingenuity in his treatment of the lines, creating a variety of textures that are accentuated by the black and white of the glaze. Beyond the textural variety, however, he has allowed the lines to flow out of the plate in three places, expanding the concept of movement and radiation. The overall effect is one of variety and interest, but unity is integrated in the basic swirl and flow that simply elaborate on the form of the plate.

8-10

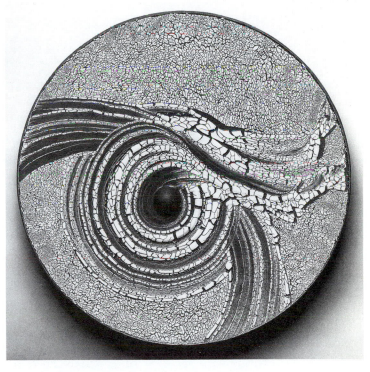

8-9

Unity through Shape

Any textile has a fundamental unity because of the fibers that form the framework of the fabric, regardless of the woven design. In Chapter 6 we noted five works whose unusual treatment of fibers provided a variety of textures. In Plate 34 we see a textile whose fibers form the basis for a striking design based on the woven shapes. Although the composition is divided into thirds with the center third marked by strong verticals, the dominating theme is one of leaping flames and startling contrasts in color and value. Close inspection reveals blocks of background pattern consisting of broad serrated lines that become angular extensions of the flamelike shapes. Variations in value form an important element of contrast, playing dark shapes against light, in an expression as dramatic as the title.

Somewhat similar shapes provide unity in an entirely different type of work in Figure 8-11. The man who composed this oil painting specializes in depicting scenes from unusual angles, giving an expansive view that stimulates the viewer into new associations. In this instance he rises high above the landscape of New Mexico, implying endless space beyond the borders of the canvas, stylizing the

8-11 Julio Larraz. *North of Roswell*. 1991. Oil on canvas, 64 × 80½″. Courtesy Nohra Haime Gallery, New York.

8-11

barren hills into a rhythmic pattern. The shadows of the hills serve as both accent and structural basis, as though the unified shapes were strung upon it in sequence, the smaller foreground forms amplifying into a unified climax.

Unity through Color

The painting in Plate 35 is noteworthy for several reasons. It is the work of one of the leaders of the avant-garde in Russia that flourished before the Revolution, a man who was self-taught, depicting peasant life as he knew it in a Russian village. He has caught all of these elements in the work, with its stylized treatment of forms and his unique development of rhythms in a landscape obviously his own. The colors are eloquent of Russian winter in their blue-white coldness, unified by the rhythmic distribution of darks among the drifts of white. Circular forms of drifts, trees, and smoke from chimneys form other unifying elements. Most striking, however, is the artist's unexpected use of the complementary color, red-orange, with which he touches the distant sky, molds the cloaks of the peasants, and deftly accents the edges of walls and rooftops. This master touch not only gives the painting an appealing vitality, it unifies the varied notes of landscape, architecture, climate, and people into a glowing harmony that rises above the chill of winter.

A different landscape is the subject of unifying color in Plate 36, a work diverse by nature, being a combination of photography and oil painting. Here we see a Gaelic wilderness depicted by a young man devoted to divesting landscape painting of the romantic allusions prevalent in English painting early in this century. Spending long periods sketching and photographing wild and remote places, he was determined to force the viewer to *participate* in the landscape rather than standing back and viewing it through traditional veils of illusion. Accordingly, he presents a deep thicket, almost ominous in aspect, but adds a personal interpretation of beauty through the filigree of lines and patterns in soft blues and roses painted upon the photographic surface. The two media are thus combined in a balance in which neither dominates, and the total effect is unified by the flow of soft color that permeates the composition.

Unity through Repetition

When we speak of repetition we think of pattern and texture, as we discussed them in Chapter 6. Unity is inescapable, of course, in allover pattern in which similar motifs are repeated throughout. However, it is important to consider the role of repetition in more complex designs. In Figure 8-12 we see a work in which repetition plays a complex role. The material is cotton webbing, which is of itself composed of tiny units forming an overall pattern. The webbing

8-12

is plaited, resulting in a series of undulations that create lights and shadows. These undulations provide another set of repetitions horizontally across the composition, amounting to a pattern composed of stylized waves. Finally, the structure of the work establishes its own pattern because it consists of six vertical panels, all essentially identical. As a wall hanging, a screen, or a space divider, such a design offers a fascinating accent. There is lively pattern and flowing rhythm, culminating in variety that is unified through the various repetitions and the structrural design itself.

If we look carefully at the watercolor in Figure 8-13 we discover extensive variety. No two of the heavily outlined parallelograms are identical in shape, the two small ovals are differentiated by value, and the circles are not the same size. Moreover the entire surface is broken into rectangles that vary not only in size but in color and texture. Here the repetition is not of exact shapes but of fundamental characteristics, yet such repetition becomes a strong unifying force.

8-12 Sherri Smith. *Galaxy*. 1985. Cotton webbing, plaited, 53 × 84 × 1″.

8-13 Todd McKie. *Slide Show*. 1978. Watercolor on paper, 24-⅞ × 21-⅛″ (62.2 × 53.6 cm). Worcester Art Museum (gift of Sidney Rose in memory of his mother, Mary D. Rose).

Opposition and Transition

The principles of design guide us in the use of the elements, but in the case of variety and unity we find an additional principle adapted particularly to the reconciliation between the two. Although the expression "opposition and transition" sounds like two principles, it is, in fact, two facets of the same process. When two

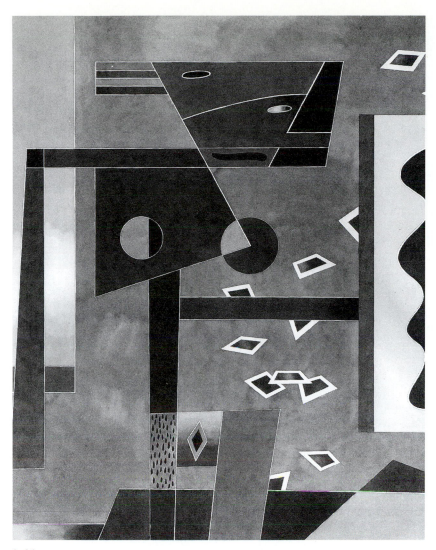

8-13

opposing elements exist within a composition, a dynamic force is set up, producing a tension that can make a work disquieting. For example, jarring colors next to one another or rough and smooth textures in juxtaposition can be extremely effective, or they can be dissonant elements in a composition. When the latter is the case, unity can be achieved by using gradations of the colors that finally blend or by repeating the varying textures at intervals throughout the work, thus providing a gradual transition. Let us examine a painting to clarify what is involved.

Caravaggio, painting in sixteenth-century Italy, made dramatic use of *chiaroscuro* (light and dark) to give a strong emotional quality to his work. In the painting in Figure 8-14, a work recently discovered after centuries of obscurity, the contrasts are less theatrical than in many of his works, but there is a pronounced light at

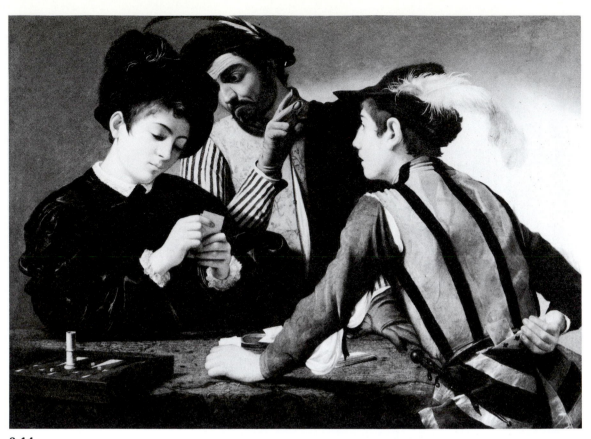

8-14

the right in *opposition* to the velvety dark shirt on the player at the
left. The manner in which these two extremes are reconciled is ob-
vious yet skillful *transition*. The dark and light are simply combined
into stripes, first broad stripes widely spaced on a light ground near
the highlight, then narrower stripes, equally dark and light in width,
on the figure in the center. The motif is carried through the feather
on this figure's cap, which leads our eye toward the darkest area,
here broken by the face of the player on the left, which is much
lighter than the faces of the other two. Hands, faces, and the game
board all play their roles in the transition, being placed strategically
to play light against dark in satisfying balance.

Among his other accomplishments, M. C. Escher created a
series of designs based specifically on the transition of opposing
shapes. An example is the design in Figure 8-15 in which he com-
bines thirteen fish with thirteen waterfowl, managing to bring all of
them together in such unity that they become an interplay in posi-
tive and negative shapes. His first step is to place all 26 so they are
headed in the same direction. With careful manipulation, the artist
then works the two opposing shapes into a perceptive arrangement
in which the positive shapes of one become the negative shapes of
the other. Thus, the spaces between the fowl are the same shape as
the fish and the fish are held together by shapes that resemble the

136 *The Principles of Design*

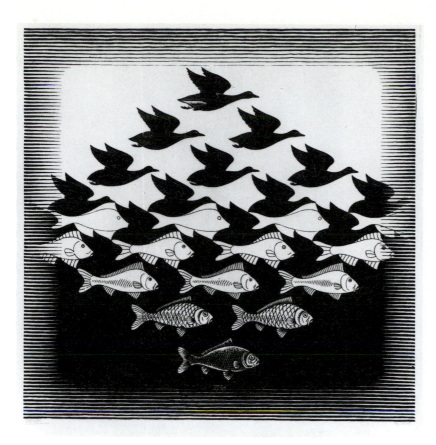

8-15

fowl. A third unifying force is the diamond shape in which the figures are composed, a simple turning of the basic square that forms the total work. Transition is carried still further by the border of lines that pulls the entire composition together, gradually blending almost imperceptibly from black on white at the top to white on black at the bottom. Transition is also a matter of individual detail. The top goose and bottom fish are rendered with surface detail, but as the design works toward the center the detail disappears, and all the shapes become either white or black silhouettes. This work is a conscious exercise of variety and opposition blended into unity by means of transition.

Symbolic Unity

We mentioned early in the chapter the relationship between the principles of design and human life, implying the symbolism that unites them. We close with consideration of a painting that exemplifies this symbolism, not only in its style but in the culture that inspired it. Whereas European landscape painters tended to picture landscape as a setting for people, the Chinese equated landscape

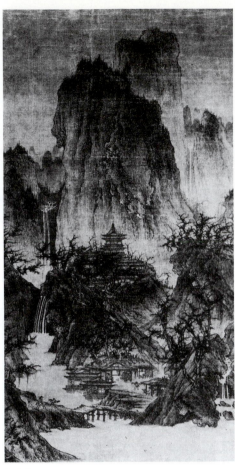

8-16

painting with a search for the soul of nature, a philosophical exercise in which the artist followed the teaching of Confucius that one who is in harmony with nature apprehends the truth without thinking. The Chinese name for landscape painting, *shan-shui*, literally means "mountain water," and Chinese paintings are filled with waterfalls, bridges, and variations of the steep cliffs and jagged rocks adjacent to crashing water. The work in Figure 8-16 expresses the belief that landscapes are large concepts and should be viewed from a distance in order for the viewer to behold all the shapes and atmospheric effects. We see here distant peaks, tumbling water, a temple, and a varied texture provided by the shapes of trees. If there are human figures, they (typically) are so small that we are not aware of them. What we see here is a scroll on which an artist has embodied a philosophy expressing the beliefs of Buddhism, Taoism, and Confucianism designed to lead the viewer not only into the beauties of nature but into the depths of human understanding.

In discussing unity and variety we have frequently mentioned balance as an aspect of a unified composition. In Chapter 9 we will consider balance as a principle in its own right, along with its interaction with emphasis and rhythm.

8-16 Attributed to Li Ch'eng (Ying-Ch'iu). *Buddhist Temple amid Clearing Mountain Peaks*. 10th century. Ink and color on silk, 44 × 22″ (1.12 × .56 m). The Nelson-Atkins Museum of Art, Kansas City, MO (purchase: Nelson Trust).

138 *The Principles of Design*

Summary

Unity and variety are inevitably intertwined since they rely upon one another to provide a balanced composition. Variety provides interest in a work through contrast and structure and by building variations on a theme or motif. Unity blends the elements of design into a harmonious whole, often by employing repetition. The blending of variety and unity frequently involves transition of two opposing forces or elements by means of subtle modifications.

9 | Balance, Rhythm, and Emphasis

9-1 Classical Greek drama is still performed during the summer months in the Theater at Epidaurus.

9-2 Chasm Falls, Fall River, Rocky Mountain National Park, Colorado.

We have accepted unity as the essential quality of any effective design and variety as the counterpart that gives it meaning. We now consider three principles involving movement, principles which may flow in and out of a design and whose influence is variable, depending upon the decisions made by the designer. As in the case of the elements of design, an analysis of the role these principles play in the universe in which we live will facilitate our comprehension of their potential for the designer.

Balance may be considered a challenge, an ideal, and a necessity. Most of us experience our first sense of triumph when we successfully meet the challenge of pulling ourselves upright beside a piece of furniture and taking those first steps that lead into a lifetime of vertical activity. Throughout that life, balance remains an ideal toward which to work, whether it involves standing on the tip of one foot and whirling in ballet or balancing our expenditures with our income. Nature provides balance for us by requiring our work to be alternated with rest, our moods to swing from cheerful to brooding, our experiences to range from joy to sorrow. We strive for balance all our lives, as we struggle with the imbalances that are forced upon us in unfair treatment, physical and emotional upsets, psychological trauma, and the daily instances of injustice and unkindness. The natural world both helps and hinders us by balancing our lives with night and day and in most parts of the world with changing seasons. On the other hand, it sometimes challenges us almost beyond endurance with hurricanes and tornadoes, blistering heat and raging winter storms, and—the ultimate challenge to balance—earthquakes, which unbalance not only our familiar environment but our physical and emotional lives as well (Plate 37).

In our discussion in this chapter the principles of balance, rhythm, and emphasis will overlap and interweave. Understanding the importance of balance in our lives, it will not be surprising that much of the discussion will deal with its influence, for it is balance that leads to rhythm and gives importance to emphasis. Almost invariably, when we consider either rhythm or emphasis, we are involved with some aspect of balance as well.

Rhythm is not so much an active challenge as an underlying force. Deriving from the Greek word meaning "to flow," it was considered the creative principle of the universe long before the Greeks named it. In a world ruled over by vengeful and merciless gods, universal rhythms made possible the attainment of balance, through

140

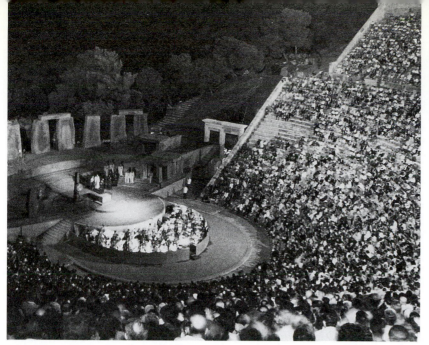

9-1

waking and sleeping, desire and fulfillment, birth and death. Pythagoras and his followers were convinced of the "music of the spheres," an ethereal harmony created by the movement of the planets, which were separated from one another by strings of varying lengths that produced harmonic sounds. In keeping with this belief, Greek artists and philosophers created a world of the mind in which sheer chaos was excluded and a divine order ruled. This universe permeated Greek life with the rhythms of the ideal, whether in philosophy or science, poetry or architecture, dance or drama (Fig. 9-1). Even in less idealistic cultures, biological rhythms govern human life, like a continual pulsation that makes life possible.

Emphasis is the clap of thunder, the peak of the mountain, the roar of the waterfall in the depths of the forest (Fig. 9-2). It is the climax toward which a musical composition builds, the theme or character in a literary work that holds our attention and that we remember. It is the holiday with which human beings in all cultures spice the routine of their years, providing anticipation and release from boredom. The achievement of a goal, a moment of deep happiness, a spectacular visual experience: These provide emphasis, a glimpse into an ideal world that we like to think exists somewhere but that allows us only the occasional glance. Our years are a series of climaxes that stand out in memory, sometimes unhappily, but occasionally as the turning points of our lives. In the visual arts, emphasis is the aspect of a work that makes it seem important.

9-2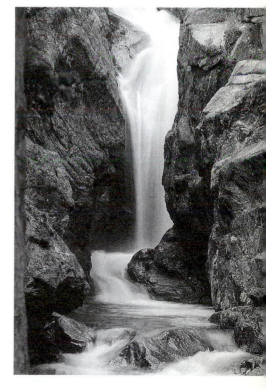

Balance in Design

Balance can be categorized in several ways. Of first importance is the distinction between *structural balance*, which involves the actual equilibrium of an object, and *visual balance*, which is

concerned with perception and its psychological reactions. If structural balance is lacking, a building, a piece of sculpture, or a boulder will topple. If visual balance is missing, we will feel uneasy. Obviously, the two are closely related. Looking at an unbalanced structure of any kind is almost certain to arouse some degree of unease and tension in the viewer.

Structural Balance

Structural balance can be *horizontal, vertical,* or *radial.* Balance of any kind is dependent upon an axis, a central pole of equilibrium around which the forces of an object or structure gravitate. A fundamental element in balance is *weight,* for it is only with equivalent amounts of weight or tension that balance is possible.

Horizontal Balance. Examples of horizontal balance in nature are limitless, from the soaring of an eagle with its enormous wingspread to the relaxed equilibrium of a well-fed leopard as it stretches itself for a nap in the branches of a tree. One of the most intriguing examples of natural balance is the kangaroo, whose huge tapered tail coordinates with the action of its rear legs to propel it across great expanses of land in a perfectly balanced rhythmic motion (Fig. 9-3).

The principle of horizontal balance can best be illustrated by a diagram of a fulcrum and lever (Fig. 9-4) or, more familiarly, the seesaw of our childhood. When equal weights are placed on the lever at equal distances from the center, the lever balances in a straight horizontal line. The minute the weight or distance is changed at one end, an adjustment must be made at the other. Most of us have memories of positioning different-sized children in order to make a seesaw balance and consequently to swing smoothly up and down. When the weight and size are the same at both ends, the balance is *symmetrical,* as in the top example in Figure 9-4. When adjustments are made as in the lower two examples, the balance is

9-3 The kangaroo: a remarkable example of balance.

9-4 Diagrams of symmetrical and asymmetrical balance.

9-5(a) Logo for Go-Tech, Inc. Designed by Peter Adam, Gottschalk & Ash International.

9-5(b) Logo for Seville's city transport system. Designed by Roberto Luna and Fernando Mendoza for Luna, Mendoza, & Perez S.A.

9-6 The Salgina Bridge, near Sohiers, Canton Grisons, Switzerland. 1930. Reinforced concrete arch with 269-ft. (82.04 m) span. Engineer: Robert Maillart.

9-3

asymmetrical. Using two examples of visual balance for a clearer understanding, a symmetrically balanced design will be identical on both sides of the central axis, as in Figure 9-5a. Another term for this is *bilateral symmetry.* This particular design is also *radial,* since it emanates from a pivotal central point. The design in Figure 9-5b looks symmetrical at first glance, but actually it is not, since folding it vertically down the center would not result in two identical images. The two halves are similar in shape and the design is definitely balanced but because of the slight variation in placement the balance is *asymmetrical.*

The concept of horizontal balance is the starting point for any bridge design since the purpose is to construct a horizontal passageway that will span an obstacle, whether that obstacle is a mountain gorge, a lake, or a freeway. The Swiss Alps provide a typical challenge, as we see in the bridge in Figure 9-6, designed as a subtle flattened arch supported on either side by vertical piers. As we view the total design with approaches at each end, the structure does not appear to be perfectly symmetrical, but this is simply because the terrain does not require it; the cliff on the right supports the highway so that fewer vertical uprights are required. The bridge itself, the structure that spans the gorge, is an example of horizontal structural symmetry at its most functional.

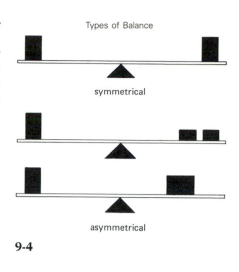

Types of Balance

symmetrical

asymmetrical

9-4

9-5(a)

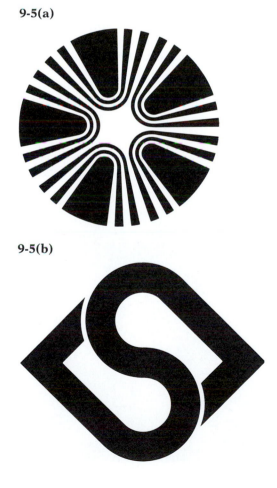

9-5(b)

9-6

(a)

(b)

(c)

9-7

Symmetry is associated with order, serenity, and often with formality. Heraldic shields and coats of arms are usually symmetrical in design, with minor deviations to accommodate the heraldic symbols (Fig. 9-7). Interior design for formal meeting areas, courtrooms, and ceremonial chambers tends toward symmetrical balance, for an orderly arrangement provides a feeling of security, as though the transactions taking place in such a setting will have a balanced and satisfactory outcome.

9-8

9-7 Three armorial bearings:
(a) God giveth the increase,
(b) Dulcius - ex asperis -
ut prosim - aliis, (c) Pers. . .

9-8 Room at Standen, England.
19th century. Designed and
built by Philip Webb.
Courtesy *Art and Antiques*.

9-9 Diagram of vertical
balance.

9-10 The boat *Elizabeth Muir*,
San Francisco.

The room shown in Figure 9-8 is part of a house designed a hundred years ago in England. This is a case of total symmetry with the exception of the small table at the left. There is no awesome formality about the room, however, but rather a sprightly charm. The house was designed by a close friend of William Morris, who revolutionized British design in an effort to overcome the soulless mechanization of labor that resulted from the Industrial Revolution. Morris's group was responsible for the credo that buildings are not "architecture" but history and poetry, and art is not "taste" but the human spirit made visible. They promoted the revival of traditional skills and stimulated the pride of the workman in his efforts; typically, all of the textiles, lighting fixtures, wallpaper, and furniture in this house were designed specifically for it, and display patterns for which Morris became well known. His vision translated the formality of symmetry into an orderly but inviting interior.

9-9

Vertical Balance. The importance of vertical balance in nature is obvious to every gardener, who knows that a tree or shrub must be planted deeply and securely if it is to survive. The giant trees of the forest are anchored by extensive root systems that balance the large branches and masses of foliage, fortifying the entire structure against all but the most severe erosion or violent storms. The diagram in Figure 9-9 demonstrates the principle of vertical balance, in which the determining factor hinges upon the relationship of the height of the object to the weight at the bottom. Any weight distributed along the intervening distance must be adjusted to retain the balance.

We are all familiar with vertical balance in masts of ships, flagpoles, and television antennas. The tall mast of a sailboat is balanced by the width of the beam or the weight of the keel, and its sails in turn are controlled by the sailor to maintain the balance of the boat when underway according to the forces of wind and water (Fig. 9-10). Flagpoles are firmly set in blocks of concrete. In their

9-10

radial

9-11

firm attachment to the roofs of buildings, television antennas appropriate the entire building as a huge counterweight that will allow the antenna to withstand storm and high wind. Our cities are riddled with deep excavations filled with the stone and concrete that make possible the vertical balance that dominates the cityscapes of the world.

Radial Balance. The fundamental characteristic of radial balance is the force that emanates from a central pole, resulting in similar elements rotating about it. (Fig. 9-11). Since humanity first recorded symbols, the sun, the ultimate life force, has been depicted as a circle with emanating rays. It is echoed in flowers and seed pods as well as in the starfish (Fig. 9-12). As a structural force, it is the hallmark of one of the most dramatic architectural forms, the dome—an elaboration of the Roman arch, which graces many of

9-12

9-12 Great variety can be found in the types of starfish.

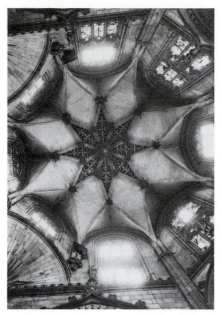

9-13 **9-14**

the imposing structures in the world today. Looking up at the Chapel of the Constable in the Cathedral of Burgos in Spain, one feels that the fifteenth-century architect must have derived at least a part of his inspiration from the form of a flower (Fig. 9-13). Five centuries later the development of *ferrocement*, layers of steel mesh sprayed with cement mortar, made possible a dome expressing an even more elaborate floral design (Fig. 9-14). Quite a different expression greets us in Figure 9-15. Seeing a mobile home park from the highway, we would hardly envision it as a flower-like design; one wonders if the planning commission had in mind the view from the air when they set out the perimeters of each space. In any case,

9-13 Octagonal dome of Chapel of the Constable, Cathedral of Burgos, Spain. 1482–94.

9-14 Pier Luigi Nervi. Salon of the Audiences, Vatican.

9-15 Mobile home park, Birch Bay, WA, near the Canadian border.

9-15

the overall effect is a pattern of radial symmetry symbolic of the life within. Sparks from a skyrocket shoot into the sky in breathtaking radial balance. So, too, many forms of sea life, even when not visibly moving, possess a dynamic quality in their radial forms (Plate 38). Like the ripples from a stone dropped into a pond, radial balance is characterized by limitless boundaries, becoming a symbol of infinity.

Visual Balance

The building in Figure 9-16 provides transition into our discussion of *visual* balance, for its success as a design is visual as well as structural. In the first place, the enormous bulk required for the projected inner space has been apportioned between two fundamental masses, each of which is refined into comparatively slender vertical forms. The one on the left is tall, pointed, textured with windows, and accented with vertical metal panels which creep up two echoing shapes with which the predominant wall is varied. This form is visually balanced by the massive block at the right, rising two-thirds as high, crowned by a single tall pole and accented by the name of the company outlined in red. This form in turn is broken into units diminishing in height in an orderly but asymmetrical fashion, ultimately settling reassuringly into the strong horizontal structure at the base. The pointed design causes the building to soar, but the solid grouping provides satisfying balance.

9-16

9-16 Two Prudential Plaza.

9-17 Loredano Silva. Illustration for *Elegy for Pasolini*. Courtesy the artist.

9-18 Jack Youngerman. *Untitled*. 1986. Charcoal and pastel on paper; abstract shapes have the energy and tension of natural phenomena. Courtesy Washburn Gallery, New York.

In visual balance we become more involved in the aesthetic quality of balance, the comparative *visual* weight of the parts of a composition. The question is not so much whether the object will fall over as whether it gives the impression of being well proportioned and aesthetically pleasing. In the painting in Plate 39 there is no concern about structural balance nor of proportion, inasmuch as the canvas is covered with slashing brush strokes which convey the artist's *impression* of the landscape rather than any specific objects. The painting is a harmonious blending of colors, shapes, and linear accents, all of which relate to balance. We note the strategic placement of the blue areas that predominate, and a roughly symmetrical treatment of the dark linear forms suggesting trees. There is indisputable balance in the distribution of the red strokes flashing throughout the composition in contrast to the depths of the background.

No analysis is required in the drawing in Figure 9-17. A quick glance tells us that it is balanced and one need not probe to discover the reason. The entire image comes close to being symmetrical except for the face, which is the central focus. Here one eye is darkened to attract our attention, and in order to balance it the opposite cheekbone is extended. This is simple balance yet it holds a clue. Balance does not mean *similar* sizes or shapes, colors or textures, placed *opposite* one another. The visual impact can be equal in quite different elements, depending upon how the artist uses them to achieve equal visual weight. The drawing in Figure 9-18 exhibits the energy and tension that characterize radial balance, yet there are no two sections that are exactly the same. There is balance in the similarity of the shapes that seem to be changing as we watch and could

9-17

9-18

very well become identical at any moment. The importance of the drawing lies in the illusion of centrifugal force, of action whirling about the central core.

We all realize that many factors interfere with balance in everyday life. Similarly, not every design is in balance. Sometimes designers deliberately create unbalanced works to attract attention, to jar us into looking twice, or simply to express the imbalance they experience in their own lives or viewpoints. The painting in Plate 40 is deliberately not balanced. The square seems to be floating in space with a wooden panel that twists, contrary to our usual association with wood. The resulting object is suspended in time and space, and that is all it is meant to do. Balance is not a consideration.

Rhythm

In several instances of balance, we have noted a resulting rhythm. The bodily balance of the kangaroo results in rhythmic movement across the landscape; the balance of sail against wind makes possible the rhythmic gliding of a sailboat over the waves. Essentially, rhythm is a regular pulsation; consequently, elements placed to establish *balance* frequently contribute to the *rhythm* of a composition as well. In music, meter provides an underlying structure through which rhythm flows smoothly. This structure, denoting a fixed time pattern, establishes the *beat*, or regular pulsation, often expressed by drum or bass, that sets the pace to which we respond emotionally, dancing or swaying or tapping our feet. We will be considering four types of rhythm: *metric, flowing, swirling,* and *climactic.*

Metric Rhythm

Visually, the simplest type of metric rhythm can be expressed by the dots in Figure 9-19, a regular repetition of a single beat such as one sets by tapping a pencil or hears from the drum in a marching band. Such a rhythm is characteristic of weaving, which by nature is repetitive. In Figure 9-20 the weaver has used variations of two motifs, each providing its rhythmic beat across the textile.

A second series of dots in Figure 9-21 has an alternating rhythm in which every other beat is emphasized. The entire façade of the building in Figure 9-22 is a composition in this rhythm, the beat of the windows alternating with the brick and stone divisions between them. The ground floor repeats the rhythm with variations dictated by larger entry openings, with the arched entry at the extreme left providing an accented chord that gives the total rhythm a point of *emphasis.* At either end of the drawing, the building shows a muted variation of the beat, with tiny window openings sounding small notes in wide expanses of brick and stone. Crucial to such a design is the *proportion* of the openings in relation to the wall panels between. The proportions here are subtle and balanced with emphasis at top and bottom as well as at the ends.

9-19 Diagram of metric rhythm: The regular rhythm of a drumbeat can be shown visually as a series of equally spaced dots.

9-20 Fabric design by Maureen Zeccola. Courtesy the artist.

9-21 Diagram of alternating rhythm: Dots of varying size indicate variations in rhythm, in this case an alternating beat.

9-22 Gordon and Virginia MacDonald Medical Research Laboratories, University of California at Los Angeles. Architects: Venturi, Scott Brown and Associates, Inc., Philadelphia, in association with Payette Associates, Inc., Boston. Completed March 1991. Construction costs: $35 million. This 7-story, 155,000-sq.-ft. building, clad in horizontal bands of limestone, cast stone, and patterned red brick, with porcelain-enamel-clad plenums at the roof line, contains laboratories and offices. Courtesy the architects.

9-19

9-20

9-21

9-22

9-23

9-24

In Figure 9-23 we see a third set of dots representing a rhythm we have all hummed, whistled, or danced to—the rhythm of the waltz. Our association of the waltz with the glamor of Vienna makes even more fascinating the fact that the same rhythm has been used visually in a print carved of sealskin, inked and printed by an Eskimo artist of the Canadian Arctic (Fig. 9-24). We are given a marvelous parallel in the print of blue geese feeding. The strong beat is undeniable, and the smaller beats supply a double bonus of rhythm and humor.

Flowing Rhythm

The design in Figure 9-25 is a classic example of the interplay of balance and rhythm. In perfect symmetrical balance, the high-way interchange was designed specifically to maintain the rhythm of highway traffic flowing along it at all hours of the day. Most of the motorists who use it are not aware of the visual interest but appreciate the fact that it facilitates the rhythmic flow of their lives by allowing them to reach their destinations without stops or interference.

Rhythmic in quite another way are the six tiles shown in Plate 41, handsomely painted in Syria in the sixteenth century as an example of "Rhodian" ware, a type of ceramic thought to have originated on the Island of Rhodes. Each tile has its rhythmic curve, but the combination creates the design, allowing the curves to join in a flowing and decorative rhythm.

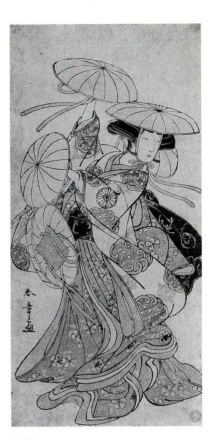

9-25

In contrast, the print in Figure 9-26 fairly vibrates with flow-ing rhythm, all of which emanates from the depiction of a single fig-ure. In its highly imaginative treatment it gives us the feeling that the designer was filled with delight as he worked, balancing hats, swirling garments, creating a wealth of pattern, both linear and cir-cular. There is much radial balance here and a masterful balance of linear design between the hats at the top and the folds of garments at the bottom. All of these attributes are swept into an overall rhythm that is distinctly flowing.

9-26

Swirling Rhythm

With swirling rhythm we return to the concept of radial bal-ance. Although a swirl does not necessarily have to be circular, there is the connotation of action revolving around a central core and of centrifugal force capable of considerable power. White-water rapids and whirlpools at the base of a roaring waterfall are undeni-ably characterized by swirling rhythm, with the adventurous possi-bility of their dashing to pieces anything that falls within their scope. A jacuzzi, on the other hand, utilizes similar power to relax and revive the human body. Once again, the human designer adapts existing principles to serve specific needs.

A beautiful example of swirling rhythm is seen in the ballet, particularly in the pirouette. Here the ballerina, on the tip of one foot, swirls into almost ethereal movement. Less ethereal is the movement depicted in the painting in Plate 42, in which the black forms of cats seem to slink against a bright yellow background. In keeping with the subject, the action is not violent but it fills the can-vas, the linear accents implying claws even where the shapes of the body do not exist. Actually, we do not *see* a cat at all but we do see the slinking, circulating movements almost as though the cats had left their swirling rhythm behind them in visual form.

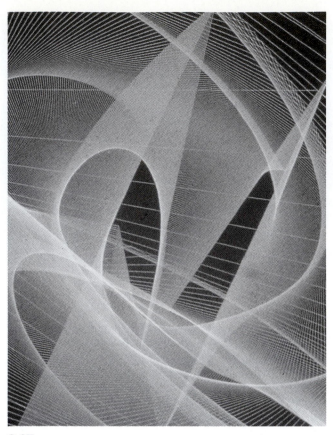

9-27

9-27 Melvin L. Prueitt.
Untitled. 1983.
Computer-generated art.
Courtesy the artist, Los
Alamos National Laboratory.

9-28 Franz Marc. *Grazing
Horses IV (The Red Horses)*.
1911. Oil on canvas, 121 ×
183 cm. The Busch-Reisinger
Museum, Harvard University
Museums (anonymous loan to
the Busch-Reisinger Museum
and the Cincinnati Art
Museum).

9-29 Daniel Barrett.
Crescendo #8. Steel sculpture.
Courtesy ACA Galleries,
New York.

Even more swirling is the design in Figure 9-27, worked out by experimentation on the computer. Here lines and shapes seem to interact with such force that even the surrounding rectangle appears to be only a momentary restriction. The parallel lines in the background separate from each other gradually, their spacing varying to such a degree that we feel another moment would change the configuration completely. This is swirling rhythm in its most dynamic form.

Climactic Rhythm

Some of the most dramatic rhythms in music are those that begin gently, growing in strength and intensity until they crash to a resounding climax. The operas of Richard Wagner contain many arias that lead the audience upward into ever greater suspense until the climactic release explodes upon the stage. Rock music is also replete with climactic rhythms, rising and crashing above the predominant beat.

Music has a distinct advantage over the visual arts in the matter of building to a climax, for the audience is in place and the conductor or singer can lead it through the stages of the composition

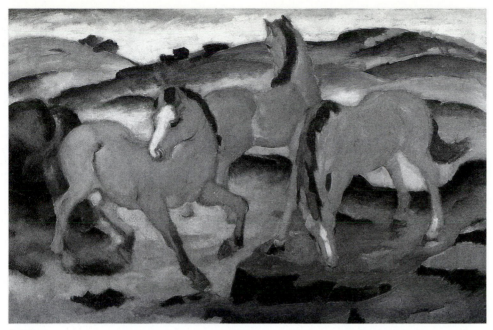

9-28

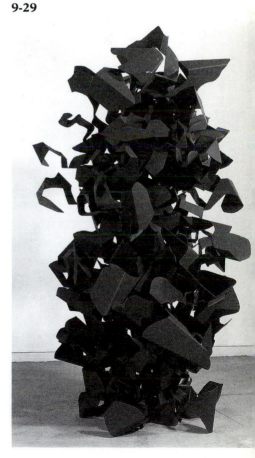

9-29

gradually with increasing emotional impact. It is seldom that the viewer of a painting or sculpture, for example, studies the work for a length of time comparable to that spent listening to a musical selection; therefore the painter or sculptor must rely on spectacular devices if the work is to carry a dramatic impact.

One of the classic means of leading the viewer to a climax is by the use of a triangular composition. The triangular form inevitably leads the eye to the peak, and thus to a sense of rhythmic progression. In the works we have studied, John Marin leads us to the peak of the Woolworth Building in Figure 1-28, and in Plate 10 Rembrandt leads us through a triangle, lowering the body of Christ with the cross at the peak. The triangular composition is fundamental to figure portraits throughout the Renaissance and onward, as in the family group by Ingres in Figure 3-14. The painting of three horses by German Expressionist Franz Marc (Fig. 9-28) does not culminate in any specific point of interest, but the rhythm of the forms leads our gaze through the composition. We view each horse in turn and almost unconsciously come to rest on the ears and mane at the top. We may not feel any great crash of climax but we respond to the rhythm and to its culmination at the apex of the triangle.

The title of the sculpture shown in Figure 9-29 makes it clear that the artist had in mind exactly the kind of rhythm we are discussing. A *crescendo* is not a climax, as is sometimes assumed, but the *development* leading to the climax, in which music or form gains in intensity in a building rhythm. This work in steel has the same movement and vitality as a plant with thick foliage, tangled in upon itself but ultimately reaching upward toward the sun. The sense of growth and movement presents a continually changing aspect for which the title is particularly appropriate.

Emphasis

In visual design, emphasis is the point toward which our eye turns immediately when we walk into an art gallery, the aspect of a piece of sculpture that catches our attention, the dominant shape in a wallhanging. We have seen emphasis repeatedly in the works we have considered—in Plate 25 the splash of orange and yellow-orange against the blues and purples is a dramatic example of the emphasis that makes a work effective. Again, in Plate 5 with its predominance of red, the dripping paintbrush against the white expanse of the painter's overalls attracts our eye immediately.

As these two works demonstrate, emphasis can be a matter of color or location. It can also be determined by light or shape. The lights and darks Wassily Kandinsky used in the abstract painting shown in Figure 9-30 create a strong impact. Our perception is guided through heavy diagonals that intercept each other and echo faintly in the calligraphy at upper right. Our eye, however, inevitably returns to the lower center of the work, where curved shapes contrast with the body of the painting—a contrast caused not only by the part-circle shapes but also by their darkness against the light background. The combination of light and shape generates a focal point toward which all other elements in the work seem to gravitate.

9-30 Wassily Kandinsky. *Cossacks.* 1910–11. Oil on canvas, 37½ × 51¼″ (94.6 × 130.2 cm). Tate Gallery, London.

9-31 Francisco Goya. *Executions of the Third of May, 1808.* 1814–15. Oil on canvas, 8′9″ × 13′4″ (2.67 × 4.05 m). Museo del Prado, Madrid.

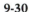

9-30

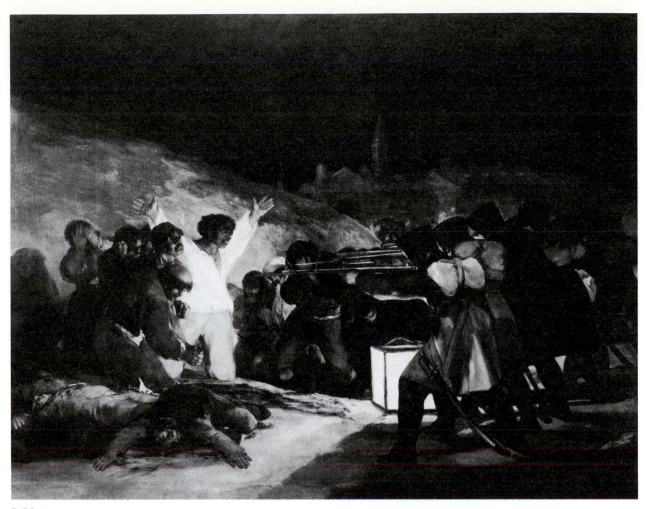

9-31

Finally, emphasis can be a matter of drama. In the painting in Figure 9-31, Francisco Goya uses location, color, and line to direct our eye, but all of these are simply tools, means of focusing our attention on the reason for the work. Goya was a Romanticist, which in painting means that color and emotional quality are essential means of expression. Here he is painting the Spanish resisters overtaken by the armies of Napoleon, and he has employed all the devices of the painter's skill to form a rising crescendo leading to the figure in white, arms outstretched in a pose of crucifixion. The contrast of white against darkness would be enough to catch our eye, but lines of all kinds converge upon him from every part of the painting. There are rifles with fixed bayonets, the grim attention of the other figures in the group, the streak of light in the foreground leading our eye directly to him, the box of light in strong contrast to the braced knees of the executioners outlined against it, and in the foreground, the prostrate bodies of those who have already fallen. This is emphasis heightened to dramatic climax by every means at the artist's disposal.

Balance, rhythm, and emphasis are the three most vital and dynamic principles of any work of art or design. This does not mean that they are the most important but rather that they have the greatest potential for movement and impact. We have noted the ways in which they work together, overlapping, creating one another in some instances. One of the most important characteristics of their relationship is *contrast,* for it is by contrasting visual shapes and forms that balance is attained, by contrasting elements against one another that rhythm is achieved, and, most fundamental of all, it is contrast that makes for emphasis. In Chapter 10 we will explore two principles that are equally basic and closely related, the principles of proportion and scale.

Summary

Structural balance has to do with the construction of objects while *visual* balance concerns perception and the emotional concept of stability. Balance of each kind may be *horizontal, vertical,* or *radial.* There are four kinds of rhythm: *metric* is based on a regular beat, *flowing* moves easily, *swirling* tends to rotate or whirl around a central axis, while *climactic* rhythm is usually expressed in a crescendo that builds to a climax. Emphasis is the point toward which our eye turns upon viewing a work, based upon contrast in color, shape, value, or size. It can be determined by direction within the work and can also be a dramatic focal point.

Proportion and Scale | 10

Keynotes to Discovery:

The Golden Mean
Fibonacci Series
logarithmic spiral

Although proportion and scale are both concerned with size, they are distinctly different principles. It is important to understand the distinction.

Proportion refers to size relationships of *parts within a whole*—a composition, a human body, a room. If a person's nose is unduly large or small, it may be spoken of as *out of proportion* to the rest of the face. It is common practice for a cartoonist to make a predominant feature of a face out of proportion in order to satirize the subject (Fig. 10-1). Scale, on the other hand, denotes size *in relation to*

10-1

10-1 J. C. Suares.
*Dr. Henry Kissinger
(as "Dr. Strangelove")*.
Cartoon. Courtesy
the artist.

159

an accepted unit of measurement. Architects' drawings and maps require a scale gauge, usually placed at the bottom, so the viewer can interpret the relationship of the marks on the paper to the actual building or landscape they represent. If a drawing is at a quarter-inch *scale,* it means that a line a quarter of an inch long (6 mm.) is equal to a specific amount of space, usually a foot, in the building that is planned. If an architect has submitted plans for your house, you can read the dimensions on the drawing and measure them off in the room where you are standing, thus deciding whether the actual planned space will be as big as you envision. What you measure will be in *scale* with the drawing. On a map, the *scale* is apt to be proportionately greater because more area is being depicted. On a state map 1¾ inches may equal 100 miles (160 kilometers) of highway or countryside, whereas on a continental United States map it may equal 200 miles (320 kilometers). The units of measurement are the units on the ruler, whether they are expressed as variations of the meter in the metric system or as inches and miles in the U. S. and British system of measurement.

When we speak of *human* scale, we use the human body as the unit. Buildings, rooms, automobiles, and all the equipment necessary for human life are designed on the human scale. In the dance, the human body is used as the unit with which innumerable configurations are formed (Fig. 10-2), a scale that makes the audience

10-2 Advertisement for Australian Dance Theatre, Adelaide, S.A.

10-2

comfortable, free to enjoy the rhythms of the dance. If the same movements were performed by figures twice as large, the effect could be threatening.

Proportion

Proportion is the principle that makes our world recognizable. Seeing the familiar shapes and proportions of trees and buildings lets us know that we are home. The proportion of visible sky makes the difference between forest and desert, and the proportion of water to land determines not only the character of our surroundings but the ways in which we travel and the kinds of recreation we pursue.

We recognize our friends by their proportions, even when we see them at a distance—the proportion of leg to torso, of weight to height, of shoulder width to length of body all differ greatly, creating individual human shapes. Proportions in our faces give us even more specific individuality. People sometimes undergo surgical procedures to alter the size of an individual feature, but it is not the *size* that is the primary concern so much as the relationship of the feature to the rest of the face—in other words, its role in the *proportions* of the face. Most of us would feel quite different if an alteration were made in our proportions. Being three inches taller would make it possible to reach objects on high shelves, and being fifty pounds lighter would totally change one's attitude about clothes. Our proportions become an integral part of our life and personality as well as of our appearance to the world.

The Golden Mean

In Chapter 9 we were introduced to the ancient Greek philosophy in which the "music of the spheres" created universal harmony. Many of their writings reveal that the Greeks also believed in mathematics as a governing force in the universe, being convinced that music has a strong relationship to mathematics. Euclid is credited with having stated the precept of the Golden Mean, a simple expression of the importance of *proportion* and *balance*, often stated as *moderation in all things.* As the key to living successfully, this simple statement holds as true today as it did in the time of the ancient Greeks. Whether we are speaking of eating, drinking, exercise, or rest, moderation and a balance among all the elements of our lives is the secret of maintaining proportion, and consequently, physical, mental, and emotional health. Aristotle expressed this sense of proportion by explaining that moderation is a median between two vices. For example, courage is a virtue. We think of its opposite, or balancing vice, as cowardice. Yet cowardice is only one end of the scale. At the other end is foolhardiness, which might be characterized as courage carried to an unreasonable extreme, thus placing it in the category of vice. Courage, then, is the virtue or *mean* between the extremes of cowardice and foolhardiness. We can test this philosophy on any virtue we choose: Generosity is the *mean* between stinginess and being a spendthrift; compassion is the *mean* between cruelty and indulgence.

10-3 The Golden Mean and Extreme Rectangle. The proportion of side *a* to side *b* is the same as the proportion of side *b* to side *a* plus side *b*. The smaller rectangle and the larger one are therefore in the same proportion. This rectangle is also known as the Golden Section.

10-4 Greek sculpture appears to have been composed within the proportions of the Golden Mean and Extreme Rectangle. (a) *Discobolus*. Museo Nazionale Romano, Rome. (b) *Minerva Medicea*, Palazzo Pitti, Florence.

LINE A

bears the same relationship to

LINE B

that

LINE B

bears to

LINE A PLUS LINE B

10-3

10-4(a)

10-4(b)

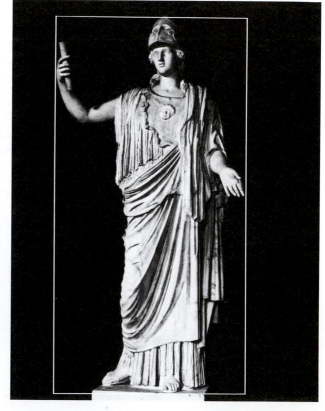

The Artistic Application

For centuries scholars have been intrigued by the manner in which the philosophy of the Golden Mean (sometimes called the Golden Section) was put into practical use by Greek painters, sculptors, and architects. By using a simple line as the mean between two other lines, they created a rectangle that became the basis for temple plans, for the composition of vases, and for the construction of sculpture. This is the way it works: At the bottom of Figure 10-3 are four lines, two of which (Line B) are the same. Line B is the mean between the other two lines simply because it is longer than Line A in the same proportion that it is shorter than the lowest, longest line. By using Line A as the width of a rectangle, and combining Lines A and B to form the length of the rectangle, the Greeks created a unique and subtle shape which they used as the floor plan of many of their temples and also within which they composed sculpture (Fig. 10-4), vases (Fig. 10-5), and many of the decorative elements of their architecture and painting. This shape has come to be termed the Mean and Extreme Rectangle, composed of three lines, of which one is the mean between the other two, the extremes.

10-5(a)

10-5(b)

10-5 The Golden Mean and Extreme Rectangle contain exactly the proportions of many Greek vases.
(a) Amphora with Achilles and Ajax playing draughts, painted by Exekias, 550–540 BC. Vatican Museums.
(b) Mythological Greek vase.

10-6(a)

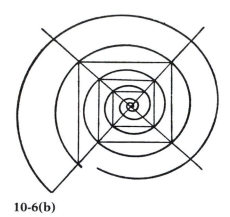

10-6(b)

The Spiral

The spiral was another form in which the Greeks saw the meaning of the universe. You will note that in the rectangle in Figure 10-3 a square is indicated by broken lines. This square, if repeated in orderly progression outward, as in Figure 10-6, forms the basis for the spiral. Circles circumscribed within each successive square flow into a curve that is exactly the same shape as the chambered nautilus. Galaxies in outer space are known to whirl in spirals, and scientists exploring the importance of DNA in human genetics have discovered its structure to be a double spiral or helix. Some biological forms that are not structural spirals instinctively

10-7

10-6(a) Radiograph of a nautilus shell.

10-6(b) Logarithmic spiral.

10-7 A millipede, Madagascar.

10-8 Sunflower head.

take a spiral form when in repose (Fig. 10-7). Known as the *loga-rithmic spiral*, this progression governs the growth of much of nature, including snail shells, tips of ferns, elephant tusks, rams' horns, and cats' claws—anything that grows by increasing in size on the outer edge so it does not change its shape. The logarithmic spiral, therefore, makes it possible for natural forms to grow to tremendous size without losing their fundamental *proportions*.

The Fibonacci Series

The Greek discoveries in the area of proportion lay obscured for twelve centuries until Leonardo da Pisa, a medieval European scholar known as Fibonacci, made them the basis for many of his mathematical studies. He discovered, among other things, a series of numbers having a close relationship to the laws of natural growth. Like elephant tusks and rams' horns, the series develops in a regular pattern, with each succeeding number being the sum of the previous two: 1+1=2, 1+2=3, 2+3=5, 3+5=8, 5+8=13, 8+13=21, and so on indefinitely. Fibonacci, working with numerical values and mathematical relationships, found a precise and specific numerical relationship between this series of numbers and the Mean and Extreme Rectangle. Furthermore, Fibonacci and his followers discovered that the numbers in his series coincide exactly with the number of seeds in the various rows or layers in pine cones, artichokes, and pineapples. Sunflower seeds grow in a spiral and counter-spiral exactly corresponding to the Fibonacci series, with each segment of growth succeeding in number of seeds the sum of the seeds in the previous two segments. A large sunflower like the one in Figure 10-8 may contain 89 spirals clockwise and 144 counterclockwise.

10-8

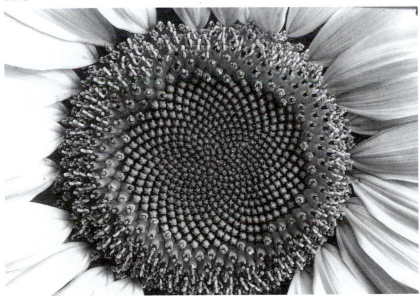

10-9(a)

10-9(b)

10-9(a) Thelma Winter.
Schematic diagram using
dynamic symmetry.

10-9(b) Jack Tworkov.
L.B. OOK #1. 1979. Oil on
Kindura paper, 14 × 11″
(35.6 × 27.9 cm). Courtesy
André Emmerich Gallery,
New York.

Dynamic Symmetry

Fibonacci's contribution to knowledge represents a consistent historical phenomenon in the revival of interest in ancient Greek culture. Sculptors of the Renaissance and architects of all periods have felt the influence of Greek proportion and design, with Greek moldings gracing the tops of New York's early skyscrapers and Greek columns adorning the fronts of banks and elegant homes. An interesting development for the designer occurred early in this century when Jay Hambidge, a classical scholar at Yale, became interested in applying the Mean and Extreme Rectangle to the composition of paintings, dividing the space on the canvas according to its *proportions* and constructing the painting upon the framework thus established, a system he called Dynamic Symmetry. The concept appeals to many artists, who see it as a guarantee of pleasing proportions within a work. In Figure 10-9 we see two works using dynamic symmetry, one a layout for a large work in enameled metal, the other a fininshed painting. As seen in Figure 10-9(a), the procedure is to construct a Mean and Extreme Rectangle, divide it into the square and smaller rectangle, and establish diagonals relating to the three shapes. The painting in Figure 10-9(b) incorporates such diagonals into the composition, dramatizing the predominant square. The system is flexible, acknowledging the ideal of Greek proportion as a basis for individual adaptation by the artist, in the assurance that the resulting composition will be proportionately harmonious.

Proportion as Information

We are being informed by proportion continually, often without realizing it. The proportions of bodily and facial features may tell us the nationality or heritage of people we see even though we do not know their names. Anthropologists have long linked the peoples of South America with those of Asia through these similarities, assuming them to have traveled from Siberia to Alaska and on down the coast before the existing land mass subsided and became the Bering Sea. Human proportion has similarly informed anthropologists in their research into paleolithic peoples and the distribution of racial characteristics in remote areas of the earth.

Proportion makes *sociological* statements as well. A history of the cities of the world would reveal a gradual change in the proportions of the cityscape, from low mud or stone buildings to the triumphal arches, impressive colosseums, and ornate baths of ancient Rome. From Rome the proportions of the dome emerged, ultimately to dominate cityscapes as diverse as Constantinople (now Istanbul) and London. Medieval cities were crowned by a spire or spires that guided Christian pilgrims plodding from vast distances, or by the turrets of a castle from which a diligent watch was kept for possible enemies. Today cityscapes all over the world are related by the similarity of their proportions in which the vertical dimension is the dominating feature (Fig. 10-10). All cities exist on a human *scale* because human activities have given them their reason for being,

10-10(a) 10-10(b)

but since the discovery of the possibilities of structural steel the settings for these activities have been piled on top of one another to centralize the metropolitan world and eliminate the unrestricted sprawl of urban life. Every city has its distinctive entity created by the shapes and proportions of individual buildings, but the preeminence of vertically oriented proportions is worldwide.

Interior proportions have changed as well. Architecture is the shaping of space and space costs money, in building floor areas, roof areas, and walls interspersed with windows. In countries ruled by hereditary monarchs, spacious palaces were considered an indication not only of the importance of the monarch but of the power of the ruler's country. Luxurious proportions were considered essential to impress visiting monarchs and potential enemies. In palaces such as Versailles outside Paris, the whims of four successive monarchs were guiding forces in creating impressive proportions, not only of the building itself but of the surrounding country. In the time of Louis XIV, 180 miles of aqueducts and canals supplied water for 1,400 fountains within the castle grounds, which were overlooked at least in part by 375 windows in the side of the castle facing the garden. With the advent of democracy, the exorbitant taxation necessary to maintain such proportions became impossible, and many palaces are financed today by admission fees paid by tourists. Some, such as Versailles and Hampton Court in England, have been partially converted to hotels. By comparing a state reception room in Washington, D. C. with only one small room at Versailles, we learn a great deal about the change in values and in proportions (Fig. 10-11). Throughout Versailles there was extensive use of marble, inlaid wooden floors, bronze sculpture, painted ceilings, and gilded moldings, all set in lavishly proportioned high-ceilinged salons (Fig. 10-11a). In a country ruled by elected officials, proportions become less awesome and the decor considerably more restrained. Although the drawing room in Figure 10-11b has classic moldings, it depends upon works by American painters

10-10(a) Montreal.

10-10(b) Singapore.

10-11(a) A room in the Palace of Versailles.

10-11(b) Edward Vason Jones, architect. The John Quincy Adams State Drawing Room. Department of State, Washington, DC.

168 *The Principles of Design*

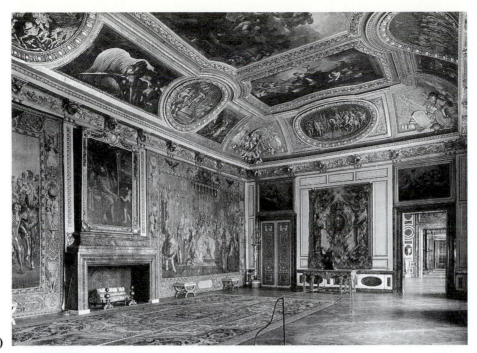

10-11(a)

10-11(b)

and cabinetmakers for its character. Stripped of furnishings, it would be simply a well-proportioned room.

The symbolism of proportion carries psychological connotations as well as sociological ones. Even in democracies, the symbol of wealth is large proportions in homes, cars, and boats, whereas thousands of people who lack money live in crowded conditions in areas with inadequate proportions. This aspect of proportion is one of the major issues plaguing society today, and as the world becomes more crowded it threatens to become worse. When the proportions of living spaces do not allow for comfort and privacy, all manner of sociological ills can result.

Scale

Having considered the *proportions* of Versailles, it may be helpful to realize that, compared with the surrounding countryside, the buildings of the palace are on a very large *scale*. This is not true of the individual interior spaces. All of the rooms are designed for human occupation and so are in scale with the people who would use them. Visitors find it interesting that such items as a bathtub and chairs seem small to us today because they were scaled to the French royalty of the fifteenth century. Even though the size of the palace appears enormous, the scale is still a human one.

10-12

Symbolic Scale

Let us now consider a structure that was *not* designed to be on a human scale but rather to transcend it. The Taj Mahal (Fig. 10-12) was erected in the seventeenth century by Shah Jaha, the Moslem emperor of India, as a memorial to his wife who, having borne fourteen children, died at the age of thirty-nine. Devastated by her death, he commissioned architects to design the most beautiful building in the world in tribute to his love for her. Designed on huge scale, its dome rises 187 feet high, and it is built of solid white marble and intricately decorated with lacy carving and precious gems. Its sole purpose was to house the remains of the Shah and his wife. The fact that human scale was no issue can be verified by picking out the tiny human figures approaching the structure and standing, scarcely discernible, within the major arch.

The Taj Mahal is only one of many ways in which scale has been used in a symbolic way. Artists in all ages have depicted the most important characters in a work as larger than the rest, as in the stele (upright stone marker) commissioned by an Akkadian king 4,000 years ago to celebrate his victory over invading armies (Fig. 10-13). The king stands at the top, dressed as a god and twice the

10-13

10-12 Taj Mahal, Agra, India. 1630–48. 186 × 186 × 187′ high (56.7 × 56.7 × 57.0 m).

10-13 *Victory Stele of Naram-Sin.* c. 2300–2200 BC Stone, height 6′6″. Louvre, Paris.

size of his own men, towering over the fallen enemy. In anthropomorphic design throughout the world, gods, in human form or otherwise, are the largest figures in the composition. Taking their place among the wonders of the world because of their size, the enormous Egyptian pyramids and funerary temples have survived for centuries. Unlike the Taj Mahal, which was erected from devotion, these giant structures were built because of the Egyptian preoccupation with death. The egoistic determination of the pharaohs to triumph over death was expressed by the preservation of their bodies, in company with all the necessities for a comfortable life, in a structure whose scale would reinforce their importance while alive.

We mentioned the practice of building large palaces to impress visiting dignitaries; the large scale of castles is less subtle. Castles were often built as fortresses on high hills, designed to impress any approaching enemy with the futility of attacking. Characteristic of castle architecture is the Krak des Chevaliers, one of a chain of fortifications built to protect the route of the Crusaders as they made their way to Jerusalem. Protected on three sides by precipices, it stands on a spur of black basalt in the Syrian desert. The human figures on the ramp to the left in Figure 10-14 provide a graphic measure of its forbidding scale.

Scale as Emphasis

Returning to the contemporary world, we discover that scale is one of the basic tools of the commercial artist. Any point to be featured in an advertisement, poster, or brochure is more emphatic if

10-14 *Krak des Chevaliers*. Syria. Crusader castle, 12th-13th century.

10-15 Cover of a prospectus offering giant inflatable cans for promotional purposes. Designers: Bill Kumke and Bill Mayer.

10-16 Rafal Olbinski. Illustration in the North Western Mutual Life Magazine on creating the entrepreneurial spirit within the corporation. Courtesy the artist.

10-14

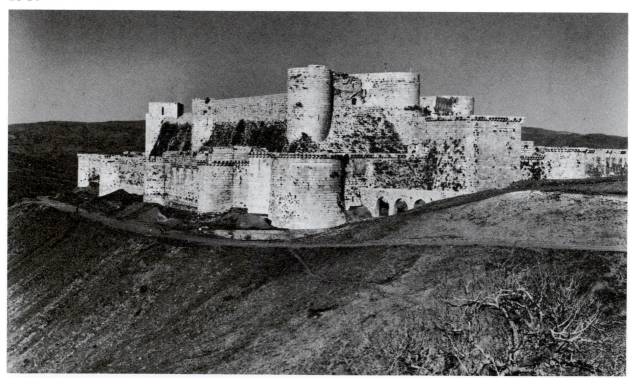

10-15

10-16

it is placed in opposition to elements of a different size. This can work both ways. In Figure 10-15 we see a drawing for a prospectus of a company offering giant inflatable cans for promotional purposes. A prospectus is a booklet or folder sent to potential customers to convince them of the quality of the product offered, and the first requirement is to attract attention. In this case, the approach is one of humor. The man reading the paper is huge in comparison to the massed populace behind him, his expression portraying puzzled incredulity as the enormous flip from a giant beer can rests at his feet. The entire effect relies upon his size as compared to the sizes surrounding him, in other words, his *scale*.

A reverse scale is used in the illustration in Figure 10-16, designed for the company magazine of a large insurance company. The theme is the creation of an entrepreneurial spirit among the employees of the company, and in this case the company is shown as the major force, symbolized by an enormous Greek column. The scale of the employees is extremely small in comparison, but the point is made of their importance in supporting the company. The implication of the support being an individual matter is manifested not only in the figures adding interest to the structure of the column but in one employee standing on his hands.

Proportion, Scale, and the Designer

We have left the consideration of the relationship of proportion and scale until last, because they sum up the physical entity to which all the other elements and principles contribute. After the designer makes the numerous decisions throughout the work, the result has specific scale in comparison with its surroundings and proportions that may be in some degree the result of the materials and processes it has undergone. We must also realize, however, that in some ways proportion and scale are the result of the primary decision made by the designer, usually preceded only by the choice of medium. The painter, planning to work in oil, acrylic, or watercolor, must decide how large a canvas to stretch, whether to use a full or half sheet or less of paper, and what the proportions will be—square, a rectangle close to the mean and extreme, a long narrow vertical or horizontal rectangle, a circle or oval, or perhaps some innovative shape that will require specially made stretchers (Plate 43).

The designer is often guided by the requirements of the design. The scale and proportions of a pitcher or a teapot must be easy to handle, a piece of movable equipment like a power tool or a kitchen appliance must also be easy to use and in scale with the task for which it is designed. The medium or tools may also influence proportion and scale. Weaving will be limited in width by the size of the loom available and the proportions will be decided upon accordingly. A work of woodcarving will necessarily be confined within the proportions of the block of wood from which it is carved.

Interiors are one of the most challenging areas of design. Here the designer is expected to create a comfortable and attractive environment regardless of the size and proportions of the room in question. Such a challenge confronted Noel Jeffrey in the room shown in Plate 44. Intended as a guest room, this area was small and square, both characteristics imposing distinct limitations on a designer. Jeffrey managed to combine nineteenth-century German furniture, Greek vases, and Egyptian sphinxes with a wealth of decorative accessories, yet the total result is one of restraint and simplicity, the pared-down style of the nineties. To counteract the small size, he made use of a device frequently used in Japan to give height to small spaces: He paid special attention to the vertical dimensions, carrying the eye upward and beyond the confines of the horizontal space. Since in a square room width and length are identical, emphasis on height tends to overcome the potential monotony of the proportions. His methods of achieving this emphasis include the tall arched niches in which vases soar upward to a triangular climax, a wall of paintings that climbs to the horizontal molding on the wall, and the decoration of the ceiling, where pattern lifts the consciousness into a higher dimension.

We end our discussion of proportion and scale with consideration of an object that has always fascinated designers—the chair. People have needed a place to sit since the human race began, and the existing designs for fulfilling that need could scarcely be contained within a large museum. Every chair must fit the human body, but the solutions have covered a wide range of shapes, degrees of upholstery, and proportions. We see in Figure 10-17 (a) a chair design based on the head of an antelope, the horns providing

10-17(a) Jeffrey Maron. *Antelope Spiral*. Courtesy Jeffrey Maron, New York.

10-17(b) Eero Saarinen. *Tulip Armchair*. Courtesy The Knoll Group.

10-17(c) Raul deArmas. *deArmas Armchair*. Courtesy The Knoll Group.

174 *The Principles of Design*

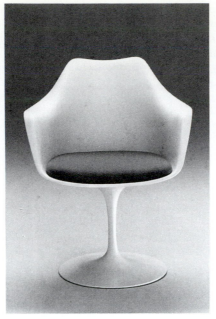

10-17(a)　　　　　　　**10-17(b)**　　　　　　　**10-17(c)**

a curved accent in the back, the legs curving gently, the seating minimal, a mere accoutrement to the verticality of the design. Chair (b) was designed by architect Eero Saarinen, designer of the TWA Terminal at Kennedy Airport which we saw in Figure 2-7. For his chair, Saarinen has been inspired by the tulip; the chair is a flowing plastic enclosure in which the seat seems to be an extension of the curving petals of the arms and back. One does not sit *on* it, as in the case of the antelope chair, but rather slides *into* it. Chair (c) contrasts totally with both the first two chairs; it is not high like chair (a) and it is not a solid shape as in chair (b). Instead it is totally linear except for the large upholstered seat. The curved back offers support and the seat is ample for comfort, even for shifting position. These are only three solutions to a design project that promises to be forever with us, and they exemplify much that we have discovered about the creative process, originality, and the elements and principles of design. Among the three chairs we see line, shape, mass, color, space, and texture as well as unity, variety, balance, emphasis, rhythm, proportion, and scale. None of the three embodies all of the elements and principles, but each design results from the interplay and interweaving of those that are pertinent to it. This, then, is the basis for design: a knowledge of the ingredients, and the skill to guide the ingredients into an effective and aesthetically pleasing result.

Summary

Proportion is the relationship of sizes within an entity or composition, while scale is measured according to an outside unit of

measurement. The Greeks reached the ideal proportion in the Golden Mean. They also appreciated the importance of the spiral in growth and life. The Fibonacci Series expresses growth patterns and has many applications which are not yet fully understood. Dynamic symmetry is a system for constructing two-dimensional works on a framework in accordance with the Golden Mean. Scale can be a source of information about people, buildings, and cities, and it also has numerous symbolic meanings.

Glossary

Abstract expressionism A painting style of the late 1940s in which nonobjective forms were used to express emotion. Also called *action painting* because of the large canvases which necessitated vigorous physical action by the artist.

Abstraction Originating with a recognizable form but simplified or distorted into a new entity, as a mountain might be *abstracted* into a triangular form.

Achromatic Lacking the quality of color, as in black and white or any neutrals mixed from them.

Acrylic A plastic substance used as a binder in paints, technically known as acrylic polymer emulsion. Also used as a medium for sculpture.

Actual space Space involved in three-dimensional design such as pottery, sculpture, architecture, and so on, in which the space forms an integral element of design.

Additive Descriptive of a structural method in which form is created by building up materials, as by modeling or welding. Compare *subtractive*.

Additive primary colors In light, those *primary* colors—red, blue, and green—which in theory can be blended to add up to white light, or all light.

Aesthetic From the Greek *aesthetikos*, pertaining to sensory perception and traditionally associated with the contemplation of *beauty*. The reaction of the viewer to a work of art is generally termed *aesthetic*, although contemporary interpretation does not always emphasize the association with beauty.

Afterimage The tendency of the human eye to see a hue after looking for several minutes at its complementary hue.

Alloy A substance composed of two or more metals or of a metal and a nonmetal intimately united, usually by fusing together and blending in each other when molten.

Ambience The total environment of a work of art as it is created by the various parts of the composition working together.

Analogous Referring to colors adjacent on the *color wheel*.

Anthropomorphic The ascribing of human traits to things not human.

Appliqué A fabric-decorating technique in which various shapes, colors, and types of materials are stitched onto a background to create a design.

Aquatint A printmaking process in which a porous ground of resin is applied to a plate, after which the plate is dipped by stages into an acid bath to create a range of tonal values.

Arabesque A style of decorative design employing flowers, fruit, and sometimes human or animal figures entwined in an intricate pattern of interlaced lines.

Arcade A series of *arches* supported by piers or columns to form an open passageway.

Arch A structural device in which two vertical uprights are joined by a curved top to support the weight of a wall above. The classic arch consists of wedge-shaped blocks placed in a semicircle in counter thrust, so that they converge on a *keystone* at the center of the opening.

Armature A framework of metal, wood, cardboard, or other rigid material used as a basis for forming objects of soft materials such as clay, plaster, or wax.

Art The application of skill and taste to the production of an aesthetic result, independent of, but not necessarily excluding, practical use or purpose.

Arts and Crafts Movement A group led by William Morris in the late nineteenth century that stressed decorative design in useful objects with emphasis on books and home furnishings.

Asymmetry Symmetry in which both halves of a composition are not identical.

Atmospheric perspective The effect of an intervening body of air between an object and the viewer, causing a softening of outlines, blurring and cooling of colors, and loss of detail at the horizon; the simulation of depth in two-dimensional art by the portrayal of this effect. Also known as *aerial perspective*.

Bas-relief or low relief A form of sculpture that is carved from, or attached to, its background. The carving is less than half the natural circumference of the object carved.

Batik A form of resist dyeing in which non-printing areas are blocked out with wax, which cracks in the dyeing process, causing a background of linear texture.

Bauhaus A school of design founded in Germany in 1919, known for its adaptation of design principles to mass production; also applied to works, especially furniture, designed by the staff.

Beater The part of a loom that holds the *reed*, pressing each new weft against the previous one, ultimately creating the web of the fabric.

Beating down A method of working metal by hammering a sheet over a recessed area to form bowls or other objects.

Bentwood Wood that is bent rather than cut into shape, using steam to shape it.

Bilateral symmetry Symmetrical balance in which a central axis cutting through the design would produce two identical mirror images.

Binder The substance into which pigments are ground to produce paint, which will then adhere to a *support*.

Biomorphic Taken from nature, from the Greek meaning "structure based on life."

Bisque The term for pottery objects that have been fired but have no glaze.

Bonsai The art of growing a potted plant or tree by special methods of culture that cause it to retain a dwarf size and character.

Brayer A hand roller, usually of hard rubber, used to apply ink in the printing process.

Bronze An alloy of copper and tin and various other metals.

Burin A sharp tool used in engraving processes.

Burr In *intaglio*, the ridge of metal cast up on either side or both sides of the *engraving* or *drypoint* tool. In engraving it is usually removed, but in drypoint it remains on the plate, creating the characteristic softness of the lines.

CAD Computer-aided design.

Calligraphy The art of beautiful writing such as is found in medieval manuscripts or on Oriental scrolls.

Cantilever A structural member, as in architecture, in which one end is firmly imbedded in an upright so that the other end can extend into space unsupported.

Cartoon A drawing made to scale on paper, used in transferring designs as a basis for painting, mosaic, or tapestry.

Casein A painting medium using milk curd as a binder.

Casting The process by which liquid or plastic material is shaped by pouring it into a mold and allowing it to harden.

Cauterium A metal tool used in manipulating *encaustic*.

Champlevé A style of enamel decoration in which the enamel is applied and fired in cells depressed or incised into a mold and then allowed to harden.

Chaologist A person who believes that the universe is the result of dynamic chaotic forces.

Chasing A method of ornamenting metal by use of a hammer and other tools applied to the front side of the work.

Chiaroscuro From the Italian meaning "light-dark" and referring to the use in two-dimensional works of dark and light modeling to achieve a three-dimensional effect. Often used for emotional or dramatic effect.

China A white clay ware similar to porcelain but firing at a lower temperature, so called because similar ware was brought to Europe in the seventeenth century from China.

Chroma The degree of brilliance or purity of a color. See also *intensity* and *saturation*.

Chromatic Possessing the quality of color, as in neutrals mixed from complementary colors rather than from black and white.

Chromatic neutrals Grays or tans mixed from complementary colors rather than from black and white.

Cicatrisation A technique of body decoration used in many parts of the world, in which cuts are made and then filled with ashes to produce permanent ridges in patterns.

Ciré-perdue A method of casting metal in which a model is coated with wax and a mold built around it. When heated, the wax melts and flows out, leaving a cavity into which molten metal can be poured and allowed to solidify. Also called *lost wax*.

Clarification The final stage in the process of problem solving, in which the results are appraised.

Classicism A style in art or architecture based on the Greek architectural style of the fifth century B.C. and generally characterized by logical principles and clean uncluttered lines.

Cloisonné A style of enamel decoration in which the enamel is applied to cells formed by tiny brass wires on a metal (or other) background.

Closure The process by which we unify our perceptions to achieve a specific or total shape, as in seeing unrelated curved lines as parts of a circle.

Codex The earliest form of bound book, in which pages of parchment or vellum were fastened together.

Coiling A method of building clay objects by forming rolls of clay which are built upon one another while in the plastic state.

Collage Any composition into which paper, bits of cloth, and other materials have been pasted, usually in addition to the use of paint. From the French "to paste."

Color field painting A style of painting popular in the 1960s and 1970s in which a canvas was covered with a single color with perhaps a contrasting accent, meant to evoke an emotional response through the color alone.

Complementary Colors opposite each other on the *color wheel*; for example, yellow and purple-blue are complementary.

Composition The structural design of a two-dimensional work, consisting of the organization of the elements of design according to the principles of design.

Concept The original vision or idea that leads to the development of a work.

Conceptual Imagery resulting from forces within the artist, such as dreams, emotions, and imagination. Also any art resulting from such imagery.

Concrete A mixture of cement, sand, stone, and water.

Content The message an artist or designer hopes to convey in a work, as in expressing a personal reaction or the importance of a social issue.

Copy The literal portion of an advertisement, employing alluring or persuasive terms to accompany the illustration.

Contextualism An architectural concept by which new or remodeled buildings are made to fit in with the existing environment.

Contour In two-dimensional representation, the line that represents the edge of a form or group of forms.

Craftsmanship The application of skill and dexterity in creating a work of art or design.

Creativity The stage in the process of problem solving in which the imagination is encouraged to soar in a search for totally new and innovative approaches.

Crescendo A gradual increase in emphasis within a composition, as in the increasing volume working to a climax in a musical composition.

Crewel A type of *embroidery* worked with twisted, ropelike threads, usually wool.

Cross-hatching A series of intersecting sets of parallel lines used to indicate shading or volume in a drawing.

Crystal A high-quality colorless lead glass or quartz, used for fine tableware, chandeliers, and other glass objects of fine quality.

Cubism An art movement of the early twentieth century in which objects were interpreted in geometric planes, neutral tones, and the breaking of objects into facets. Associated particularly with George Braque and Pablo Picasso.

Decentralization A concept in city design in which the shopping centers are distributed throughout the perimeter of the city rather than concentrated in the downtown city center.

Decorative design Embellishment or enrichment of the surface of an object, either through the structural process or by application after the structure is completed.

Design A work of art intended to serve a specific purpose, either aesthetic or otherwise.

Diffraction The process by which a wave of light, after passing the edge of an opaque or solid object, spreads out instead of following in a straight line.

Discretionary spending Spending by consumers for items not strictly necessary but purchased to make life more attractive, interesting, or comfortable.

DNA The molecule associated with hereditary traits in many organisms, a source of intriguing designs in computer graphics.

Dome An architectural structure generally in the shape of a hemisphere or inverted cup, theoretically the result of rotating an arch on its axis.

Drawing 1. A work depending primarily on lines and shading to depict the subject matter. 2. A method of making glass to form sheets.

Drypoint A method of *intaglio printmaking* in which a metal plate is needled with a sharp point that raises a burr, or curl of metal, which takes the ink, giving the drypoint a distinctive velvety surface.

Ductility The capacity for being drawn out or hammered thin, as in thin sheets of metal or metal wire.

Earthenware A rather coarse clay ware, firing at about 2000 degrees F., usually red in color and porous.

Eclecticism The blending of many influences and styles in one work.

Edition The term designating the body of prints struck from a single image on a plate, block, or stone.

Embossing A technique for decorating metal and other hard surfaces by raising the surface into decorative designs.

Embroidery The technique of decorating fabric with colored threads worked in a variety of stitches.

Emphasis The principle of design that stresses one feature as being the center around which the rest of the design is coordinated.

Encaustic A painting medium consisting of pigment worked with hot beeswax.

Engraving The process of incising with a sharp tool to make an impression on metal, glass, or other hard material.

Entasis A slight swelling in the body of Greek columns to strengthen the impression of supporting the weight above.

Ergonomics An applied science concerned with designing things people use in their work so the work can be done with maximum safety and efficiency.

Etching The process of incising designs on glass, metal, or other hard materials by coating with wax, cutting through the wax with a sharp tool, then applying acid to eat through the material where the wax has been cut away.

Extrusion A process in industrial design in which an object is formed by forcing material through shaped openings, after which the material hardens upon cooling.

Façade Any face of a building (usually the front) that is given special architectural treatment.

Faience Earthenware colored with opaque colored glazes, often with metallic touches, usually on a light-colored ground. Closely resembles *majolica*.

Faubourg The area in a medieval city between the original city wall and subsequent walls erected as the city expanded.

Fauvism A movement originating in France in 1905, characterized by the unconventional, apparently arbitrary, use of bright contrasting colors. Associated with Matisse.

Ferrocement A form of concrete composed of layers of steel mesh sprayed with cement mortar.

Felting A method of making cloth by interlocking loose *fibers* together through a combination of heat, moisture, and pressure.

Fiber A thread, or something capable of being spun into a thread.

Fibonacci series A discovery by Renaissance scholar Leonardo da Pisa in which the laws of natural growth are found to follow a specific mathematical pattern.

Figure-ground In two-dimensional design, the relationship that exists between the principal image and the background shapes. The term "figure-ground ambiguity" implies that both are of equal importance.

Flexibility The characteristic of a material that makes possible its adaptation to different uses and forms, as in the case of wood or metal that bends without breaking.

Focal length The distance between the lens and the film in a camera.

Font An assortment of typefaces used in computer graphics.

Foreshortening A method of depicting objects on a two-dimensional surface so they appear to lie flat and/or recede into the distance. For example, a foreshortened circular plate becomes an ellipse.

Forging A method of working metal by heating it in a furnace until it is red-hot (or white-hot) and then holding it on an anvil and pounding it into shape with hammers.

Form The actual shape and structure of an object. Also, the essence of a work of art, its medium or mode of expression. The substance of something, as "solid or liquid form."

Fractal A term invented in the 1960s for geometry that focuses on "fractured" or broken uneven shapes.

Freestanding sculpture Work free of any attachment to a background.

Fresco A medium of wall painting in which pigment suspended in lime water is applied directly to wet plaster, becoming part of the wall when the plaster sets.

Futurists A group of Italian artists and writers, originating around 1909 and interested in the expression of the dynamic energy and movement of mechanical processes.

Geodesic dome An architectural structure first devised by R. Buckminster Fuller, in which a dome is constructed of small modules based on the triangle.

Gesso A mixture of plaster or gypsum coating with glue, used to build up wood panels or canvas as a ground for painting, usually in *tempera*.

Gestalt The principle that maintains that the human eye sees objects in their entirety before perceiving their individual parts. From the German word for "form," it is based on psychological theory.

Glaze A mixture of metal oxides applied to the surface of ceramic ware and then fired, providing waterproofing as well as decorative effect. Also a transparent application of paint, in which successive layers provide luminosity to a painting.

Glazed walls Walls composed primarily of windows.

Golden mean A philosophy associated with ancient Greece, expressed as "moderation in all things," and translated mathematically into the *Golden Section*, a rectangle whose balanced proportions became the basis for much of Greek architecture, vases, sculpture, and other forms of art.

Gouache Opaque *watercolor* paint in which the *binder* is gum arabic and a paste of zinc oxide.

Graphic Referring to anything written, drawn, or engraved; more specifically any such work intended for reproduction.

Graver A tool used for cutting or engraving metal.

Gray scale A series of *value* gradations ranging from white to black.

Greek orders The architectural systems of the ancient Greeks, based on the column and with relationships and proportions specifically defined. The original Greek orders were the Doric, Ionic, and Corinthian, with the Tuscan and Composite added later by the Romans.

Greenware The term for clay objects that are thoroughly dry but have not been fired.

Grisaille An enameling technique using a single color, especially gray, to achieve a three-dimensional effect.

Ground 1. A preliminary material applied to a *support* in preparation for the drawing or painting *medium*. 2. The background or general area of a *picture plane* as distinguished from *forms* or figures. See *figure-ground*.

Grout A thin mortar used to fill the spaces between pieces in a mosaic.

Hallmark An official mark stamped on an article to attest to its origin, purity, or genuineness, used especially in England on objects of gold, silver, and pewter.

Hammering One of the methods of shaping and decorating metal.

Hard edge A style of art developed in the mid-twentieth century, in which forms are depicted and separated by meticulous, regular, geometric lines.

Hardwood The wood from a tree that has the seeds contained in a closed ovary as opposed to being coniferous. So called regardless of whether the wood is actually hard or soft, examples are usually deciduous, such as maple, walnut, and the fruitwoods.

Hatching A series of closely spaced parallel lines used to indicate shading or volume in a drawing.

Haute couture High fashion, the area of fashion design presided over by well-known designers who cater to the wealthy or prominent members of society.

Haut relief A form of sculpture that is carved from, or attached to, its background. Meaning "high relief," it indicates depth of carving equal to more than half the natural circumference of the object carved.

Hue The quality that distinguishes a color from all other colors in the color wheel. The name of a color.

Ideographic Writing that actually represents the object it describes, as in Oriental calligraphy and early Egyptian hieroglyphics.

Illumination The decoration of manuscripts with designs and symbolic devices, often entwined with fruit, flowers, and human or animal figures.

Illusionistic space Space or depth indicated or implied on a two-dimensional surface through devices such as perspective.

Imagery The representations or symbols used by the visual artist, often arising in the imagination.

Impasto Paint applied to a support very thickly, usually with a palette knife, for the purpose of providing texture and a feeling of plasticity to the paint.

Implied space Space beyond the physical boundaries of a work of art but involved in the composition through devices employed by the artist, such as directing the attention of figures within the composition outward at something the viewer cannot see.

Impressionism An art movement of the late nineteenth and early twentieth centuries, in which painters broke hues into their components in an effort to capture the effects of light on color.

Inlay A technique in which small pieces of contrasting wood, stone, shell, or other material are set into a background of wood or stone to form a pattern.

Inspiration The process by which the designer senses the possibility of creating a new and individual form from something perceived or experienced.

Intaglio Any printmaking process in which the lines to be printed are recessed below the surface of the plate. Any depressed image caused by carving, cutting, or incising.

Intarsia A mosaic, usually of wood, in which small pieces are fitted into a background or support. See *inlay*.

Integrity The quality of being whole, applied to a design that expresses its material, form, and function in a direct and honest manner.

Intensity The degree of brilliance or purity of a color. See also *chroma* or *saturation*.

Iridescence The rainbow effect by which a material or surface seems to reflect all the *hues* of the spectrum, as a result of light playing upon it.

Interlacing The term used for creating fabrics by weaving and similar methods, such as knitting and crocheting.

International Style A style in architecture originating early in the twentieth century from several sources and featuring glass walls, steel structural elements, and lack of ornamentation.

Keystone The wedge-shaped stone at the center of an arch that locks all the other pieces in place.

Kilim A napless rug or mat woven by the village women of Afghanistan, Turkey, and Persia.

Kinetic Related to the motion of bodies and the energy associated with it.

Laminated 1. Composed of layers of firmly united material in which, in the case of wood, the grain all lies parallel. 2. Made by bonding or impregnating superimposed layers of paper, wood, plaster, etc. with resin and compressing under heat.

Leather-hard The stage at which clay is dry enough to hold its shape but still contains enough moisture to make carving or other decorative processes possible.

Linear perspective A system originating during the Renaissance for depicting three-dimensional distance on a two-dimensional surface, depending upon the illusion that parallel lines receding into space converge at a point, known as a *vanishing point*.

Lithography A planographic or flat-surface printmaking technique, in which the large areas are neither recessed nor raised. Compare *relief* and *intaglio*. Printing depends upon the mutual antipathy of grease and water.

Local color The color of things seen under standard light without shadows; the "real" color of objects in the natural world.

Logarithmic spiral The spiral found in biological forms representing growth patterns that increase in size without changing shape. See *Fibonacci series*.

Lost-wax casting See *ciré-perdue*.

Luminosity The actual or illusory effect of giving off light.

Macramé A fiber construction technique in which form is achieved by knotting strands into varied patterns.

Majolica Earthenware covered with an opaque tin glaze and then decorated with colorful designs in other glazes before firing. See *Faience*.

Malleability The capacity for being extended or shaped by beating with a hammer or by the pressure of rollers, as in forming metal into new shapes.

Marquetry Decorative work in which small pieces of material (such as wood, shell, or ivory) are inlaid to form elaborate patterns in a wood veneer that is then applied to furniture.

Mass A quantity of matter extending *shape* into three dimensions. Also referred to as *form* or *volume*.

Mean and extreme rectangle The rectangle based upon the *Golden Section*, used as a basis for much of Greek art and architecture. See *golden mean*.

Medium The form in which an artist works, as in oil painting or printmaking. Also, a basis for mixing paint, usually a combination of oil and varnish. Plural, *media*.

Meter In visual arts as well as in music, the underlying structure through which rhythm flows.

Mezzotint An *intaglio* printmaking process in which the plate is initially roughened with a tool called a rocker, then gradually smoothed for intermediate values, working from dark to light.

Millefiori Ornamental glass formed by cutting across sections of fused bundles of glass rods of various colors and sizes.

Minimal art An art movement of the mid-twentieth century in which the artist uses a minimum of form, color, and shape. Often results in canvases covered in a single color, known as *color field painting*.

Minimalism The theory or practice in art or design in which the fewest possible elements are used to achieve the greatest effect.

Mixed media The term for any work that employs more than one medium, for instance, oil paint, ink, and charcoal.

Modeling 1. Shaping objects from *plastic* material, such as clay. 2. In drawing or painting, effects of light and shadow that create the illusion of three-dimensional volume.

Modular Characterized by repetitive and/or interconnecting units that can be assembled in different ways, especially in furniture or architecture.

Monochromatic Having only one *hue*, possibly with gradations of *value* or *intensity*.

Monoprint A print made by painting on glass or other flat surface with paint or ink, then pressing printing paper onto the image. Also called *monotype*.

Mosaic A surface decoration made by inlaying small pieces of various colored material to form pictures or patterns.

Motif A designed unit that is repeated to form an area of pattern.

Multiples A work of art in any medium, but especially in printmaking, in which there exist duplicated examples, all of which are considered to be originals.

Mural A wall painting usually done on canvas mounted on the wall.

Needlepoint Embroidery done on canvas, usually in simple stitches across counted threads.

Negative shape or space The shapes or space surrounding a positive image within a given area. When a shape is drawn, the negative shape or space is what surrounds it.

Neutral Having no hue. Colors such as grays, beige, black, and white, mixed either from black and white or from complementary colors.

Niello The art of decorating metal with incised designs filled with a black enamel-like alloy known as nigellum.

Nonobjective Having no relationship to recognizable objects. See *nonrepresentational*.

Nonrepresentational Referring to works that have no relationship to recognizable objects but are meant to be appreciated for their line and shapes, and perhaps color, alone.

Normal value The *value* of a color when it appears in its pure unmixed state.

Obsidian A kind of shiny black glass formed by volcanic action.

Occult balance A term sometimes applied to asymmetrical balance. See *Asymmetry*.

Op Art The popular term for optical art, a movement in the sixties in which painters based their work on experimentation with the science of optics.

Organic Shapes or forms associated with living plants or animals.

Originality The quality of having been created without recognizable reference to other works.

Overlapping The placing of one shape or form within a composition so it partially obscures another form, thus providing the illusion of shallow space within a two-dimensional area.

Palette 1. The range of colors used for a painting. 2. The range of colors characteristically used by a single artist or group of artists. 3. The surface on which an artist mixes paint.

Papyrus The material used for early scrolls, made from the pithy stems of the papyrus plant growing in the valley of the Nile River.

Parchment The skin of a young sheep or goat prepared as a ground for writing, used extensively before the discovery of paper.

Parquetry A technique of inlaying floors with varied pieces of wood, usually cut to form an allover geometric pattern.

Parterre An ornamental garden in which paths wind among beds arranged to form a pattern, usually geometric.

Patina 1. A surface appearance of something grown beautiful with age or use. 2. A film (usually green) formed on copper and bronze by long exposure or by treating with acids, and valued aesthetically for its color and antique appearance.

Perception The experience of seeing in which the action of the sensory organs is augmented by experience and association.

Perceptual imagery *Imagery* derived from experience or perception of the natural world.

Perspective A system of representing three-dimensional space on a two-dimensional surface. See *linear perspective, atmospheric perspective*.

Pewter An alloy of tin, with varying amounts of lead, copper, and antimony. In early America, used as a substitute for silver in household furnishings because of its lower cost.

Photorealism A painting movement of the mid-twentieth century in which artists painted from photographs or depicted objects and people as they felt the camera would show them, complete with every minute detail.

Pictorial space The space involved on a two-dimensional surface, in which any indication of depth is illusory and is provided by devices of the artist.

Pinching The simplest method of forming objects from clay, consisting of forming an object by molding the clay with the fingers.

Planography A printmaking process in which the printing surface is flat, neither raised nor recessed. See *lithography*.

Plastic 1. Capable of being formed or molded, as clay. 2. Any synthetic polymer substance that can be molded or formed, such as polyester or acrylic.

Plasticity The capacity for being altered or molded, as in the case of clay.

Plate 1. A smooth, flat piece of metal that is etched or engraved with a design for printing purposes. 2. To cover with an adherent layer chemically, mechanically, or electrically, as silver is plated on copper to form silver plate.

Pliability The quality of being supple enough to be bent freely without breaking.

Plique á jour A style of enameling in which enamels (usually transparent) are fused into the openings of a metal filigree to produce an effect suggestive of stained glass.

Plywood A structural material consisting of thin layers of wood bonded together with the grain of adjacent layers arranged at right angles.

Point The initial contact between a drawing instrument and its ground, the extension of which becomes a *line*.

Pointillism A technique of applying tiny dots of color to canvas. Particularly associated with the work of Georges Seurat.

Polychromed Made with, or decorated in, several colors—especially carved wood that has been painted to bring out the form.

Pop Art An art style dating from the mid-1950s that takes as its subject matter popular, mass-produced symbols.

Porcelain A pure white, hard ceramic ware that fires at very high temperatures, used especially for fine tableware, figurines, vases, and sculpture.

Positive shape or space The shape created within a given space and the space that it occupies, as opposed to the surrounding shapes or space, known as negative.

Post-and-lintel An architectural system in which a horizontal beam (lintel) is supported by two upright posts.

Post-impressionism A general term used to designate the various painting styles that followed Impressionism, during the period 1885 to 1900. The term is applied primarily to the work of Van Gogh, Cézanne, Gauguin, Seurat, and their followers.

Pressing A method of forming glass objects by pouring molten glass into molds and then pressing it against the sides of the mold with paddles or other tools.

Primary color A *hue* that theoretically cannot be created from a mixture of other hues, but from which other hues of the spectrum are created. In light, the primary hues are red, blue, and green; in pigment they are usually considered to be red, yellow, and blue.

Print An impression from a master plate, stone, or block created by an artist, most often repeated many times for multiple images that are identical or similar. Usually made on paper. Also, a similar process applied to cloth.

Printmaking The art of making prints.

Proportion Size or weight relationships among structures or among elements in a single structure. Compare *scale*.

Punty A long metal rod used in fashioning semi-molten glass.

Quilting The process of sewing together small pieces of cloth (in a pattern or at random) to form a design, and then stitching to a backing fabric to create a puffed surface. Usually a layer of padding is sandwiched between the top and backing.

Radial symmetry A type of balance in which elements radiate from a central point, producing a circular shape or form.

Raising A method of hammering metal to form bowls and other objects, working from the back over a wooden form.

Raku A type of earthenware originating in Japan in which the lead glazed pre-heated *bisque* is placed in the red-hot kiln with long-handled tongs and removed after the glaze has matured, a matter of 15 to 30 minutes.

Reed That part of the loom that keeps the warp yarns perfectly aligned.

Refraction The process by which a wave of light, when passed through a prism, bends instead of pursuing a straight line.

Register The term for lining up successive wood or linoleum blocks in the process of printing so that blocks of different colors will print in the proper positions.

Relief Anything that projects from a background, as in relief sculpture. Any printmaking process that depends upon a raised image for inking. See *woodcut*, *wood engraving*.

Repoussé A method of decorating metal by hammering with blunt tools from the reverse side.

Representational Consisting of images depicted in a realistic manner.

Residual clay Clay that has remained in the place in which it was found.

Retrofill The designing of new buildings in a city, or the adding on to old ones, so that new construction blends with the other buildings. See *contextualism*.

Rigidity The quality of being stiff and unyielding, as in stone.

Riveting A method of joining metal by drilling holes and inserting a metal bolt or pin.

Rocker In *mezzotint*, a serrated cutting tool with a wide curved edge that roughens the surface of the plate.

Rococo An artistic style of the eighteenth century characterized by fanciful curved forms and elaborate ornamentation.

Romanticism A style of art and architecture in which the designer looks to the past with nostalgia, interpreting previous styles through personal associations and imagery that results in dramatic contrasts and intricate detail.

Sandcasting A method of casting concrete or metal relief sculpture by pouring the material to be cast into molds of wet sand.

Saturation The degree of purity and brilliance in a color. See also *chroma* and *intensity*.

Scale Size or weight relationships in a structure or between structures, especially as measured by some standard such as the human body.

Secondary color Colors mixed by combining two primary colors, as green is mixed by combining yellow and blue.

Sedimentary clay Clay that has been carried by the action of wind and water to be deposited in new locations as along river banks.

Serigraphy A *printmaking* process based on stencils in which the image is transferred by forcing ink or paint through a fine mesh. See also *silk screen*.

Shade Any degree of darkness in a hue that is below its normal (or middle) value.

Shape The two-dimensional contour that characterizes an object or area, in contrast to three-dimensional *form*.

Silk screen A *printmaking* process in which the image is transferred to paper or cloth by forcing ink through fine mesh screens, usually of silk, in which non-printing areas are "stopped out" to prevent color penetration. See also *serigraphy*.

Simulationism The term given a movement of the 1980s in which artists sought to express a soulless society in a capitalistic world, using a wide variety of assemblages and objects, most of them technological in implication.

Simultaneous contrast The phenomenon by which complementary colors appear to be brighter and more intense when placed side by side.

Slab construction A method of forming clay by rolling it into flat sheets and then joining the sheets to each other or to other *forms*.

Slip Clay in a semiliquid state, used for casting or for forming in presses.

Softwood The term for the wood of coniferous trees such as fir or pine, so called regardless of whether the wood is actually hard or soft.

Solidity The quality of being uniformly close and solid in texture, as in a mass that is rigid, such as stone.

Spinning 1. The forming of fibers into yarns so they can be woven or otherwise used to create fabrics. 2. The method by which round metal objects are formed on a revolving lathe.

Split complement The two hues on either side of a complementary color on the color wheel. For example, on the Munsell wheel, purple-blue is the complement of yellow; therefore purple and blue become the split complements of yellow.

Stained glass Colored glass that has been formed into sheets and cut into small pieces that are fitted together to form a pattern, often held together by strips of lead.

Stamping A fully automatic process for cutting, shaping, and designing metal into a desired form.

Steel An alloy of iron and carbon with an admixture of other elements.

Stitchery Any fabric-decorating technique in which the thread stitches predominate on the surface and carry the major design.

Stoneware A type of clay ware, usually gray or tan, with a warm earthy quality and firing in the middle range of temperatures.

Structural balance The physical equilibrium of a work.

Structural design Design concerned with the creation of basic *form* in an object, as distinguished from its surface enrichment.

Stylization The achievement of design quality by simplification of natural forms.

Subtractive Descriptive of a structural method in which form is created by carving or cutting away. Compare *additive*.

Subtractive primary colors Those colors which subtract from white light the wave lengths of all colors except the one seen.

Suburban sprawl The term applied to cities when the central business area has been fragmented into shopping areas scattered about the suburbs. See *decentralization*.

Successive contrast The phenomenon by which the *afterimage* of a visual impression appears to the closed eyes in the complementary colors of its original.

Support The surface upon which a two-dimensional work is created, such as canvas, wood, or paper.

Surrealism An art movement originating in the early twentieth century, which emphasized intuitive and non-rational ways of working as a means of recreating the chance relationships and the symbols that often occur in dreams.

Symbol An image that represents something else because of accepted association, as in the case of national flags symbolizing the country they represent.

Symmetry The correspondence in size, shape, and relative position of parts on opposite sides of a median line or about a central axis.

Synesthesia A sympathetic stimulation of senses, for example, the sensing of color in relation to musical sounds.

Tactile Capable of being experienced through the sense of touch, as the smoothness of satin or the roughness of tree bark.

Tactile texture The surface quality of a substance as it is felt by the fingers.

Tapestry A type of weaving in which the *weft* yarn carries the design and appears on the surface only in certain areas, not being carried across the warp as is usual in weaving processes.

Tempera A painting medium using egg yolk as a binder.

Tensile strength The greatest longitudinal stress a substance can bear without falling apart, as the strength of wire or cable when stretched over long distances.

Tertiary color A color mixed by combining one primary color and one secondary color. For example, yellow and blue produce the secondary color green, and yellow and green produce the tertiary color yellow-green.

Tesserae Small pieces of glass, tile, stone, or other material used to form a *mosaic*.

Tetrad Any four colors equidistant from one another on a *color wheel*.

Textile A woven fabric.

Thermoplastic Descriptive of *plastics* that can be reheated and reshaped without undergoing chemical change.

Thermosetting Descriptive of *plastics* that undergo a chemical change during curing and become permanently shaped.

Throwing The term for forming clay objects on the potter's wheel. Objects so formed are characteristically symmetrical and round.

Tie-dye A form of dyeing in which the fabric is twisted and tied in various sections so the dye does not reach the tied portions.

Tiering The portrayal of images on a two-dimensional surface in tiers or layers, as a means of indicating distance. The upper tier represents the most distant part of the scene while the lowest tier is equivalent to the foreground. Also known as *layering*.

Tint Any degree of lightness in a hue that is above its normal (or middle) value.

Tonality The relationships of colors within a composition or design.

Tone Any hue that has been grayed, either by the addition of its complement or by the use of black or white.

Topiary The art of cutting, trimming, or training trees into ornamental shapes.

Trademark A symbol applied to an object or piece of merchandise to denote its being the product of a specific manufacturer, with exclusive use protected by law.

Triad Any group of three colors equidistant on the color wheel.

Triglyph A grooved panel alternating with sculptured metopes in a frieze of a Greek temple.

Trompe-l'oeil French for "fool-the-eye"; a two-dimensional visual representation so carefully contrived that the viewer has the illusion of seeing a three-dimensional object or space.

Truss A structural form in architecture consisting of rigid bars or beams arranged in a series of triangles joined at their apexes, especially used in bridge and roof design.

Urban renewal The redesigning of cities to focus attention on the revival of the city center.

Value The lightness or darkness of a color in relation to a scale ranging from white to black.

Vanishing point In *linear perspective*, the imaginary point at which parallel lines appear to converge.

Vault An arched roof, usually of stone or concrete, created by a series of intersecting arches.

Veneer A thin layer of fine wood that is placed over a coarser stronger wood to give a piece of furniture or other object the appearance of superior quality.

Vernacular architecture Architecture built by the owners for their own use without pretense of professional design.

Vignette A representation in which the center of interest is sharply focused but the image fades out at the perimeter.

Visual balance Our perception of balance as it appears in a design.

Visual texture The visual surface characteristics of a substance without reference to its tactile quality; in other words, the quality of pattern on a smooth surface.

Voisin plan A plan created by Le Corbusier in which housing was concentrated in high-rise buildings set in landscaped areas.

Volume The bulk or mass of a structure. Compare *form*.

Voussoir The wedge-shaped stones that culminate in the keystone in the classic arch.

Voyeuse A type of chair designed in the eighteenth century, which had an arm rest across the back for the benefit of a standing person watching a card game played by the person sitting in the chair.

Warp In weaving, the lengthwise yarns held stationary on the loom and parallel to the finished edge of the fabric.

Watercolor A painting *medium* in which the binder is gum arabic.

Web The fabric created by the interlacing of the *warp* and *weft*, the product of the loom.

Weft In weaving, the crosswise yarns that intersect the warp to create a fabric.

Weighting A process of giving body to silk by dipping the fabric in a solution of sugar or metallic salts.

Welding A method of fusing metals by use of electricity or of acetylene and oxygen.

Woodcut A *relief printmaking* process in which the image is raised from the background by carving away the rest of the block. Carving is generally done with the grain of the block.

Wood engraving A *relief printmaking* process in which the image is raised from the background by carving away the rest of the block. Carving is generally done with finely tipped tools on the end grain of the block, making possible meticulous details.

Woof A set of yarns or other material perpendicular to the longer dimension or warp of a woven fabric; the crosswise element in a woven construction. Same as *weft*.

Bibliography

Adams, Ansel. *Ansel Adams: Images 1923–1974*. Greenwich, Conn.: New York Graphic Society, 1974.

Albers, Anni. *On Designing*. Middletown, Conn.: Wesleyan University Press, 1971.

Albers, Josef. *Interaction of Color*. New Haven: Yale University Press, 1975.

Almeida, Oscar. *Metalworking*. New York: Drake, 1971.

Ambasz, Emilio, ed. *The International Design Yearbook 3*. New York: Abbeville, 1987.

Ambasz, Emilio, ed. *Italy: The New Domestic Landscape*. New York: The Museum of Modern Art, 1972.

Arnheim, Rudolf. *Art and Visual Perception: A Psychology of the Creative Eye . . . the New Version*. Berkeley: University of California Press, 1974.

Artist's Proof: The Annual of Prints and Printmaking. New York: Pratt Graphics Center and Barre Publishers. Annually.

Atil, Esin, *Ceramics from the World of Islam*. Baltimore: Garamond/ Pridemark Press, 1973.

Bacon, Edmund N. *Design of Cities*. New York: Penguin, 1976.

Ball, Victoria Kloss, *Opportunities in Interior Design*. Skokie, Ill.: National Textbook, 1977.

Barry, John. *American Indian Pottery*. Florence, Ala.: Books Americana, Inc., 1981.

Bath, Virginia. *Needlework in America*. New York: Viking, 1979.

Beagle Peter. *American Denim*. New York: Abrams, 1975.

Bennett, Corwin. *Spaces for People: Human Factors in Design*. Englewood Cliffs, N.J.: Prentice Hall, 1977.

Berenson, Paulus. *Finding One's Way with Clay*. New York: Simon and Schuster, 1972.

Bernstein, Jack. *Stained Glass Craft*. New York: Macmillan, 1973.

Birren, Faber. *The Textile Colorist*. New York: Van Nostrand Reinhold, 1980.

Birren, Faber. *Color and Human Response*. New York: Van Nostrand Reinhold, 1978.

Birren, Faber. *History of Color in Painting: With New Principles in Color Expression*. New York: Van Nostrand Reinhold, 1980.

Bishop, Robert, and Elizabeth Safanda. *A Gallery of Amish Quilts*. New York: E. P. Dutton, 1976.

Bittner, Herbert. *Kaethe Kollwitz, Drawings*. New York: Thomas Yoseloff, 1970.

Blocker, H. Gene. *Philosophy of Art*. New York: Scribner's, 1979.

Bloomer, Carolyn M. *Principles of Visual Perception*. New York: Van Nostrand Reinhold, 1976.

Bloomer, Kent C., and Charles W. Moore. *Body, Memory and Architecture*. New Haven: Yale University Press, 1977.

Blunden, Maria, and Godfrey Blunden. *Impressionists and Impressionism*. New York: Rizzoli, 1980.

Boericke, Art, and Barry Shapiro. *Handmade Houses: A Guide to the Woodbutcher's Art*. San Francisco: Scrimshaw, 1973.

Bolles, Edmund Blair. *A Second Way of Knowing: The Riddle of Human Perception*. Englewood Cliffs, NJ: Prentice Hall, 1991.

Bress, Helen. *The Weaving Book*. New York: Charles Scribner, 1981.

Bring, Mitchell, and Josse Wayembergh. *Japanese Gardens: Design and Meaning*. New York: McGraw-Hill, 1982.

Brodatz, Philip. *Wood and Wood Grains: A Photographic Album for Artists and Designers*. New York: Dover, 1972.

Brown, Rachel. *The Weaving, Spinning and Dyeing Book*. New York: Alfred A. Knopf, 1978.

Bunting, Ethel-Jane W. *Shindi Tombs and Textiles: The Persistence of Pattern*. Albuquerque: The Maxwell Museum of Anthropology and the University of New Mexico Press, 1980.

Bunzel, Ruth. *The Pueblo Potter*. New York: Dover, 1972.

Caponigro, Paul. *Paul Caponigro*. Millerton, N.Y.: Aperture, 1972.

Carrington, Noel. *Industrial Design in Britain*. Winchester, Mass.: Allen and Unwin, 1976.

Carron, Shirley. *Modern Pewter: Design and Technique*. New York: Van Nostrand Reinhold, 1973.

Cavagnaro, David. *This Living Earth*. Palo Alto, Calif.: American West Publishing Co., 1972.

Chaet, Bernard. *An Artist's Notebook: Techniques and Materials*. New York: Holt, Rinehart and Winston, 1979.

Charlish, Anne, ed. *The History of Furniture*. New York: Crown, 1982.

Cheatham, Frank R., Jane Hart Cheatham, and Sheryl Haler Owens. *Design Concepts and Applications*. Englewood Cliffs, N.J.: Prentice Hall, 1987.

Clarke, Beverly. *Graphic Design in Educational Television*. New York: Watson-Guptill, 1974.

Clarke, Carl D. *Metal Casting of Sculpture and Ornament*. Butler, Md.: Standard Arts, 1980.

Collier, Graham. *Form, Space, and Vision*. 3d ed. Englewood Cliffs, N.J.: Prentice-Hall, 1972.

Constantine, Albert. *Know Your Woods*. New York: Scribner, 1972.

Constantine, Mildred, and Jack Lenor Larsen. *Beyond Craft: The Art Fabric*. New York: Van Nostrand Reinhold, 1972.

Cooper, Helen A. *Winslow Homer Watercolors*. New Haven: Yale University Press, 1986.

Croy, Peter. *Graphic Design and Reproduction Techniques*. rev. ed. New York: Focal Press, 1972.

d'Arbeloff, Natalie. *Designing with Natural Forms*. New York: Watson-Guptill, 1973.

Defining Modern Art: Selected Writings of Alfred H. Barr, Jr. ed. Irving Sandler and Amy Newman. New York: Abrams, 1986.

De Jonge, C. H. *Delft Ceramics*. New York: Praeger, 1970.

John Dewey. *Art as Experience*. Capricorn Books, NY, 1958.

D'Harcourt, Raoul. *Textiles of Ancient Peru and Their Techniques*. Seattle: University of Washington Press, 1974.

Diekelmann, John, and Robert Schuster. *Natural Landscaping*. New York: McGraw-Hill, 1982.

Dixon, Dwight R., and Paul B. Dixon. *Photography: Experiments and Projects*. New York: Macmillan, 1976.

Douglass, Ralph. *Calligraphic Lettering*. 3d ed. New York: Watson-Guptill, 1975.

Drexler, Arthur. *Design Collection: Selected Objects*. New York: Museum of Modern Art, 1970.

Eckbo, Garrett. *Home Landscape: The Art of Home Landscaping*. rev. and enl. ed. New York: McGraw-Hill, 1982.

Ehncke, R. H. *Graphic Trade Symbols by German Designers*. Magnolia, Mass.: Peter Smith, n.d.

Ehrenzweig, Anton. *The Hidden Order of Art*. Berkeley: University of California Press, 1976.

Eichenberg, Fritz. *The Art of the Print*. New York: Abrams, 1976.

Eisenstaedt, Alfred. *Witness to Nature*. New York: Viking, 1971.

Ellinger, R. *Color, Structure, and Design*. New York: Van Nostrand Reinhold, 1980.

Elson, Vivkie G. *Dowries from Kutch*. Los Angeles: Museum of Cultural History, 1979.

Ernst, Bruno. *The Magic Mirror of M. C. Escher*. New York: Ballantine, 1976.

Escher, M. C. *The Graphic Works of M. C. Escher*. Ballantine Books, NY, 1960.

Escher, M. C. *The Graphic Works of M. C. Escher*. New York: Ballantine, 1971.

Espejel, Carlos. *Mexican Folk Ceramics*. Barcelona: Editorial Blume, 1975.

Evans, Helen M., and Carla D. Dumesnil. *Man the Designer*, 2d ed. New York: Macmillan, 1982.

Evans, Joan. *Pattern: A Study of Ornament in Western Europe*. 2 vols. New York: Da Capo, 1976.

Faulkner, Ray, and Edwin Ziegfeld. *Art Today: An Introduction to the Visual Arts*. 5th ed. New York: Holt, Rinehart and Winston, 1974.

Faulkner, Ray, and Sarah Faulkner. *Inside Today's Home*. New York: Holt, Rinehart and Winston, 1974.

Faulkner, Sarah. *Planning a Home*. New York: Holt, Rinehart and Winston, 1979.

Floethe, Louise L. *Houses Around the World*. New York: Charles Scribner, 1973.

Forgione, Joseph, and Sterling McIlhany. *Wood Inlay*. New York: Van Nostrand Reinhold, 1973.

Forms in Metal: 275 Years of Metalsmithing in America. New York: American Crafts Council, 1975.

Fromme, Babbette Brandt. *Curators' Choice: An Introduction to the Art Museums of the U. S.* 4 vols. New York: Crown, 1981.

Gardner, Paul V., and James S. Plant. *Steuben: Seventy Years of American Glassblowing*. New York: Praeger, 1975.

Gardner's Art Through the Ages. 7th ed. rev. by Horst de la Croix and Richard G. Tansey. New York: Harcourt Brace Jovanovich, 1980.

Gaunt, William. *The Impressionists*. New York: Weathervane Books, 1975.

Giedion, Siegfried. *Architecture and the Phonomena of Transition: The Three Space Conceptions in Architecture*. Cambridge, Mass.: Harvard University Press, 1971.

Gittinger, Mattiebelle. *Splendid Symbols: Textiles and Tradition in Indonesia*. Washington, D.C.: The Textile Museum.

Gombrich, E. H. *The Sense of Order*. Oxford: Phaidon, 1979.

Gostelow, Mary. *A World of Embroidery*. New York: Charles Scribner, 1975.

Graphics Annual 85/86. Ed. Walter Herdeg. Zurich: Graphis Press, 1985.

Greenwood, Kathryn M., and Mary F. Murphy. *Fashion Innovation and Marketing*. New York: Macmillan, 1978.

Gregory, R. I. *The Intelligent Eye*. New York: McGraw-Hill, 1970.

Grillo, Paul. *Form, Function, and Design*. New York: Dover, 1975.

Gruen, Victor, and Larry Smith. *Centers for Urban Environment*. New York: Van Nostrand Reinhold, 1973.

Guzelimian, Vahe. *Becoming a MacArtist*. Greensboro, N. C.: Compute! Publications, Inc., 1985.

Haas, Ernst. *The Creation*. New York: Penguin, 1978.

Hall, Jim. *Mighty Minutes: An Illustrated History of Television's Best Commercials*. New York: Harmony, 1984.

Hall, Julie. *Tradition and Change: The New American Craftsman*. New York: Dutton, 1977.

Hamburger, Estelle. *Fashion Business: It's All Yours*. New York: Harper & Row, 1976.

Harling, Robert, ed. *Dictionary of Design and Decoration*. New York: Viking, 1973.

Hatje, Gerd, and Peter Kaspar. *1601 Decorating Ideas for Modern Living*. New York: Abrams, 1974.

Held, Shirley. *Weaving: A Handbook of the Fiber Arts*. 2d ed. New York: Holt, Rinehart and Winston, 1976.

Herbert, Barry. *German Expressionism*. London: Jupiter England, 1981. New York: State Mutual Book.

Hess, Thomas B. *Willem de Kooning*. The Museum of Modern Art. NY, 1968.

Hitchcock, Henry Russell. *In the Nature of Materials: The Buildings of Frank Lloyd Wright, 1887–1941*. New York: Da Capo, 1975.

Honour, Hugh. *The Arts of China*. New York: American Heritage, 1969.

Hoyt, Charles King. *More Places for People*. New York: McGraw-Hill, 1982.

Irving, Donald J. *Sculpture: Material and Process*. New York: Van Nostrand Reinhold, 1970.

Itten, Johannes. *Design and Form*. 2d rev. ed. New York: Van Nostrand Reinhold, 1975.

Itten, Johannes. *The Art of Color*. New York: Van Nostrand Reinhold, 1974.

James, George Wharton. *Indian Basketry*. New York: Dover, 1972.

Janson, H. W. *History of Art*. 2d ed. Englewood Cliffs, N.J.: Prentice Hall, 1977.

Jencks, Charles. *The Language of Post-Modern Architecture*. 3d rev. ed. New York: Rizzoli, 1981.

Johnson, Stewart J. *The Modern American Poster*. New York: Museum of Modern Art, 1983.

Johnson, Timothy E. *Solar Architecture: The Direct Gain Approach*. New York: McGraw-Hill, 1982.

Jones, Dewitt. *Visions of Wilderness*. Portland, Oreg.: Graphic Arts Center Publishing Co., 1980.

Kahlenberg, Mary Hunt, and Anthony Berlant. *The Navajo Blanket*. Los Angeles: Praeger/Los Angeles County Museum of Art, 1972.

Kelly, J. J. *The Sculptural Idea*. Minneapolis: Burgess, 1970.

Kepes, Gyorgy, ed. *Arts of the Environment*. New York: Braziller, 1972.

Knobler, Nathan. *The Visual Dialogue*. 3d ed. New York: Holt, Rinehart and Winston, 1980.

Kohler, Carl. *History of Costume*. Magnolia, Mass.: Peter Smith, n. d.

Kowal, Dennis, Jr., and Dona Z. Meilach. *Sculpture Casting*. New York: Crown, 1972.

Krevitsky, Nik. *Batik, Art and Craft*. New York: Van Nostrand Reinhold, 1973.

Kurtz, Stephen A. *Wasteland: Building the American Dream*. New York: Praeger, 1973.

Lam, C. M., ed. *Calligrapher's Handbook*. New York: Taplinger, 1976.

Larsen, Jack L., and Jeanne Weeks. *Fabrics for Interiors*. New York: Van Nostrand Reinhold, 1975.

Lauer, David A. *Design Basics*. New York: Holt, Rinehart and Winston, 1979.

Leach, Bernard. *A Potter's Work*. Pub. Jupiter England, New York: State Mutual Book, 1981.

Legg, Alicia, ed. *Sculpture of Matisse*. New York: Museum of Modern Art, 1972.

Ley, Sandra. *Russian and Other Slavic Embroidery Designs*. New York: Charles Scribner, 1976.

Libby, William Charles. *Color and the Structural Sense*. Englewood Cliffs, N.J.: Prentice Hall, 1974.

Life Library of Photography. New York: Time-Life Books, 1970–1971.

Loewy, Raymond. *Industrial Design*. New York: Overlook Press, 1980.

Lynch, Kevin, *Managing the Sense of a Region*. Cambridge, Mass.: MIT Press, 1976.

Lynes, Russell. *The Lively Audience: A Social History of the Visual and Performing Arts in America, 1890–1950*. New York: Harper & Row, 1986.

McCarter, William, and Rita Gilbert. *Living with Art*. New York: Alfred A. Knopf, 1985.

McQuillan, Melissa. *Impressionist Portraits*. Boston: New York Graphic Society Books/ Little Brown, 1986.

Magnani, Franco, ed. *Living Spaces: 150 Design Ideas from Around the World*. New York: Whitney Library of Design, 1978.

Mathisen, Marilyn. *Apparel and Accessories*. New York: McGraw-Hill, 1979.

Mayer, Ralph. *The Artist's Handbook of Materials and Techniques*. New York: Viking, 1982.

Mayor, A. Hyatt. *Prints and People*. New York: The Metropolitan Museum of Art, 1971.

Medley, Margaret. *The Chinese Potter*. New York: Charles Scribner, 1976.

Mehrabian, Albert. *Public Places and Private Spaces: The Psychology of Work, Play, and Living Environments*. New York: Basic Books, 1976.

Mendelowitz, Daniel M. *A History of American Art*. 2d ed. New York: Holt, Rinehart and Winston, 1973.

Metal: A Bibliography. New York: American Crafts Council, 1977.

Metcalf, Robert, and Gertrude Metcalf. *Making Stained Glass*. New York: McGraw-Hill, 1972.

Miserez-Schira, Georges. *The Art of Painting on Porcelain*. Radnor, Pa.: Chilton, 1974.

Moholy-Nagy, Sibyl. *Native Genius in Anonymous Architecture in North America*. New York: Schocken, 1976.

Moore, Henry. *Sculpture and Drawings (1964–73)*. New York: Wittenborn, 1977.

Morton, Philip. *Contemporary Jewelry*. 2d ed. New York: Holt, Rinehart and Winston, 1976.

Muller, Joseph-Emile. *Fauvism*. Trans. S. E. Jones. New York: Praeger, 1967.

Mumford, Lewis. *Culture of Cities*. New York: Harcourt Brace Jovanovich, 1970.

Murphy, Seamus. *Stone Mad: A Sculptor's Life and Craft*. Boston: Routledge and Kegan, 1976.

Nelson, George. *Problems of Design*. Whitney Library of Design, 1974.

Nelson, George. *How to See: A Guide to Reaching our Manmade Environments*. Boston: Little, Brown, 1979.

Nelson, Glenn C. *Ceramics: A Potter's Handbook*. 5th ed. New York: Holt, Rinehart and Winston, 1984.

Newman, Jay, and Lee Newman. *Plastics for the Craftsman*. New York: Crown, 1973.

Newman, Thelma. *Plastics as Design Form*. Philadelphia: Chilton, 1972.

Norberg-Schulz, Christian. *Meaning in Western Architecture*. New York: Praeger, 1975.

Nordness, Lee. *Object U. S. A*. New York: Viking, 1970.

Ocvirk, Otto G., Robert O. Bone, Robert E. Stinson, and Philip R. Wigg. *Art Fundamentals: Theory and Practice*. 4th ed. Dubuque, Iowa: Wm. C. Brown, 1981.

Paak, Carl E. *The Decorative Touch*. Englewood Cliffs, N.J.: Prentice Hall, 1981.

Parker, W. Oren, and Harvey K. Smith. *Scene Design and Stage Lighting*. 4th ed. New York: Holt, Rinehart and Winston, 1979.

Patterns. Catalogue of 1982 American Craft Museum exhibition.

Pearce, Peter. *Structure in Nature Is a Strategy for Design*. Cambridge, Mass.: MIT Press, 1978.

Pecktal, Lynn. *Designing and Painting for the Theatre*. New York: Holt, Rinehart and Winston, 1975.

Peltz, Leslie Ruth. *Fashion, Color, Line, and Design*. Indianapolis: Bobbs-Merrill, 1971.

Peterdi, Gabor. *Printmaking*. New York: Macmillan, 1971.

Petrakis, Joan. *The Needle Arts of Greece*. New York: Charles Scribner, 1977.

Pfannschmidt, Ernest Erik. *Twentieth Century Lace*. New York: Charles Scribner, 1975.

Philip, Peter. *Furniture of the World*. New York: Mayflower, 1978.

Phillips, Dave. *Graphic and Optical Art Mazes*. New York: Dover, 1976.

Phillips, Derek. *Planning Your Lighting*. New York: Quick Fox, 1978.

Picton, John, and John Mack. *African Textiles*. London: British Museum Publications, 1979.

Pile, John F. *Design: Purpose, Form and Meaning*. New York: Norton, 1979.

Prueitt, Melvin. *Art and the Computer*. New York: McGraw-Hill, 1984.

Rader, Melvin, and Bertram Jessup. *Art and Human Values*. Englewood Cliffs, N.J.: Prentice Hall, 1976.

Ramazanoglu, Gulseren. *Turkish Embroidery*. New York: Van Nostrand Reinhold, 1976.

Rees, David. *Creative Plastics*. New York: Viking, 1973.

Rhodes, Daniel. *Clay and Glazes for the Potter*. rev. ed. Philadelphia: Chilton, 1973.

Richardson, John Adkins, Floyd W. Coleman, and Michael J. Smith. *Basic Design: Systems, Elements, Applications*. Englewood Cliffs, N.J.: Prentice Hall, 1984.

Richter, Gisela M., ed. *Sculpture and Sculptors of the Greeks*. 4th ed. rev. and enl. New Haven: Yale University Press, 1971.

Risebero, Bill. *Modern Architecture and Design: An Alternative History*. Cambridge: MIT Press, 1983.

J. Romero y Murube. *Alcazar de Sevilla*. Editorial Patrimonio Nacional. Madrid, 1971.

Roth, Laszlo. *Package Design*. Englewood Cliffs, N.J.: Prentice Hall, 1981.

Roukes, Nicholas. *Sculpture in Plastics*. New York: Watson-Guptill, 1978.

Rowe, Ann Pollard. *A Century of Change in Guatemalan Textiles*. New York: Center for Inter-American Relations, 1981.

Russell, Douglas. *Stage Costume Design: Theory, Technique, and Style*. New York: Appleton-Century-Crofts, 1973.

Russell, Stella Pandell. *Art in the World*. New York: Holt, Rinehart and Winston, 1975.

Saff, Donald, and Deli Sacilotto. *Printmaking: History and Process*. New York: Holt, Rinehart and Winston, 1978.

Saff, Donald, and Deli Sacilotto. *Screenprinting: History and Process*. New York: Holt, Rinehart and Winston, 1979.

Salomon, Rosalie K. *Fashion Design for Moderns*. New York: Fairchild, 1976.

Sandler, Irving. *The Triumph of American Painting: A History of Abstract Expressionism*. New York: Harper & Row, 1970.

Santayana, George. *The Sense of Beauty*. New York: Dover Publications, Inc., 1955.

Verlag Schnell and Steiner, *Our Lady of the Height Ronchamp*. Munich-Zurich, 1965.

Scully, Vincent J. *Modern Architecture: The Architecture of Democracy*. New York: Braziller, 1982.

Sculpture in Fiber. New York: American Craft Council, 1972.

Shafer, Thomas. *Pottery Decoration*. New York: Watson-Guptill, 1976.

Silvercraft. Elmsford, N.Y.: British Book Center, 1977.

Smith, Paul J., and Edward Lucie-Smith. *American Craft Today*. New York: American Craft Museum/Weidenfeld and Nicolson, 1986.

Southwork, Susan, and Michael Southwork. *Ornamental Ironwork*. Boston: David Godine, 1978.

Sproles, George B. *Fashion: Consumer Behavior Toward Dress*. Minneapolis: Burgess, 1979.

Stella, Frank. *Working Space*. Charles Eliot Norton lectures delivered at Harvard, 1983–84. Cambridge: Harvard University Press, 1987.

Stern, Robert A. M. *New Directions in American Architecture*. New York: Braziller, 1977.

Stix, Hugh, and Marguerite Stix. *The Shell: Five Hundred Years of Inspired Design*. New York: Ballantine, 1972.

Stoddard, Alexandra. *Style for Living*. Garden City: Doubleday, 1974.

Stone, Anna. *Sculpture: New Ideas and Techniques*. Levittown, N.Y.: Transatlantic, 1977.

Strache, Wolf. *Forms and Patterns in Nature*. New York: Pantheon, 1973.

Swedlund, Charles. *Photography*. 2d ed. New York: Holt, Rinehart and Winston, 1981.

Thomson, F. P. *Tapestry: Mirror of History*. London: David and Charles, 1980.

Thorpe, Azalea S., and Jack Lenor Larsen. *Elements of Weaving.* Garden City, N.Y.: Doubleday, 1978.

Tiffany. Intro. by Victor Arwas. New York: Rizzoli, 1979.

Varney, Vivian. *Photographer as Designer.* Worcester, Mass.: Davis, 1977.

Vasarely, Victor. *Notes Brutes.* Venice: Alfieri, 1970.

Waller, Irene. *Textile Sculptures.* London: Studio Vista, 1977.

Wassermann, Tamara E., and Jonathon Hill. *Bolivian Indian Textiles: Traditional Designs and Costumes.* New York: Dover, 1981.

Westbrook, Adele, and Ann Yarowski, eds. *Design in America: The Cranbrook Vision, 1925–1950.* New York: Abrams, 1983.

Westphal, Katherine. *Dragons and Other Creatures: Chinese Embroidery.* Berkeley, Calif.: Lancaster-Miller, 1979.

Willcox, Donald. *New Design in Wood.* New York: Van Nostrand Reinhold, 1970.

Wittkower, Rudolf. *Sculpture: Processes and Principles.* New York: Harper & Row, 1977.

Wong, Wucius. *Principles of Three-Dimensional Design.* New York: Van Nostrand Reinhold, 1977.

Wood, Jack C. *Sculpture in Wood.* New York: Da Capo, 1977.

Woods, Michael. *Perspective in Art.* Cincinnati: North Light, 1984.

Young Americans: Metal. New York: American Craft Council, 1979.

Zakos, Spiros. *Lifespace and Designs for Today's Living.* New York: Macmillan, 1977.

Zelanski, Paul, and Mary Pat Fisher. *Design Principles and Problems.* New York: Holt, Rinehart and Winston, 1984.

Photographic Credits

Color Plates: 2: Adam Woolfitt/Robert Harding Picture Library, **6:** Elsa Peterson, **7:** A. F. Kersting, **10:** Scala/Art Resource, **11:** John Cliett, **12:** George Erml, **13:** David Riley, **18 and 19:** Macbeth/Munsell Color, **24:** Langdon Clay, **27:** ;cr 1993 The Art Institute of Chicago. All rights reserved. **28:** Frank R. Cheatham, Lubbock, TX, **31:** from Josef Albers. *Interaction of Color*, revised edition, Plate IV-1. By permission of Yale University Press and the Josef Albers Foundation, **33:** Jack Liu, **34:** Katharine Wetzel, **35:** David Heald, ;cr The Solomon R. Guggenheim Foundation, New York, FN 52.1327, **36:** Eileen Tweedy, London, **37:** Martin E. Klimek/Marin *Independent Journal*, **38:** Peter Parks, Oxford Scientific Films, Ltd., **42:** David Heald, ;cr The Solomon R. Guggenheim Foundation, New York FN 57.1484, **44:** Peter Vitale/Noel Jeffrey, Inc.

Chapter 1 **1:** J. Grabowski. *Wycinanka Ludowa* (Warsaw: Wydawnictwo Sztuka, 1955), **2:** P. Perrin/Sygma, **4:** Copyright UC Regents: UCO/Lick Observatory Image, **5:** Rich Doyle/Uniphoto, **6:** Ernst Haas, **7:** Ted Wood, **8:** Carr Clifton, **9:** Chip Clark, **10:** Doug Perrine/DRK Photo, **14:** George Erml, **15:** Giraudon/Art Resource, **17:** Alinari/Art Resource, **20:** Art Resource, **21:** Edmund Blair Bolles. *A Second Way of Knowing: The Riddle of Human Perception* (Englewood Cliffs: Prentice-Hall, Inc., 1991). Used by permission of Prentice Hall Press/a division of Simon & Schuster, New York. **25:** Chris McElcheran, **30:** Bruno Jarret/J. E. Bulloz, Paris, **33:** Art Resource, New York.

Chapter 2 **1(a):** L. West/Photo Researcers, **1(b):** Bruce Coleman, Inc. **4:** Joy Spur/Bruce Coleman, Inc., **5:** Carolina Biological Supply, Burlington, NC, **7:** ESTO, **8:** Clemens Kalischer, **11:** George Erml, **17(a):** Ken Karp, **17(b):** Courtesy Black & Decker, **20:** Courtesy Chrysler Corporation, **21:** AP/Wide World Photos, **22:** Jill Poyourow, **23:** Courtesy Compaq Computer Corporation. All rights reserved. **25, 26(a and b), 27, 28:** Courtesy Schnell & Steiner Verlag, by permission of Notre Dame du Haut, **29:** Ezra Stoller © ESTO, **30:** Kevin Horan.

Chapter 3 **1:** Kjell Sandved/Uniphoto, **2:** William Garnett, **3:** R. Steven Fuller, **5:** From Theodore Bowie (Ed.), *The Sketchbook of Villard de Honnecourt*, p. 145. Bloomington: Indiana University Press, 1959. By permission of Theodore Bowie. **7:** Mazonowica/Art Resource, **9:** From Lao Tsu. *Tao Te Ching Number Forty-Five*, a new translation by Gia-Fu Fend and Jane English (New York: Vintage Books, 1972). **10 and 13:** Giraudon/Art Resource, Paris, **15:** Cliche RMN, **16:** Photo © 1993 The Art Institute of Chicago. All rights reserved. **19:** (c) Elke Walford, **23:** National Film Board of Canada/Dept. of Indian and Northern Affairs, Ottawa, **24:** Gary Zahn/Bruce Coleman Inc., **25:** Nefsky/Art Resource, **26:** From *The History of China* (New York: American Heritage Publishing Company, 1969), p. 37; and E. Wallis Budge *Egyptian Hieroglyphic Dictionary* (New York: Dover Books, 1978). **29:** William Thuss.

Chapter 4 **8:** Giraudon/Art Resource, **10:** Wildenstein & Co., New York, **14:** Alinari/Art Resource, **15:** Alinari/Art Resource, **16:** Vantage Art, **17:** © 1993 The Art Institute of Chicago. All rights reserved. **18:** © 1993 Her Majesty Queen Elizabeth II, **20:** Elliott Erwit/Magnum Photos, Inc., **21:** Julius Shulman.

Chapter 5 **2:** British Tourist Authority, **4:** Frank S. Balthis/Nature's Design, **6:** George Jennings, Jr., **8:** Dept. of Indian and Northern Affairs, Ottawa, **9:** Robert Gossington/Bruce Coleman Inc., **10:** Red Hook, **16:** David Heald, **18:** Russell Dixon Lamb/Photo Researchers, **19:** Art Resource, New York, **20:** Ministry of Tourism, Province of British Columbia, **21:** Courtesy Harry B. Helmsley, **23:** Kay Kaylor, HBC, **25:** Hector R. Acebe/Photo Researchers, **26:** A. F. Kersting, **28:** George Erml.

Chapter 6 Frank S. Balthis/Nature's Design, **2:** Jack Lenor Larson, Inc., **3:** C. A. Henley/Larus, Australia, **4:** Robert P. Carr/Bruce Coleman Inc., **5:** Wardene Weissel/Bruce Coleman Inc., **7:** George Erml, **9:** Courtesy the Farley Company, Hartford, **10:** Wettstein & Kauf, **13:** Peter Frey/The Image Bank, **14:** Enzo Ricci, **16:** SEF/Art Resource, **18:** Robert E. Mates, copyright The Solomon R. Guggenheim Foundation, New York, FN 53.1350. **19:** Nick Merrick/Hedrich-Blessing, **20:** Dean Miller.

Chapter 7 **5:** From the Reference Catalog of Daniel Smith Artists' Materials, 4130 First Avenue South, Seattle, WA 98134-2302; toll-free customer service line (800) 426-7923.

Chapter 8 **1:** Tate Gallery, London/Art Resource, New York, **3:**

4: Leonard Lee Rue, Jr./Bruce Coleman Inc., 6: Tate Gallery, London/Art Resource, New York, 7: G. White/Robert Harding Picture Library, 9: Dick Beaulieux, 10: Roger Schreiber © 1991, 12: George Erml.

Chapter 9 1: Greek National Tourist Organization, 2: © David Muench, 3: Bill Bachman, 6: The Museum of Modern Art, New York, 7: *The Art of Heraldry* (Arno Press). 8: Ianthe Ruthven, 10: Glenn Christiansen, 12: Bill Wood/Bruce Coleman Inc. 13: A. & R. MAS, 14: Art Resource, New York, 15: Harald Sund, 16: Hedrich-Blessing, 24: Dept. of Indian and Northern Affairs, Ottawa, 25: Harald Sund, 29: Jerry Thompson, 30: Tate Gallery, London/Art Resource, New York.

Chapter 10 4 and 5(a): Alinari/Art Resource, 5(b): Scala/Art Resource, 6: Eastman Kodak Company, 7: Art Wolfe, 8: Dwight Kuhn, 10(a): Will and Deni McIntyre/Photo Researchers, 10(b): Alain Evrard/Photo Researchers, 11(a): A. F. Kersting, 12: Government of India Press Information Office, 13: Hirmer Fotoarchiv, 14: A. F. Kersting, 17(a): Jeffrey Maron, 248 Lafayette Street, New York 10012.

Index

Index to Color Plates